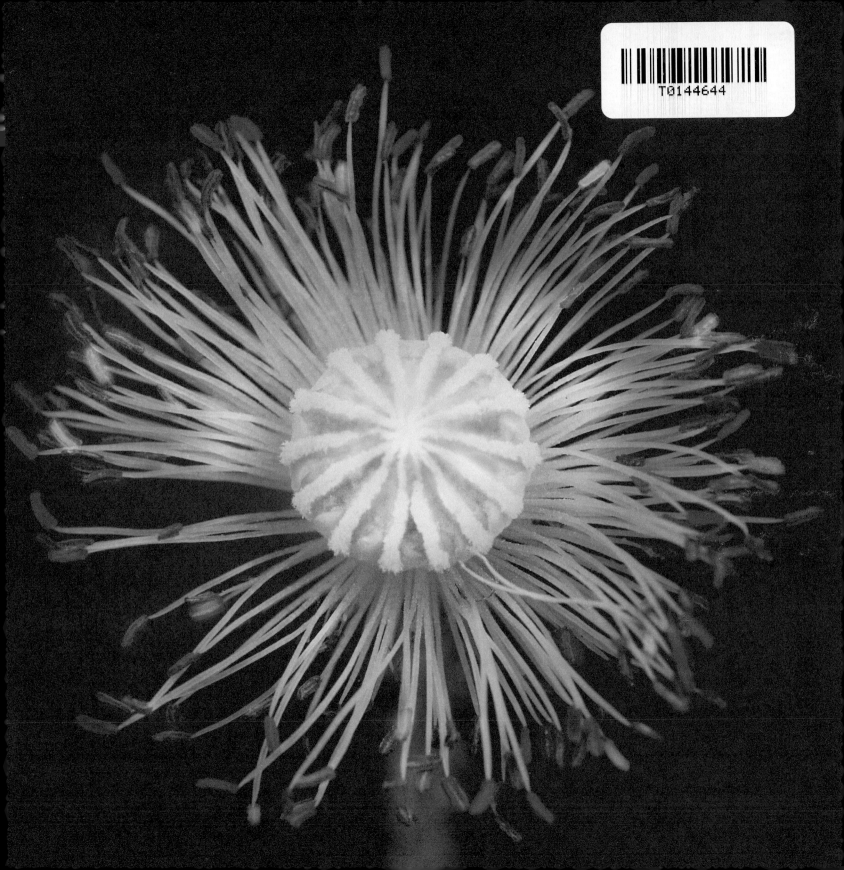

First published 2015 by Focal Press

Published 2016 by Routledge
711 Third Avenue, New York, NY 10017
2 Park Square, Milton Park, Abingdon, Oxon OX14 4RN

*Focal Press is an imprint of the Taylor & Francis Group,
an informa business*

Notices
Practitioners and researchers must always rely on their
own experience and knowledge in evaluating and using
any information, methods, compounds, or experiments
described herein. In using such information or methods
they should be mindful of their own safety and the safety
of others, including parties for whom they have a
professional responsibility.

Product or corporate names may be trademarks or
registered trademarks, and are used only for
identification and explanation without intent to infringe.

Library of Congress Cataloging-in-Publication Data
Davis, Harold, 1953-
 The Photoshop darkroom 2 : creative digital
 transformations / Harold Davis, Phyllis Davis.

 p. cm.
 Includes index.
 ISBN-13: 978-0-240-81531-2
 ISBN-10: 0-240-81531-9

 1. Adobe Photoshop. 2. Photography--Digital
techniques. 3. Photography--Retouching. 4. Photography,
Artistic. I. Davis, Phyllis, 1963- II. Title.
 TR267.5.A3D36 2011
 006.6'96--dc22

 2010037557

British Library Cataloguing-in-Publication Data
A catalogue record for this book is available from the
British Library.

ISBN 13: 978-0-240-81531-2 (pbk)

The Photoshop® Darkroom 2
Creative Digital Transformations

Harold Davis
Phyllis Davis

Routledge
Taylor & Francis Group

LONDON AND NEW YORK

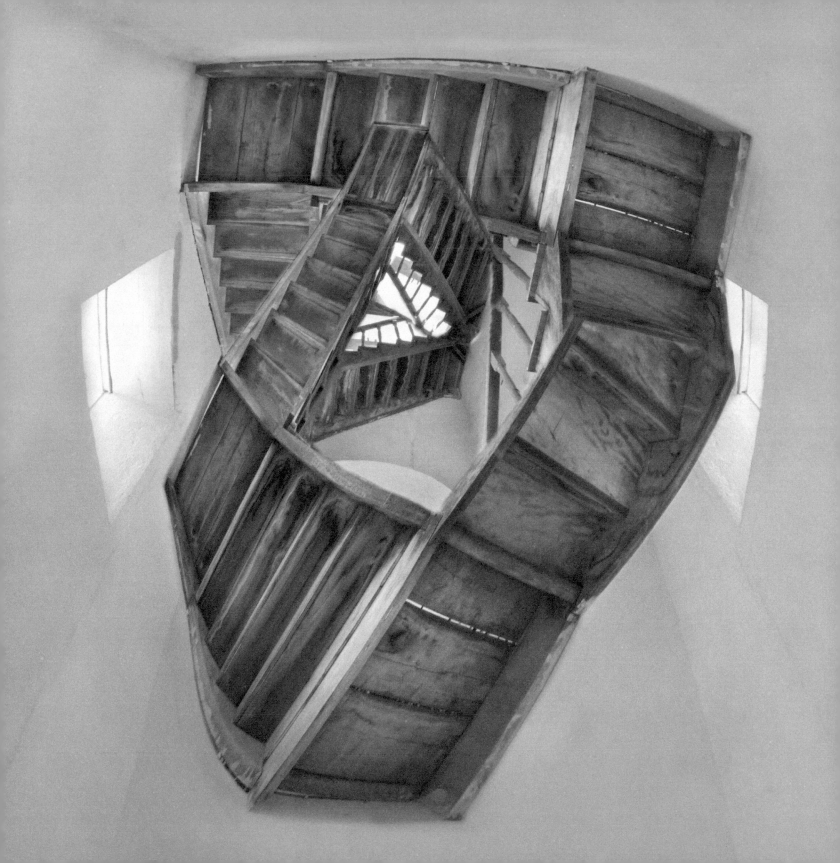

Contents

›› Introduction

Back in the old days, working in a chemical darkroom, I could only have dreamed of a post-processing tool as wonderful as Photoshop. But for me that's exactly what Photoshop is—a tool. It's a tool that helps me as a professional image creator. The image is what matters, not the tool.

The Photoshop Darkroom 2: Creative Digital Transformations looks at the features of Photoshop as practical aids in making great digital images. I don't focus on the latest and greatest Photoshop menus and palettes. For the most part, the Photoshop techniques shown in the book can be done using the core features of Photoshop. These features have generally been available going back many versions. Think of it this way: in a film darkroom the recipes for developer changed over time, but the underlying idea of how to develop film and paper stayed the same.

The goal of *The Photoshop Darkroom* series is to inspire *you* and provide *you* with techniques to try. A digital image starts with a capture or a scan and proceeds through post-processing towards its final state. How well your image comes out depends upon your mastery of the craft of digital post-processing and—far more important—your imagination. I'd like *The Photoshop Darkroom* books to be your guide and companion on this exciting journey.

A digital camera is a special purpose computer attached to a lens and a scanner. It makes sense to process imagery in the more powerful context of a desktop computer (and Photoshop) rather than in the camera.

It also is just common sense to make the best photos you can using your camera. Relying on Photoshop to fix sloppy photography is a waste of time and creative energy. Therefore I'll give you pointers about how to photograph with digital post-processing in mind—which is very different than being a lazy photographer.

The Photoshop Darkroom 2: Creative Digital Transformations follows *The Photoshop Darkroom:*

Creative Digital Post-Processing and can be read either as a sequel to the first volume or on its own. We've worked hard to make this volume self-contained—however, we didn't want to be overly repetitive of material that is amply covered in the first volume. Where appropriate I'll provide page references to the earlier *Photoshop Darkroom* book for more in-depth coverage of certain topics.

The emphasis in this volume is on creative transformations. This involves a wide range of image creation challenges from cleaning up an image that is "almost there"—and requires a little retouching—to creating entirely new fantastic digital images that are derived using compositing and other techniques.

As with the first *Photoshop Darkroom* book, I make no claims that the techniques I present are the only way, or even the best way, to do something. Photoshop is an incredibly rich and complex software environment with many moving parts and many ways to do anything. The most I can do is to show you the way I work in Photoshop on a daily basis as a professional photographer and image creator. If you can find a better or more fun way to accomplish the same tasks, more power to you—and please drop me a line to tell me your technique.

Once again, I am blessed with the perfect co-author, Phyllis Davis. Phyllis makes me complete in many ways. She is also a great antidote to my tendency to wave my hands about the details of a process—because she insists on complete clarity and wants every step to be explained carefully.

I love spending time behind the camera and I love spending time working on images in Photoshop. It's my hope that this book helps inspire you to work on your digital imagery in post-processing with as much joy as I do—enjoy!

Harold Davis

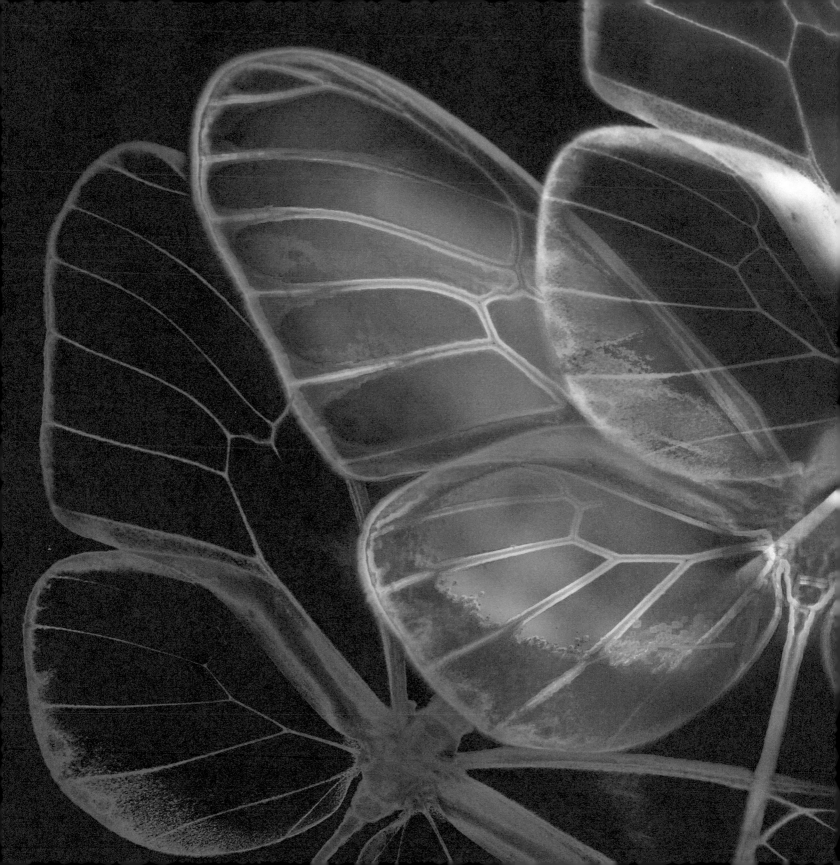

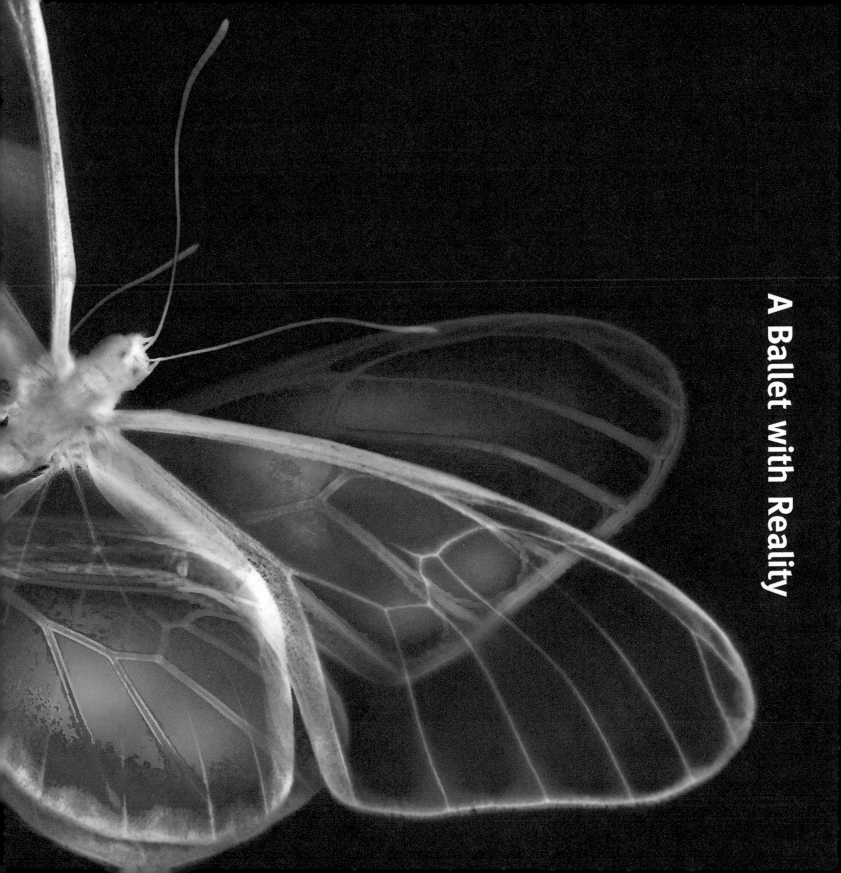

A Ballet with Reality

›› Everything you always wanted to know about Digital Asset Management (DAM) *

Workflow roadmap

Workflow refers to the entire process of creating a digital photograph from the moment the shutter is pressed to the final use for your image. It also includes the very important topic of how you store and preserve your images.

If you think that archiving and backing up photo files is a big pain—well, maybe you're right. But don't do it and you'll live to regret it! A digital photo is not a tangible object. It only exists as long as the computer file that holds its data is safe and can be accessed.

Also, you need to be able to find a gosh, darn %&#@ image file when you need it!

Anyone who works seriously with digital photographs will tell you that when it comes to workflow and Digital Asset Management (DAM), planning and organizing in advance helps.

Approaching DAM as a global task that needs to encompass all your digital assets and activities helps to lessen the problems and headaches you will encounter.

Think digitally!

1

Shooting Photos

Consider: Multi-RAW processing
Extending dynamic range
HDR/Hand-HDR
Shooting pieces for compositing

For more about shooting for digital, take a look at PD1: 104.

Don't try to edit using your camera's LCD. Decisions about which images to delete or work on should be made at the computer where you can really see them

4

Processing RAW Files into Photoshop

• Multi-RAW processing via ACR (PD1: 15–67)
• Multi-RAW processing via Lightroom (PD2: 16–19)
• HDR with third party software such as Photomatix
• Camera-vendor RAW processing software
• Other software alternatives

You may not want to go into the Photoshop darkroom with every capture

2

Getting Photos from Camera to Computer

Hardware options: Card reader (PD1: 14)
Cable (USB) direct to camera
Wireless

Software options: Finder (Mac)/Explorer (Win)
iPhoto, etc.
Lightroom
Camera vendor software

Beware of software such as iPhoto that only copies images into its database without placing individual image files on your computer

3

Archiving Original Files

Be redundant!

File formats: DNG (PD1: 12, PD2: 13)
RAW, e.g. NEF (Nikon), CR2 and CRW (Canon), etc.

Software: Structured file system using Finder (Mac)/Explorer (Win)
Lightroom catalog
Other software solutions

For more about saving and naming files on your computer, take a look at PD1: 24–25.

*but were afraid to ask

Saving Photo Files

- Follow a consistent workflow for archiving
- Save a master version with layers
- Flatten the final version
- Size appropriately for uses
- Save in RGB and CMYK as needed
- Save JPEGs for the web

Be redundant!

Enhancing Converted RAW Images in Photoshop

- Multi-RAW processing (PD1: 15–65, PD2: 16–26)
- Hand-HDR (PD1: 106–119, PD2: 108–121)
- Retouching and cloning (PD2: 30–37, 68–95)
- Adjusting exposure (PD1: 72–73)
- Special Effects
- Filters
- LAB color (PD1: 150–197, PD2: 184–195)
- Sharpening (PD1: 198–201)

The sky's the limit! Anything you can think of you can probably do in Photoshop

Keeping Track of Files

- EXIF data
- Keywording
- Structuring storage (PD1: 25)
- Cataloging in the file system
- Lightroom catalog
- Specialized software
- Using internet resources such as Flickr as a catalog

References used in this book

Many of the topics shown in this workflow roadmap are covered in this book, or in the first *Photoshop Darkroom* book. When there is a cross-reference, it's listed with the abbreviation for the book and the page number.

PD1: 15–17 means *The Photoshop Darkroom: Creative Digital Post-Processing* (Focal Press: 2010), pages 15–17.

PD2: 123–125 means *The Photoshop Darkroom 2: Creative Digital Transformations* (Focal Press: 2011), pages 123–125.

Backing Up

Be redundant!

Backup software
Synchronization software for redundant backup

Hardware: Recordable media such as DVDs are perishable and not big enough.

Hard drives are the best bet...but all hard drives eventually fail.

You have to backup your backup drives!

RAID 5 (good balance between performance, safety, and cost, see PD1: 27)

Go forth and print and publish!

›› The RAW advantage

Here's the JPEG and here's the version I made from a RAW file

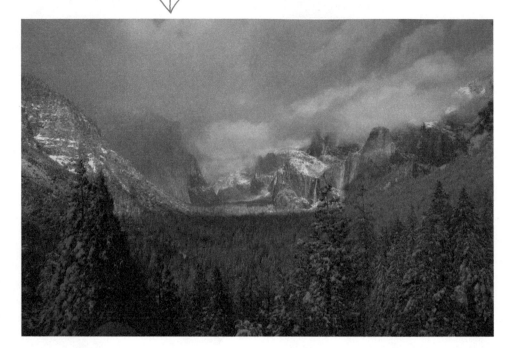

A RAW file has potential

If there's one single point that I want people who take one of my workshops to understand about digital photography and the Photoshop darkroom, it is the RAW advantage.

When you capture a digital photograph as a RAW file, you are saving all the data that was available to the sensor. This is in contrast to other kinds of digital captures, such as a JPEG capture made by lower-end cameras. With a JPEG capture, a great deal of data is simply thrown away.

Your RAW capture is just a file by itself. It can't be printed or displayed as part of a website. You need to process the image before you can do almost anything with it.

Think of it this way: a RAW file is simply potential information that you can use to create your image from. The really, really, really exciting thing is that you can process the same photograph—the same RAW file—more than once.

Then, when you combine the different processed versions, you can use the best bits from each. This leads to extraordinary image making power. Using RAW lets you take advantage of the power of digital.

JPEG vs RAW

Within a single RAW file is a huge range of exposure values and color temperatures.

It's much easier to correct problematic exposure and color temperature issues in the RAW conversion process than downstream once you've already finished converting the image.

The only advantages that the JPEG file format has over RAW is that it is compressed, and fast to work with.

If the JPEG is good, you can just send it off to a client without further work.

On the other hand, it's like film. What you see is what you get—and you only have one opportunity to get it right. You don't have the chance to tease elusive values out of the file the way you can with RAW.

There's no virtue to shooting JPEG—and having to get it right in the camera—as opposed to RAW. It all comes down to common sense: what's the most expedient way to get the image you want.

How your camera thinks about RAW

Most camera manufacturers have their own proprietary type of RAW file. In other words, there's no such thing as a standardized RAW file. For example, Nikon's RAW file format produces images in the NEF file format and Cannon's RAW files are encoded as CRW and CR2 files. As justification for saving data in proprietary formats, the camera manufacturers say that they uniquely understand the characteristics of their own sensors and therefore know how to encode the RAW data better.

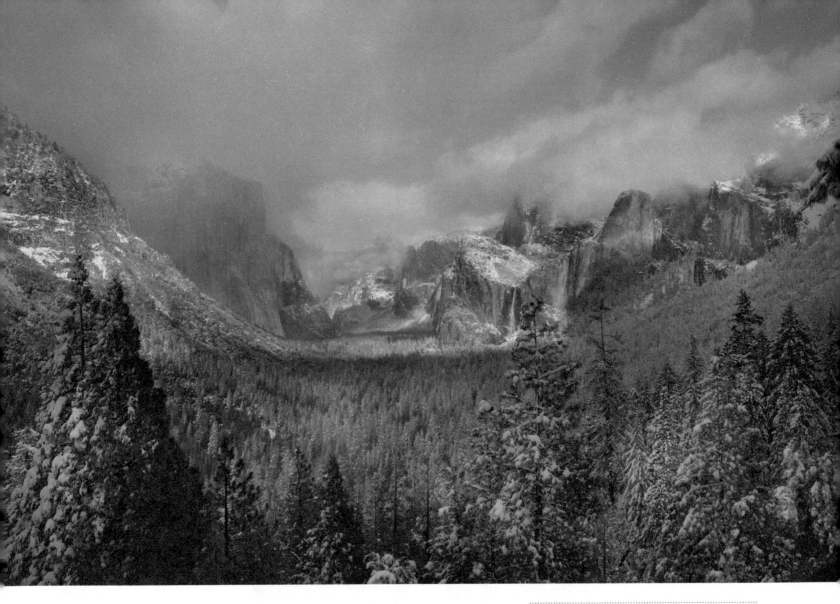

The DNG file format

DNG files are an effort at creating a universal RAW format. In my opinion, there's less than meets the eye in this effort because part of the DNG format specifically reserves "hidden" areas for each manufactures' proprietary secret sauce.

None-the-less, there are some reasons to consider archiving RAW files in the DNG format (as Lightroom will do automatically for you)—and it's far better than not archiving at all. For more about the importance of archiving your image files, turn to pages 10–11.

Shooting RAW and JPEG at the same time

Most cameras that shoot RAW will let you shoot JPEG and RAW simultaneously. This possibly gives you the advantage of both worlds. If the JPEG file is good enough, you're all done and can send it off to a client. But having the RAW file gives you the opportunity to make corrections in the conversion process if you need to.

Harold sez I always want to keep my original files. So converting to DNG is fine, but I still want to archive my NEF files. This means that if I use DNG, I have two sets of original files to archive (NEF and DNG). Twice as much storage space on my computer. Why bother? I don't think Nikon or Canon are going out of business any time soon (an often heard pro-DNG argument is that it is likely to be around longer than any camera manufacturer).

>> In which Ed's feet make an appearance

What's a photographer to do?

I was stuck at the top of a stairwell in a decaying tenement in Havana, Cuba. Now, this tenement was also an art deco beauty and once upon a time she had been fine.

This stairwell was calling out to be photographed. I knew I was not likely to be back in this location any time soon. So I pulled out all the stops: tripod, fisheye lens, and a programmable timer for a long exposure in the dim light. I even found an old toilet tank to climb on for a better point of view.

Looking at the results in the computer a few weeks later and a few thousand miles away, the best shot was flawed. Not only were my tripod legs visible, but worse, Ed's feet were in the photo.

That's a peril of shooting with a fisheye lens in low-light conditions.

¡Hola Ed!

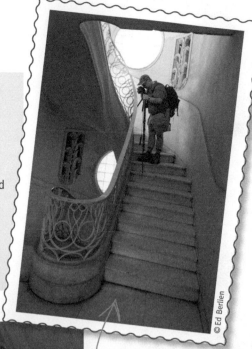

© Ed Bertien

Getting ready for the shot before I found the toilet tank to stand on

A fisheye lens helps emphasize the curvature of the stairway

Ed's feet

My tripod leg (yes, I really was five floors up on this railing—don't tell Phyllis!)

Looking at the photos a few weeks later, this fisheye shot was the best composition, but there were a number of problems, and I couldn't go back to reshoot the stairwell

This capture is underexposed, but that's something that is easy to deal with

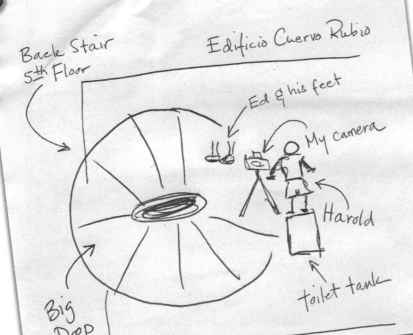

Lucky Luciano and Winston Churchill slept here

MONUMENTO NACIONAL · 1930–1998
HNC
HOTEL NACIONAL
de Cuba
★★★★★

Back Stair
5th Floor

Edificio Cuervo Rubio

Ed & his feet

My camera

Harold

toilet tank

Big Drop

Next Steps: What to do about the exposure, Ed's feet, and my tripod legs

Confronted with a challenge like this Cuban stairwell, it's important to be careful about the order in which one proceeds. (For more about workflow, see page 10.)

The first thing to do is to get the post-processed exposure right. This means using one of several techniques to get lights, darks, and color right in the image. There are a number of good ways to go about this starting with a RAW image. Multi-RAW processing using Adobe Camera RAW (ACR) is perhaps the best-known and is explained in detail in PD1 starting on page 30.

This example uses an alternative process with different virtual copies in Lightroom to adjust exposure and then exports the virtual copies into Photoshop as a layered document (pages 16–18).

After getting this part of the process right, then and only then, can we begin to deal with the issue of Ed's feet (not to mention my tripod legs). Cloning out Ed's feet is shown starting on page 32.

›› Multi-RAW processing using Lightroom

Pre-visualizing and making a plan

It is important anytime you are processing a RAW file to have a strategy. In order to have a strategy, you need to pre-visualize where you want the photo to end up. The purpose of the strategy is to plan how you get from the default RAW conversion of the image to where you want it to go.

The strategy for this image is to start with a dark background and layer successively lighter versions on top using masks for specific areas. This is one of the most common RAW conversion strategies.

Other typical strategies are to start with a version that is too light and place darker layers on top, or start with an average rendition of the RAW capture and layer light *and* dark areas on top.

Which strategy you choose depends upon the image and how you pre-visualize the outcome. To find out more about creating a RAW conversion strategy plan, take a look at PD1, page 40.

1 In Lightroom, choose File ► Import Photos from Disk to open the RAW capture in Lightroom. Click Develop to open the image in the Develop module.

Click here to open the image in the Develop module

This is the way the RAW image opens by default in Lightroom. It is easy to see that it is much too dark

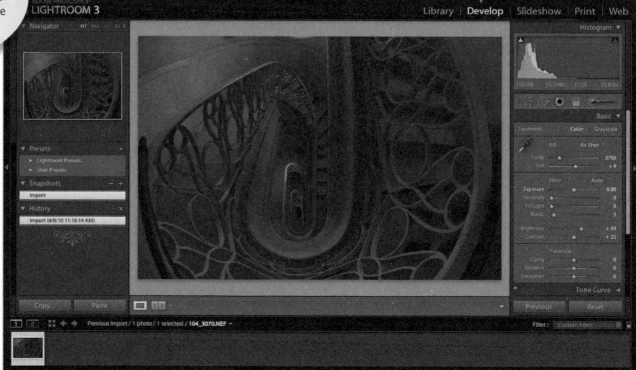

2 Start by lightening the image using the Exposure slider. Move the slider to the right. You want to take care not to "overexpose" any area of the image. So only move the slider far enough to the right so the lightest area of the image is properly rendered. If any area seems too light or blown out, you have gone too far for this first step.

I also used the Saturation and Vibrancy sliders to increase the overall color saturation of the image

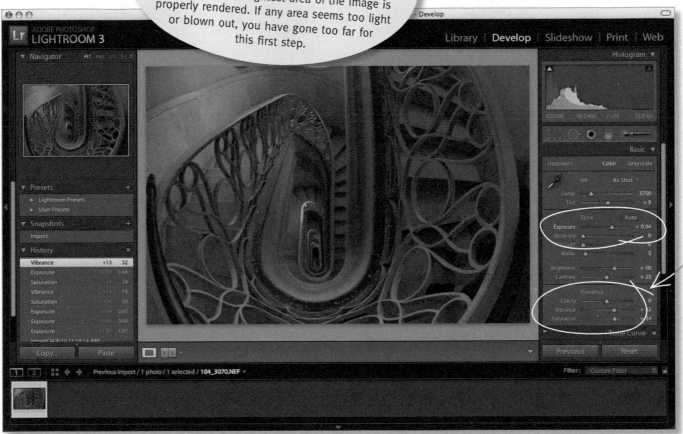

3 Select Photo ▶ Create Virtual Copy to create a copy of the image. This copy appears selected next to the original image in the Filmstrip at the bottom of the Lightroom window.

Virtual copy selected on the Filmstrip

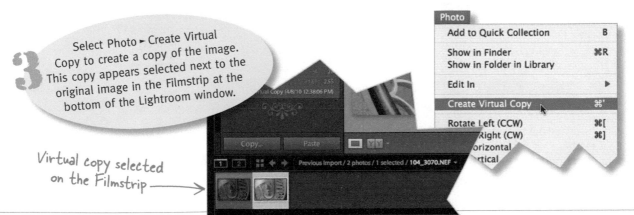

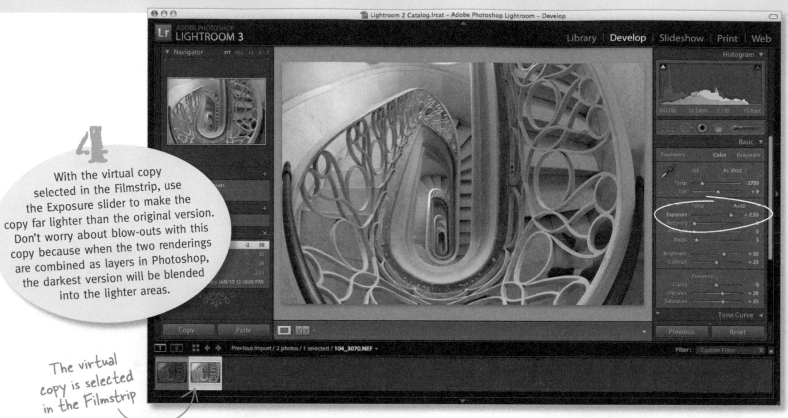

4 With the virtual copy selected in the Filmstrip, use the Exposure slider to make the copy far lighter than the original version. Don't worry about blow-outs with this copy because when the two renderings are combined as layers in Photoshop, the darkest version will be blended into the lighter areas.

The virtual copy is selected in the Filmstrip

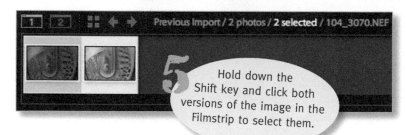

5 Hold down the Shift key and click both versions of the image in the Filmstrip to select them.

Photo

Add to Quick Collection	B
Show in Finder	⌘R
Show in Folder in Library	
Edit In ▶	
Create Virtual Copy	⌘'
...left (CCW)	⌘[
...ht (CW)	⌘]
...tal	

Edit in Adobe Photoshop CS4...	⌘E
Edit in Other Application...	⌥⌘E
Open as Smart Object in Photoshop...	
Merge to Panorama in Photoshop...	
Merge to HDR in Photoshop...	
Open as Layers in Photoshop...	

6A From the Lightroom Photo menu choose Edit In ▶ Open as Layers in Photoshop...

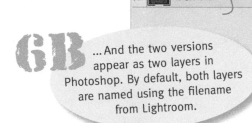

6B ...And the two versions appear as two layers in Photoshop. By default, both layers are named using the filename from Lightroom.

The two versions appear as layers in the Photoshop Layers palette

7

Rename the layers "Lighter" and "Darker."

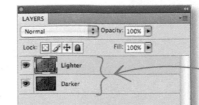

Now you're in Photoshop

104_3070.psd @ 12.5% (Lighter, RGB/16) *

12.5% Doc: 69.9M/254.4M

The two layers are stacked one on top of the other in the Layers palette. This means that at this point you can only see the "Lighter" layer since it is at the top of the stack. On pages 22–25, you'll use a layer mask and painting to blend the two layers, making the best parts of each layer visible.

Harold sez

I'm an individualist and I love Photoshop! If you had a painter out there who did one great painting a week, you would say this is a really prolific painter.

People expect more volume from digital photographers and digital image makers. It's not reasonable! I should be really happy if I create one great image a week. I'm not

a volume operation. I'm after quality, not quantity. Therefore, using Photoshop by itself without Lightroom makes more sense to me for the bulk of my workflow (when a client needs me to batch a large number of similar images for a specific project, I do use Lightroom).

Lightroom is a great program and I really understand why many photographers like to base their workflow around it.

Multi-RAW processing: Lightroom or ACR?

This process using Lightroom could have been done with Adobe Camera RAW (ACR) and multi-RAW processing. For more about this see PD1, pages 30–62. The choice is yours, and the underlying processing engine is the same.

You get to the same place. Either way—Lightroom or ACR—you are opening multiple versions at different exposures of the same image and combining them as layers in Photoshop.

Some folks prefer Lightroom, some folks like ACR. If you are using Lightroom as the engine for your digital workflow to keep track of your images, then it really makes sense to use Lightroom for this kind of conversion. If you don't already use Lightroom, then ACR may be the better choice.

Next Step

Combine the layers in Photoshop by adding a layer mask to the "Lighter" layer to mask out any blow-outs and paint in contrast (pages 22–24).

Bringing a Flower to Life

I shot this beautiful Asiatic Ranunculus with the flower in a bud vase wrapped with a black velvet cloth.

Previously, I mentioned the importance of pre-visualizing how you want your image to come out and having a post-processing strategy (page 16). With this flower, I knew that I wanted it to appear like a jewel on a completely black background and that I would need a good post-processing strategy to create my desired effect.

Since I wanted the background of the image to be a deep black, my post-processing strategy was to start with a very dark version for the background where the velvet was very black and the flower was barely visible (bottom). This version became the "Dark" layer at the bottom of the layer stack in the Layers palette.

Next, I processed an overall version that was the primary basis for how the flower was rendered in the final image (middle). I added it to the Layer palette above the "Dark" layer as the "Overall" layer. Then, I added a Hide All layer mask to the "Overall" layer and "painted" in the flower, leaving the black velvet background from the "Dark" layer intact.

Some areas in the center of the flower still needed more punch. So I prepared a light version (top) and added it to the top of the layer stack in the Layers palette as the "Highlights" layer. Finally, I added a Hide All layer mask to this layer and selectively "painted" in a few brighter areas, mainly on the edges of the petals.

Any single version from the RAW file would not have captured my vision of this gorgeous flower. But combining the three versions from the same RAW file, creates the jewel-like image I saw in my mind's eye when I composed the photo in my viewfinder.

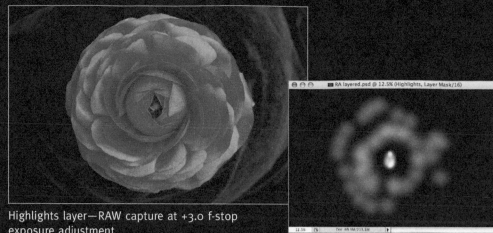

Highlights layer—RAW capture at +3.0 f-stop exposure adjustment

Mask for Highlights layer

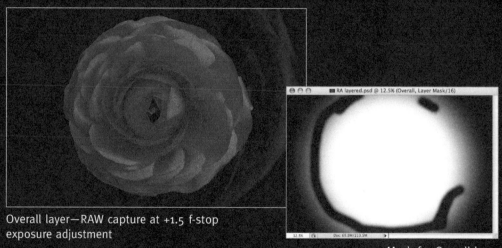

Overall layer—RAW capture at +1.5 f-stop exposure adjustment

Mask for Overall layer

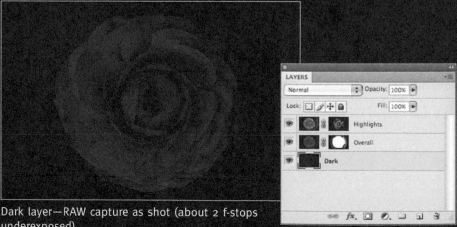

Dark layer—RAW capture as shot (about 2 f-stops underexposed)

Layers palette showing the layers and their masks

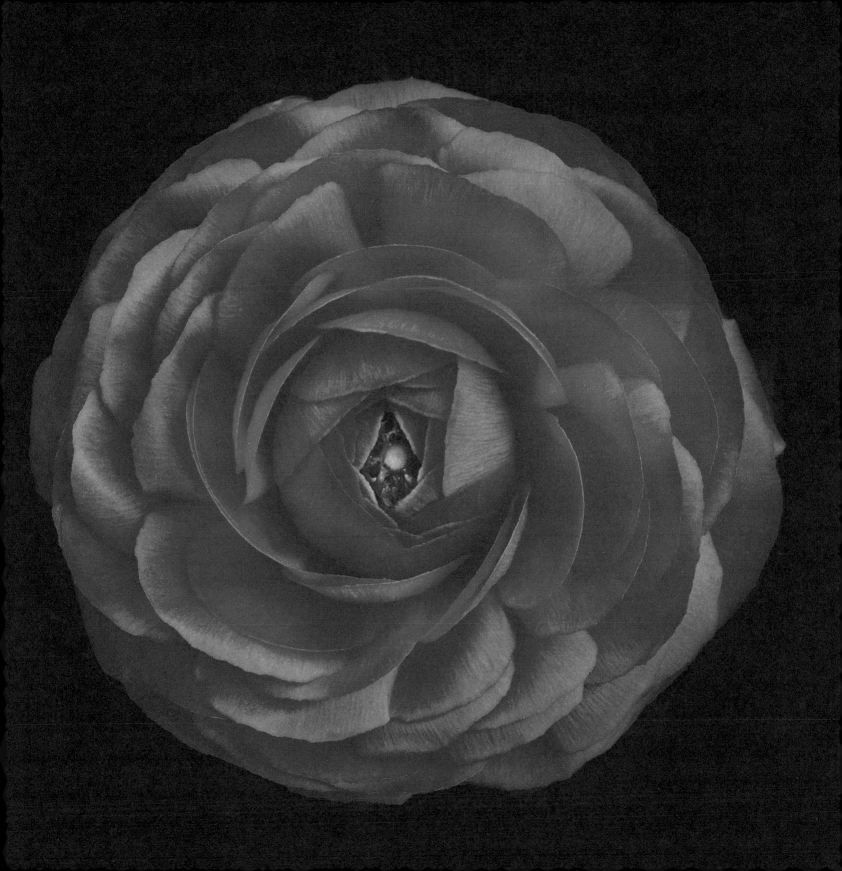

>> Layers and masking in Photoshop

If you are new to layer masks, there's a detailed case study in PD1 starting on page 34

Understanding layer masks

A layer mask is used to control which parts of a layer are visible in the final image. When you apply a layer mask to a layer, black areas in the mask hide the layer, white areas reveal the layer, and anything in between black and white—gray—is partially revealed. You can easily remember this using

the rhyme "black conceals and white reveals."

When you add a Hide All layer mask to a layer, the layer mask starts out completely filled with black, making the layer completely invisible. When you add a Reveal All layer mask, the mask is filled with white, making the entire layer visible.

Which kind of layer mask you choose to work with depends on the situation, how you like to work, and your overall strategy for dealing with the image.

There is a huge range of tools you can use in Photoshop to alter a layer mask. The two I use most often are the Brush and Gradient Tools.

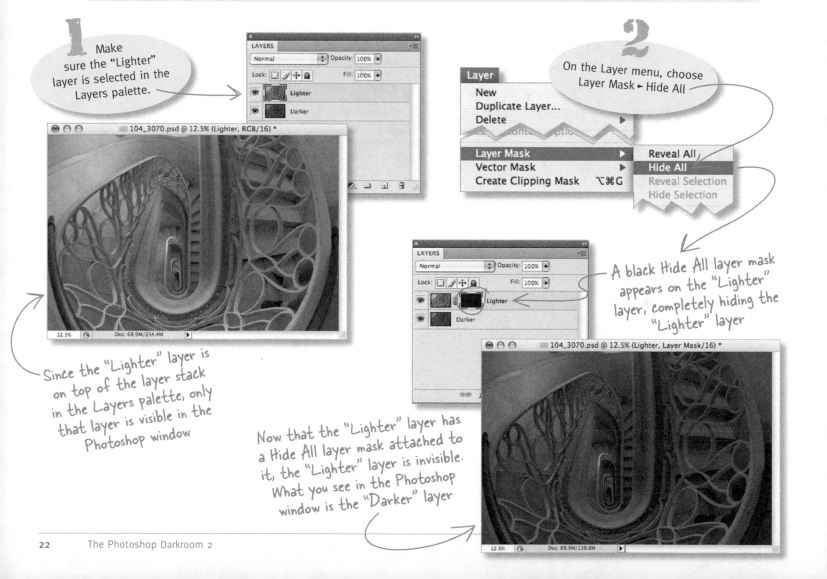

Make sure the "Lighter" layer is selected in the Layers palette.

On the Layer menu, choose Layer Mask ► Hide All

A black Hide All layer mask appears on the "Lighter" layer, completely hiding the "Lighter" layer

Since the "Lighter" layer is on top of the layer stack in the Layers palette, only that layer is visible in the Photoshop window

Now that the "Lighter" layer has a Hide All layer mask attached to it, the "Lighter" layer is invisible. What you see in the Photoshop window is the "Darker" layer

›› Painting on a layer mask

For more information about Brush Tool settings and presets, see PD1, pages 48-49

Getting rid of blow-outs and adding contrast

The point of using a layer mask for this image is to selectively remove areas that are too bright and to add contrast to areas that need to seem darker.

This is accomplished by adding the "Lighter" layer over the "Darker" layer. Those areas from the "Darker" layer that need to come through are made visible by painting with black on the layer mask attached to the "Lighter" layer.

The parts of the "Lighter" layer that need to be in the final image are made visible by painting with white on the layer mask.

Harold sez Most of the time the Brush Tool's Opacity, Flow, and Hardness settings shown below are the ones I start with. There are many more ways to set up the Brush Tool, but this is generally a good place to begin.

Here's how

1 Select the Brush Tool from the Toolbox.

2 Click the layer mask on the "Lighter" layer to make sure it's selected.

3 Make sure the foreground color is set to white.

4 On the left side of the Photoshop Options Bar, click here to open the Brush Preset Picker.

5 Set the Opacity to 30% and the Flow to 50%.

Photoshop File Edit Image Layer Select Filter Analysis

Ps Br 12.5% ▾ 🖐 🔍 ✋ ▢▾ ▢▾

Brush: 400 Mode: Normal Opacity: 30% Flow: 50%

Master Diameter 400 px

Hardness: 0%

1	3	5	9	13	19
5	9	13	17	21	27
35	45	65	100	200	300
9	13	19	17	45	65

6 Set the Master Diameter to 400 px and the Hardness to 0%.

When painting on a layer mask, I usually work with a very soft brush (Hardness=0%)

You can find different brush shapes and select one by clicking in here. Some brushes have harder or softer edges. I usually use a soft, round brush

Now to paint on the layer mask →

7

Paint with the Brush Tool in the image window to make specific areas lighter and add contrast to the image.

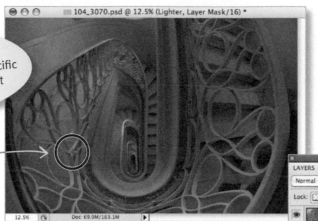

The Brush Tool at work

Since the layer mask in the "Lighter" layer is selected in the Layers palette, the "paint" you are applying with the Brush Tool is going on the layer mask not onto the actual layer. As you paint, you will see your painting strokes appear on the layer mask thumbnail in the Layers palette

Here's what the layer mask looks like after painting on it. The black areas hide the "Lighter" layer and the white areas reveal the "Lighter" layer

You can see what parts of the "Lighter" layer are visible if you hide the "Darker" layer by clicking the eyeball next to the "Darker" layer in the Layers palette

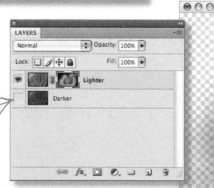

Next Step

Now that you evened out the tone of the image using layers and masking, it's time to make selective areas even lighter using the Screen blending mode (pages 25–26).

›› Using Screen blending mode

The artful dodger

Photoshop comes with a couple of tools obviously intended for photographers who remember the chemical darkroom: the Burn Tool and the Dodge Tool.

In the chemical darkroom, burning made selected areas in prints darker by exposing these areas longer. Dodging lightened areas by cutting the exposure time on selected areas.

The virtual tools in Photoshop are a mechanism for accomplishing the same common chores

digitally, but the sad fact is that the two tools do not work as well as an alternative technique.

It is both more powerful and more flexible to blend a layer with itself, change the blending mode—to Screen for dodging and to Multiply for burning—add a Hide All layer mask, and then selectively paint in the areas you want to burn or dodge.

To find out more about dodging and burning using the Screen and Multiply blending modes, look at PD1 pages 72–73.

 Harold sez I haven't used the Photoshop Burn or Dodge Tools in years because there are better ways to "burn" and "dodge"!

You can find out more about duplicating layers by taking a look at page 65 in PD1

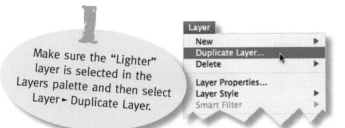

1 Make sure the "Lighter" layer is selected in the Layers palette and then select Layer ► Duplicate Layer.

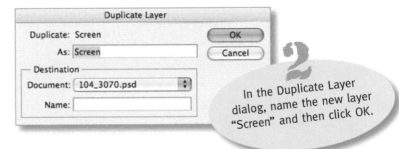

2 In the Duplicate Layer dialog, name the new layer "Screen" and then click OK.

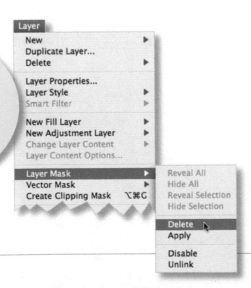

3 Remove the duplicated layer mask on the "Screen" layer by selecting the "Screen" layer in the Layers palette and choosing Layer ► Layer Mask ► Delete.

4 Add a new Hide All layer mask to the "Screen" layer by selecting Layer ► Layer Mask ► Hide All.

Keep going on the next page ⟶

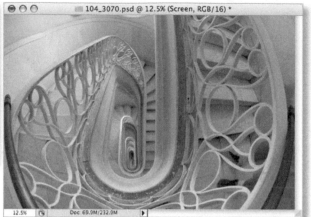

When you change the blending mode from Normal to Screen, the image gets a lot lighter. To see how much lighter the image is, you will need to select Layer > Layer Mask > Disable to "turn off" the Hide All layer mask on the "Screen" layer, making the layer visible

5 With the "Screen" layer selected in the Layers palette, select Screen from the blending mode drop-down list.

With the Screen blending mode selected, you can really see my tripod legs and Ed's feet now!

★ There's a good general explanation of blending modes in PD1 on pages 70–71. You'll find detailed information about using Soft Light blending mode starting on page 36 in this book

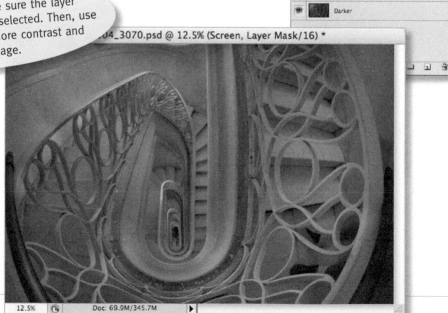

6 In the Layers palette, make sure the layer mask on the "Screen" layer is selected. Then, use the Brush Tool to paint in more contrast and brighten the image.

Next Step

When you are happy with the initial overall tone and shading, the next step is to retouch and remove flaws. It's time to get rid of Ed's feet and my tripod legs (pages 30–35).

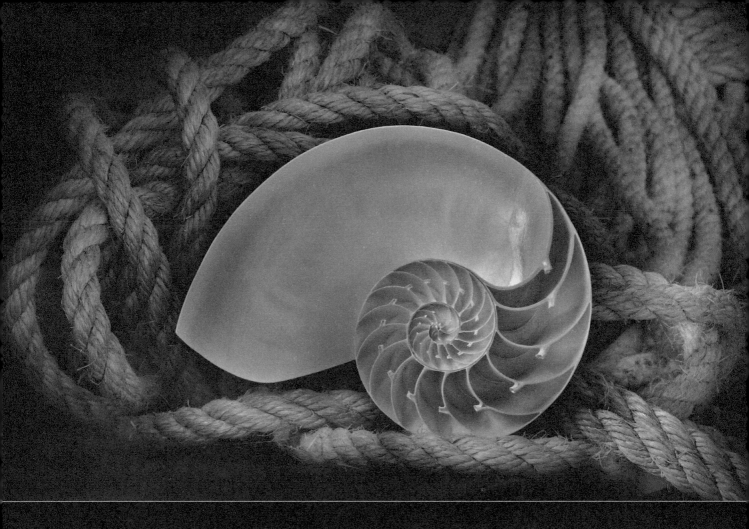

Using Multiply to Darken

To lighten the Cuban stairs, I blended a layer with itself using Screen blending mode. What if you want to darken an image instead of lightening it?

Blending a layer with itself using the Multiply blending mode performs essentially the opposite action of the screen blending mode and attractively darkens an image.

By using a layer mask you can selectively decide which portions of the image should go darker.

For example, when I created the still-life image of a nautilus shell with the rope background shown above, I was photographing by natural light in a historic Coast Guard boathouse.

The shell and the rope were quite attractive, but the shelf they were resting on was covered with the rubble of ages (see the detail right).

Using the Multiply blending mode made hiding the dirt and stones simple. In post-processing, I made a duplicate layer and selected the Multiply blending mode. This made the background in

the duplicate layer quite dark. I added a Hide All layer mask to the layer and then painted in the dark background, hiding the rubble and the shelf.

Creating a High-Key Image

A high-key image is successful through its use of predominantly white and bright tones. Conventionally, this is achieved through lighting, choice of subject matter, and overexposure.

Historically, with monochromatic images that tended toward high-key, the effect was often emphasized using chemical darkroom techniques when an image was printed.

Using the Screen blending mode means that you can accomplish a high-key effect in the Photoshop darkroom if it is appropriate for the image.

While a number of techniques can be used to create high-key effects, the most effective approach is to blend layers successively using the Screen blending mode.

I captured this image of a lonely islet in San Francisco Bay near China Beach towards the end of a foggy winter day. While the scene in front of me was not brightly lit—I was photographing at dusk—as I pre-visualized the image it became clear to me that I would present it as high-key.

To start with, I overexposed the photo by about two f-stops. When I processed the image in Photoshop, I wanted to make sure to maintain the tonal gradations between the sky, the islet, the reflections, and the water. It was also important to the success of the image that the distant freighter could be clearly seen.

To accomplish my goals, in Photoshop I duplicated the image a number of times and blended the duplicates using Screen blending mode, layer masks, and selectively painted in lighter parts of the photo.

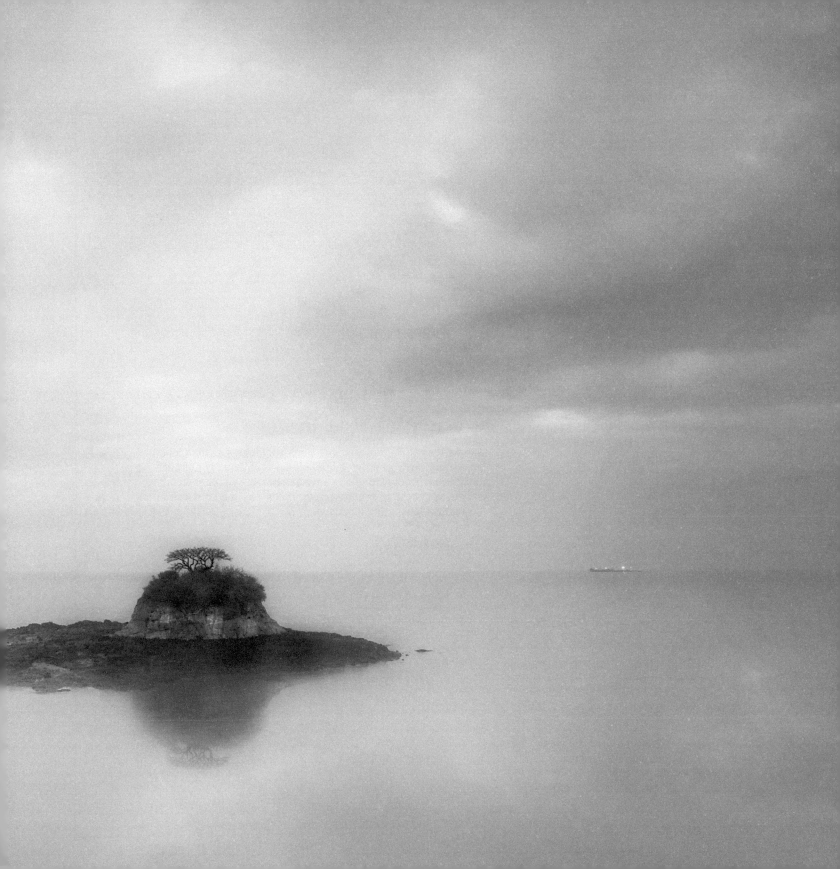

›› **Cloning and retouching**

The Clone Tool to the rescue

The Clone Tool is one of the oldest and clunkiest parts of the entire Photoshop apparatus. When used crudely on a Background layer, it destroys pixels and leaves a nasty visual residue. If anyone is doing a forensic analysis of a digital image, they can usually pick up traces of this kind of sloppy Clone Tool usage. Recent versions of Photoshop have tried to improve on the Clone Tool and, yes, sometimes it does work well (see the info about content-aware fill on pages 38–39).

But when a background is complex and there is something in your photo that just has to go—for example, the tripod legs and Ed's feet in the Cuban photo—the Clone Tool becomes your new best friend.

Probably more than any other tool in Photoshop, it is important to understand how to use the Clone Tool carefully and correctly. Heavy-handed cloning can ruin a photo more quickly than almost anything else you can do.

Light, agile, and intelligent use of this powerful but destructive agent of change can transform the reality of your photos from the discard pile to highly publishable.

How the Clone Tool works

When you work with the Clone Tool, you first select settings—diameter, hardness, opacity, and flow—for the "brush" that you are going to paint with, just like you would set up the Brush Tool.

After the Clone Tool settings are ready, then you tell Photoshop what area of your image to use as the "paint." To do this you'll need to select a *sample point*.

What's in a name?
The official name for the cloning tool in Photoshop is the Clone Stamp Tool. But, most Photoshop users I come in contact with call it the Clone Tool. So that's what I'll call it here.

Set it up

Select the Clone Tool from the Toolbox

The Photoshop Way Back Machine

Way back when in Photoshop versions 1 through 5.5, the Clone Stamp Tool was called the Rubber Stamp Tool. And, by golly, it does indeed work kind of like a rubber stamp—a rubber stamp where you choose the source pixels. That's why the little icon in the Toolbox looks like an ink stamp.

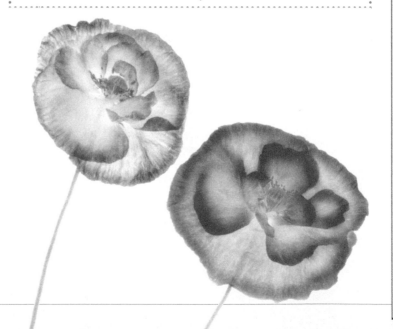

2 Click (here) on the left side of the Options Bar to open the Picker

Set the Opacity and Flow of the Clone Tool to 100%

Set Sample to "All Layers"

Photoshop File Edit Image Layer Select Filter Analysis 3D View Window Help

Brush: 152 Mode: Normal Opacity: 100% Flow: 100% ☑ Aligned Sample: All Layers

Master Diameter 152 px

Hardness: 0%

1	3	5	9	13	19
5	9	13	17	21	27
35	45	65	100	200	300
9	13	19	17	45	65

Use these sliders to set the width of the Clone Tool and how fuzzy it is (I usually set Hardness to 0% for a very soft edge)

The Clone Tool uses the Brush Tool Preset Picker to set the shape and hardness of the Clone Tool

The Clone Tool is really the Brush Tool in disguise. It works just like the Brush Tool, except you don't paint with a single color, instead you paint with an area sampled from the image.

☑ Aligned **The Aligned check box**

This little check box controls where the Clone Tool gets its "paint." When you use the Clone Tool, you first set up a sample point which samples the area under the cursor and uses this sample as "paint." The Aligned check box comes into play when you start painting with the Clone Tool.

I set the Clone Tool's source point at this water drop

drops in a row.jpg @ 12.5...
12.5%

Original image of water drops on a leaf

Mouse released here and here

drops in a row.jpg @ 12.5...
12.5%

Aligned checked: The line of drops continues even though cloning is interrupted because I released the mouse and then pressed it again.

Mouse released here and here

drops in a row.jpg @ 12.5...
12.5%

Align unchecked: Painting starts at sample point (the first drop) every time I release the mouse and start cloning again.

›› Ready, set, clone...

Painting vs. Cloning

The Clone Tool is your first line of defense in retouching. If the Clone Tool will fix something, then it is usually the easiest and best tool to use.

But bear in mind that what the Clone Tool does is sample from the image itself and paint using that sample. If the sample is a complex visual pattern, then "painting" with this sample may not work very well. For example, in the Cuban stairway, the top of the railing where my tripod leg sits needs to be a solid color. You don't want no fancy patterns there!

So the best way to go about this is to use the Eyedropper Tool to sample the color of the railing, and then use the Brush Tool to paint over the area on the railing where the tripod leg is. Note that in this case you will want some hardness in the brush (as opposed to the Clone Tool which is used mostly with 0% Hardness).

When you are painting with the Brush Tool for this kind of retouching purpose, you'll generally want to use a Hardness setting between 5% and 15%. The reason for this is that surfaces such as the top of the railing have edges. If you used a completely soft brush, you would end up with a blurry edge rather than a realistic hard edge.

1 *Start cloning*

Archive the layered version of the Cuban stair image by selecting File > Save As to save a new version of the image

2 Choose Layers > Flatten Image to merge all the layers together. There is now one "Background" layer in the Layers palette

Palettes are panels, too

In your version of Photoshop you might notice that palettes have been renamed panels. But, don't worry! Whatever they are called, palettes (aka panels) still work the same way they always have.

3 Select the Clone Tool from the Toolbox and set it up (see pages 30–31)

Cloning workflow

Here are a few things I do when working with the Clone Tool:

1. Always, always, always archive a copy of the image before you start cloning. You can use File ▸ Save As to do this, or you can Save the image as a Copy, or you can Duplicate the image and then save the duplicate.

2. Always, always, always work on a duplicate layer. You will destroy pixels when you clone. You will sometimes go too far when you clone. You need a way to "take back" selective portions of what you've done and you can't rely on the History Palette because you may want to remove some cloning you did 42 steps back.

4 Select Layer > Duplicate Layer and name the new layer "Ed's Feet." You are going to use this layer to clone out Ed's feet. In a few steps, when it comes time to remove the tripod legs, you'll create another layer to do that

It's important to make only one major edit per layer. That way, if you decide later that you don't like something you did, you can adjust that layer or remove it altogether

Overlay under cursor

Turning off Overlay in CS4 and later

Photoshop CS4 and later versions come with an "overlay" cloning feature. Overlay tries to show you what will be cloned in before you click and drag the mouse by placing a ghost image over the actual image as shown to the left.

Frankly, I would rather do my cloning without this feature. I find it distracting to have this slightly time-delayed, ghost image hovering under my mouse. To turn overlay off, select Window ▸ Clone Source. In the Clone Source palette that opens, uncheck Show Overlay.

5 Zoom in on Ed's feet in the image window, then hold down the Option key (Mac)/Alt key (Windows) and click to create a sample point

Sample point

As you clone, you may need to move the sample point to match shading and color in the image

6 Use the Clone Tool to remove Ed's feet from the photo. Vary the size of the Clone Tool as you work. The Clone Tool should be just a little larger than the area you are cloning out

The Clone Tool in action

Very Important: In order to work effectively with the Clone Tool, you'll need to zoom in and magnify the image to make sure that your cloning achieves the effect you want

This is the Navigator

You can zoom out in the image window to see how your work is going or position the Navigator near the window where you are working to keep an eye on progress. To open the Navigator, choose Window > Navigator

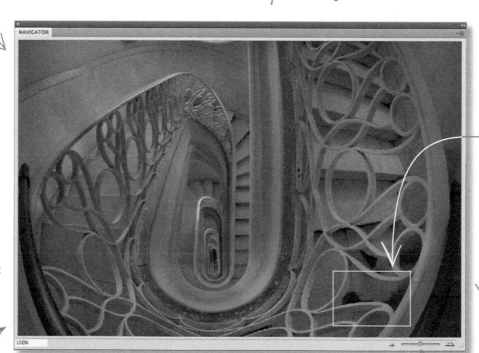

This yellow box shows the area that is visible in the image window

You can use this slider to make the image window zoom in or out

7 Keep working until the feet are gone. The next step will be to get rid of the tripod legs

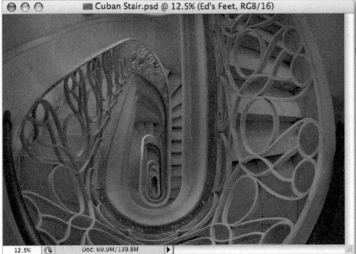

8 With the "Ed's Feet" layer selected in the Layers palette, choose Layer > Duplicate to make a copy of the cloned layer. Name this layer "Tripod Legs." (You could also follow steps 1 and 2 on page 32 to archive a copy of the image and then flatten the layers.)

Next Step
Cloning and painting out the tripod legs (pages 36–37)

The Patch Tool

Another retouching tool, the Patch Tool, is sort of like the Clone Tool on steroids. The Patch Tool is grouped with several retouching tools on the Photoshop Toolbar.

With the Patch Tool, you marquee select the area you want to clone into another portion of your image, and then you drag that selection over where you want to clone it in. Photoshop automatically takes care of blending in the color and shading of the surrounding area.

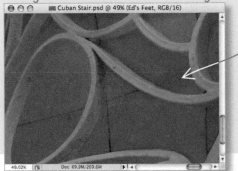

After cloning out Ed's feet, a line dividing the marble tiles was missing here

First, I selected the Patch Tool, set the Patch to Destination in the Options Bar, and used the Patch Tool to marquee select the dividing line I wanted to copy from here

Then, I dragged the patch over to the missing area

›› Painting and cloning in the railing

Recreating a railing

Taking out the tripod leg on the left poses a different challenge than cloning out Ed's feet. As you can see here, the tripod leg is up on the railing and the railing has a definite curve and sharp edge. There's no way you can clone in that sharp edge, because any sample you take from the image will include a railing edge that curves in the wrong direction. (Yes, you can rotate the clone sample in CS4 and later using the Clone Source palette, but I find this hugely frustrating and really hit-and-miss.)

So what's a retouching Photoshop user to do? Grab the Brush Tool and start painting!

1 Make sure the "Tripod Legs" layer is selected in the Layers palette

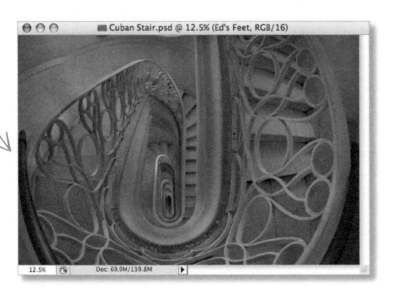

2 Use the Eyedropper Tool to sample the color of the railing close to where you will be painting

Seeing is believing

An important thing to remember about retouching is that the object is to create something plausible. If it seems visually plausible, people will believe it. It doesn't have to be exactly as it might appear in life, it just has to be believable.

3 Select the Brush Tool from the Toolbox and use the Brush Preset Picker to make the brush diameter smaller than the railing and set the Hardness to 50%. (For info on setting up the Brush Tool, take a look at page 23. Also, see PD1, pages 48–49.)

4 Paint and clone in the railing, alternating between the Brush and Clone Tools for this bit of retouching work.

Use the Navigator palette (see page 34) to help you see the progress you are making and to adjust the magnification of the image window as you work.

I cloned out the bottom part of the tripod leg covering the marble wall

I used the Patch Tool to clone this line on the wall

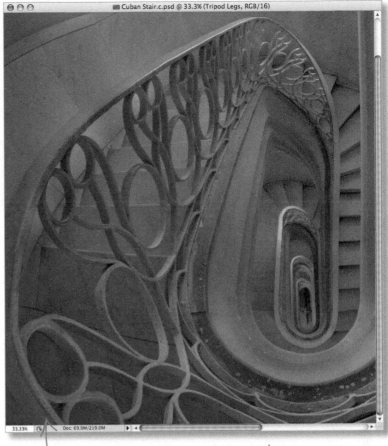

Cuban Stair.c.psd @ 33.3% (Tripod Legs, RGB/16)

✔Checkpoint

5 Now that the retouching is done, save and archive a version of the image with all the layers. Then, flatten the layers by selecting Image>Flatten and save the file with a new name, ready for further adjustments.

I painted in the top of this railing

✔Checkpoints and workflow

Harold sez Every time I finish a major step when editing an image, I *always* save a version of the file. This version usually has several layers. (For example, the Cuban Stair shown in step 4 above had six layers by the time I finished cloning and painting.)

Next, I flatten the layers in the image so there is only one layer, and then I save a copy of the file with another name.

The layers of the previously saved file let me track my progress in a project. They also let me return to an earlier checkpoint if I goof up and need to go back. For more about checkpoints and my workflow, take a look at PD1, page 25.

Next Step

Okay…Ed's feet and my tripod legs have completely gone bye-bye. But looking at the image, my feeling is that it needs something more. I want to change the image from something that feels like a documentary photo to a more artistic image with a graphic effect that could be used for, say, a book cover.

I'm not quite sure how to make the shift from straight photo to artistic effect, yet. But when I have this kind of puzzle, I usually start by playing with LAB color and blending modes. So it's time to change color spaces (pages 46–49).

Content-Aware Fill

Versions of Photoshop starting with CS5 provide a number of tools that make content-aware selection and filling easier. Content-aware fill is like an automated version of the Patch Tool. It works very well for tasks like removing power wires or road signs that appear against a blue sky.

By all means, experiment with the content-aware features if they are available in your version of Photoshop. If you are like me, however, you'll probably find that with a repair job of any complexity, you know what to do better than the computer. This means going back to the good old-fashioned Clone, Brush, and Patch Tools.

In some cases, content-aware fill can save a great deal of time. But be careful not to rely on too much automation in situations that require visual sensitivity. In our experience, Content-Aware Fill doesn't work very well with complex patterned backgrounds.

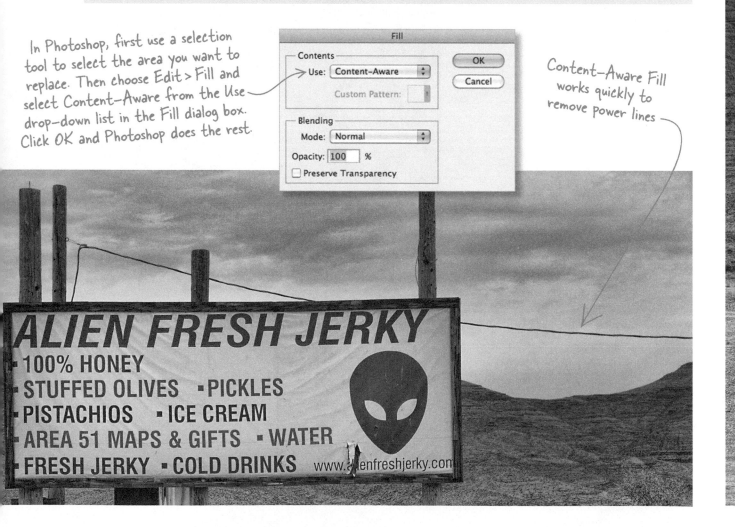

In Photoshop, first use a selection tool to select the area you want to replace. Then choose Edit > Fill and select Content-Aware from the Use drop-down list in the Fill dialog box. Click OK and Photoshop does the rest.

Content-Aware Fill works quickly to remove power lines

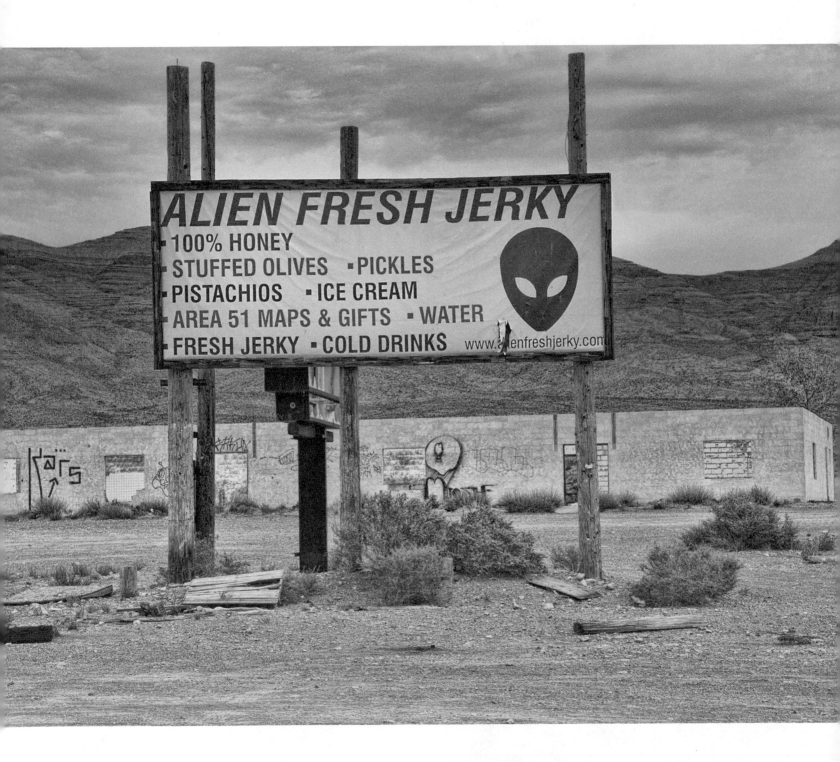

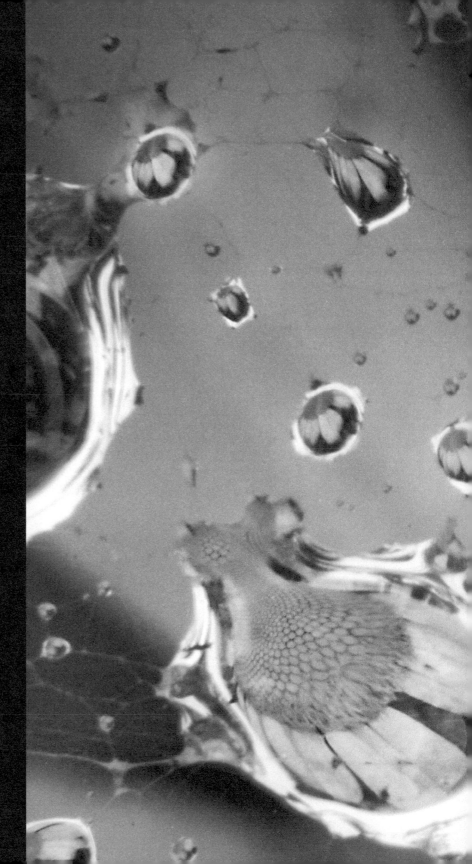

Spiderweb Studio

I like to photograph water drops after an overnight rain using my "spiderweb studio." This "studio" is a series of spider webs that I have allowed to form horizontally in my garden with some space beneath the webs. I find a flower that I like, cut it off, and then strategically position it within my spiderweb studio under the web and water drops.

This allows me to photograph the web and water drops straight down. The flower that I placed under the web and water drops is displayed in the reflections and refractions in the drops.

To create this image in my spiderweb studio, I used a 200mm macro-telephoto lens equipped with an extension tube and an auxiliary close-up filter. I also used a magnifying eyepiece to accurately focus on the reflections of the flowers in the water drops.

I used a small aperture (f/32) for maximum depth-of-field. Even at this small aperture, only a very shallow plane is in focus because of the extreme magnification.

When I reviewed the captures from this setup on my computer in Photoshop, I was pleased with them. However, I realized that the image needed more contrast between the light and dark areas, and the reflections of the flowers in the water drops needed to seem sharper. Also, I wanted to emphasize the importance of the reflected flowers in this composition. To do this, I needed to make the flowers more colorful while making the background less colorful by desaturating it.

To achieve these three goals—increasing contrast, emphasizing sharpness in the reflections, and selectively desaturating the background—I used the techniques described on pages 46–56. Namely, I combined the base image with a LAB equalization using Normal and Soft Light blending modes, and then combined the result with a monochromatic version. I painted in the monochromatic version at low opacity in the background to create the desaturated effect while leaving the water drops vibrantly colored.

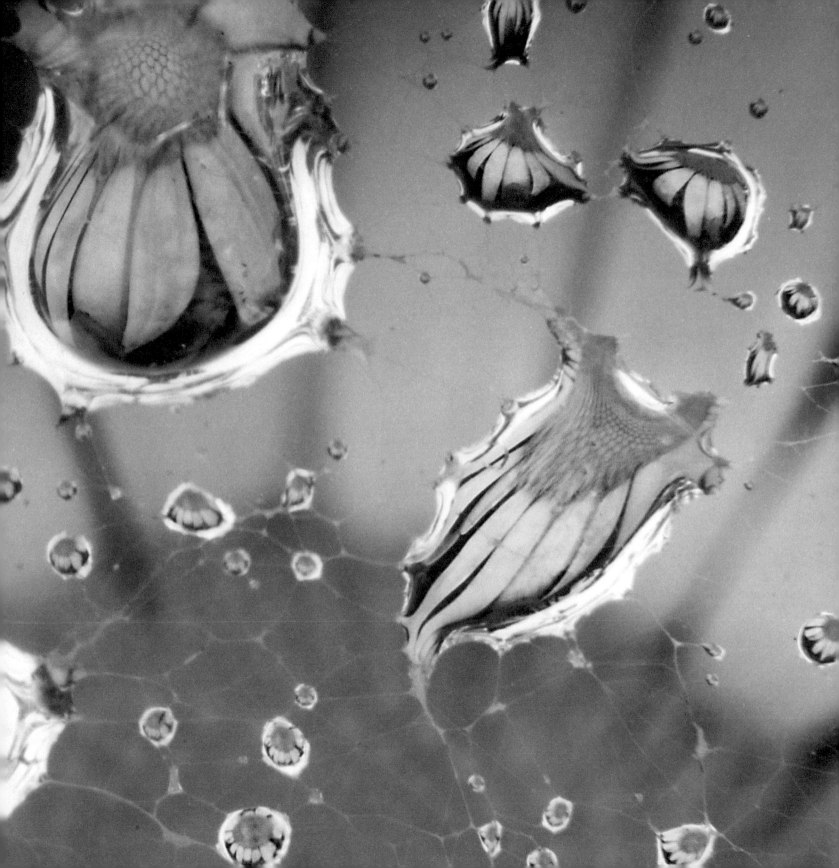

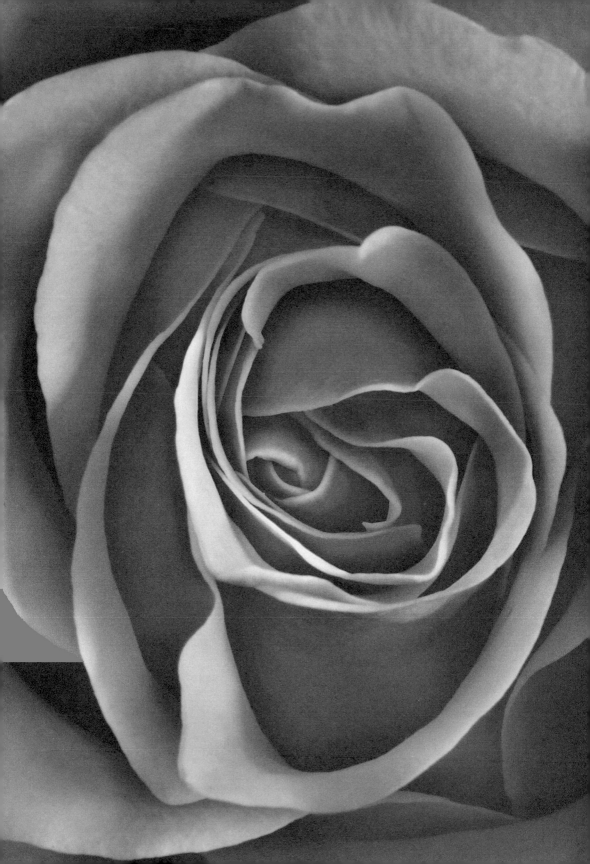

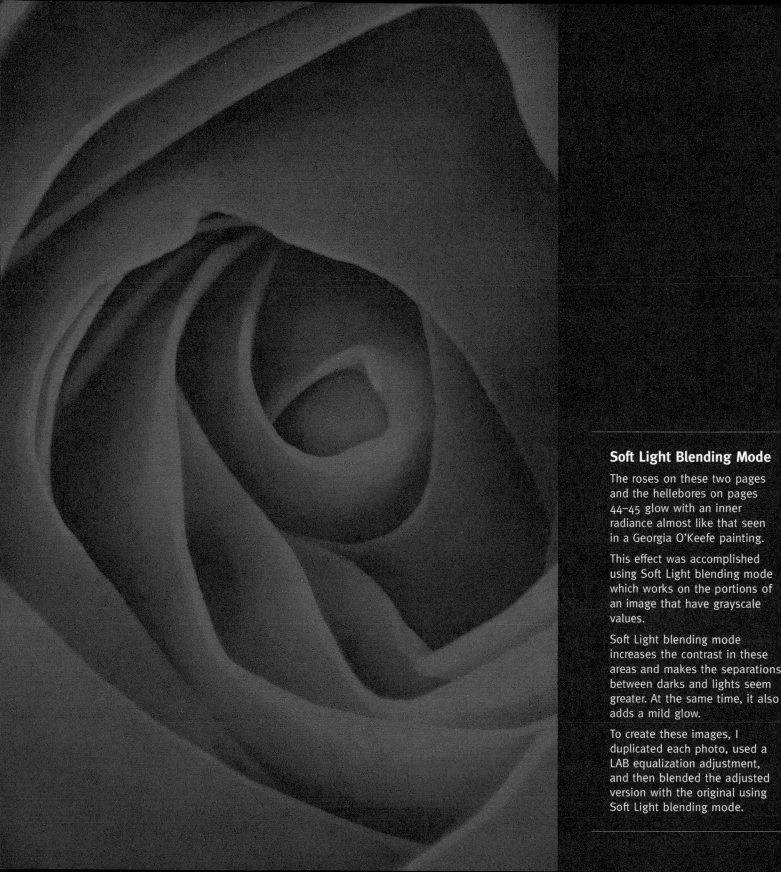

Soft Light Blending Mode

The roses on these two pages and the hellebores on pages 44–45 glow with an inner radiance almost like that seen in a Georgia O'Keefe painting.

This effect was accomplished using Soft Light blending mode which works on the portions of an image that have grayscale values.

Soft Light blending mode increases the contrast in these areas and makes the separations between darks and lights seem greater. At the same time, it also adds a mild glow.

To create these images, I duplicated each photo, used a LAB equalization adjustment, and then blended the adjusted version with the original using Soft Light blending mode.

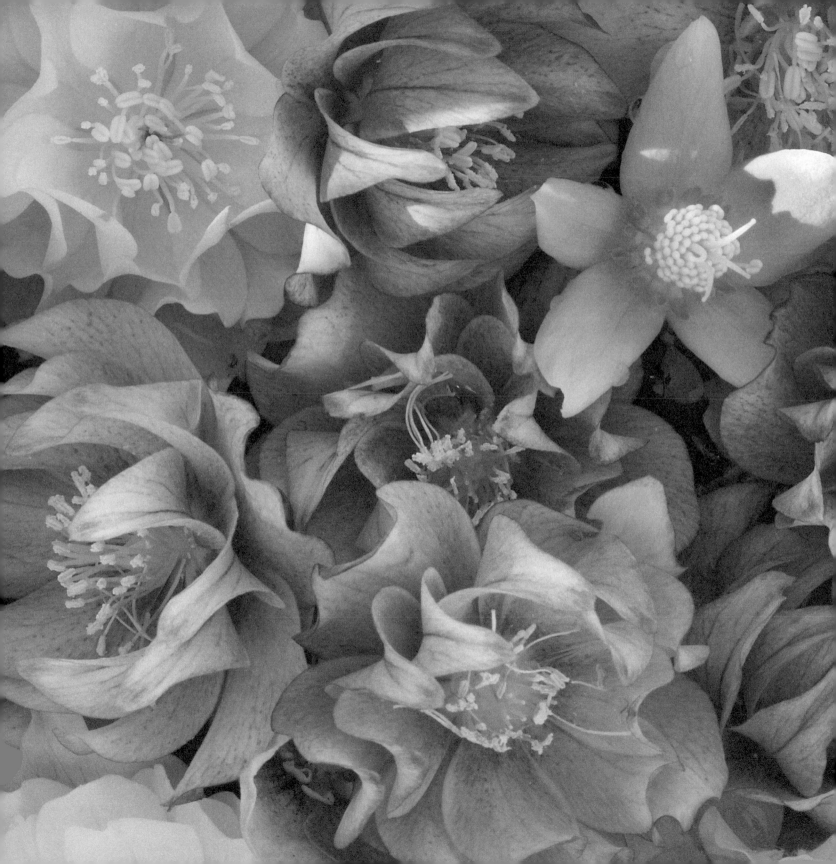

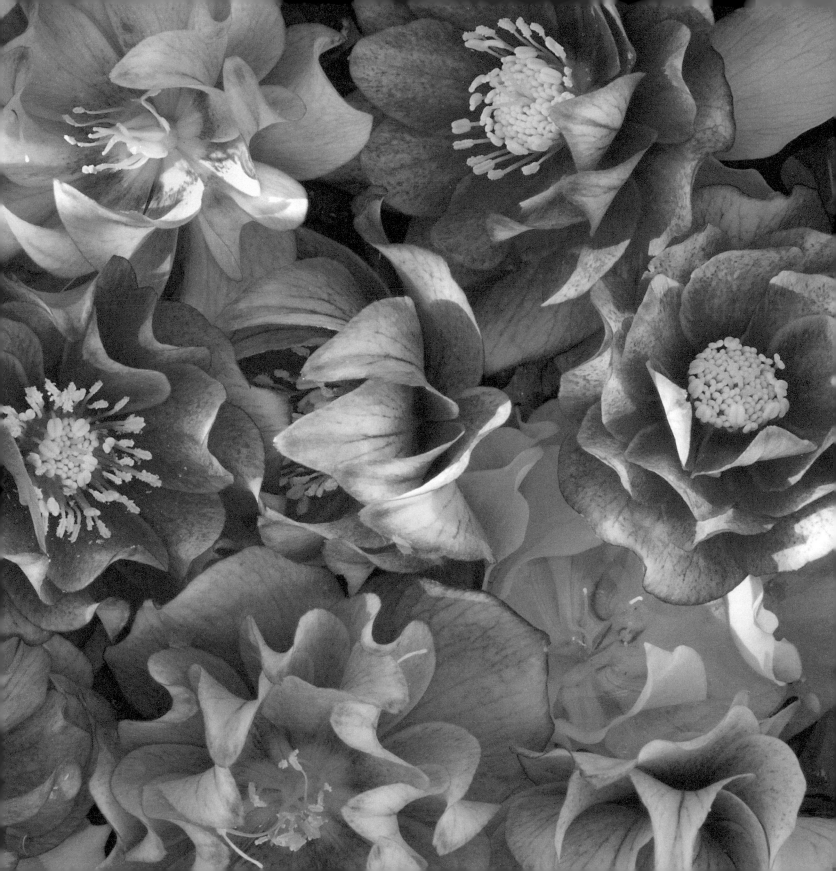

›› Creative coloring and toning

Experimenting with LAB

So far, so good. It's great to be able to save this image by removing my tripod—not to mention Ed's feet. But we're not there yet. The retouching phase of the workflow is quite successful. The image looks perfectly natural and there's no trace of the elements that have been cloned and painted out.

However, I'm not ecstatic about the overall look yet. There's no way that this photo as it stands would work as a dramatic, licensable image. Something fairly radical needs to change about the color and toning of this image before it really works.

It's always easier to see when something isn't right than to know how to fix it. Sometimes I'm not sure where I'm going before I experiment with lots of different things, for example LAB color channels and adjustments.

As part of my workflow, I normally convert a duplicate of each photo to LAB color and experiment with inversions and equalizations of both the image as a whole and the separate LAB channels (for more about these techniques, see PD1, pages 150–193).

So in the normal process of my workflow, I converted the image to LAB, duplicated it and experimented with adjustments. One of these adjustments—an overall equalization of all the channels in LAB—gave me the idea of how I wanted to proceed. Perhaps counterintuitively, this image needed to be radically—but selectively—desaturated.

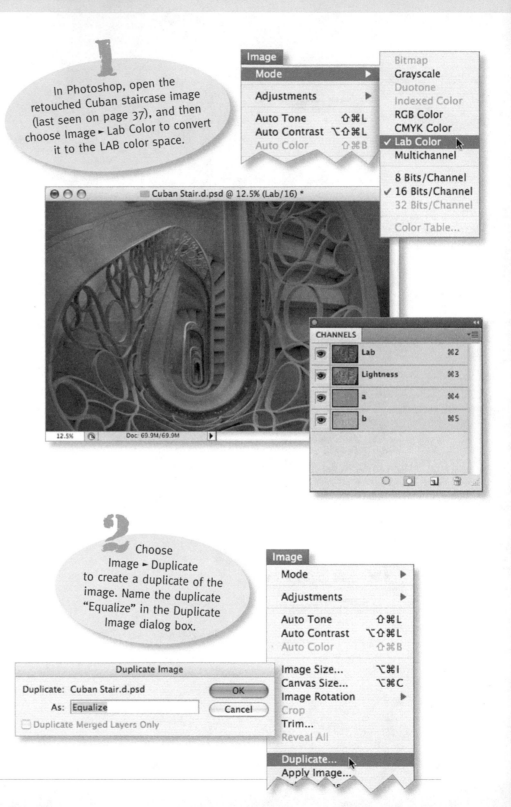

1 In Photoshop, open the retouched Cuban staircase image (last seen on page 37), and then choose Image ▸ Lab Color to convert it to the LAB color space.

2 Choose Image ▸ Duplicate to create a duplicate of the image. Name the duplicate "Equalize" in the Duplicate Image dialog box.

3

Choose Image ►
Adjustments ► Equalize

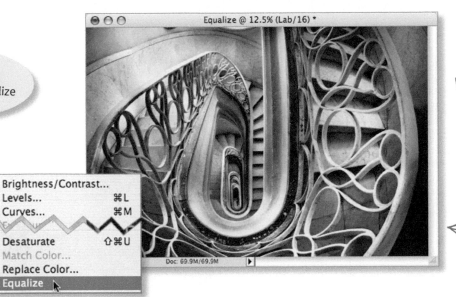

Equalize @ 12.5% (Lab/16) *

Image	
Mode	►
Adjustments	►
Auto Tone	⇧⌘L
Auto Contrast	⌥⇧⌘L
Auto Color	⇧⌘B

Brightness/Contrast...	
Levels...	⌘L
Curves...	⌘M
Desaturate	⇧⌘U
Match Color...	
Replace Color...	
Equalize	

When you equalize an image, the black and white values spread out, creating an image with more contrast from light to dark

4

Hold down the Shift key and use the Move Tool to drag the equalized image onto the Cuban staircase image you opened in Step 1. Release the Shift key *after* you release the mouse button or the two versions won't be perfectly aligned.

5

In the Layers palette, you'll see that Photoshop automatically names the equalized image that you just dragged over "Layer 1." Rename that layer "Equalized."

6

You're finished with the duplicate image that you created in Step 2 and equalized in Step 3, so save it for archiving purposes, and then close it.

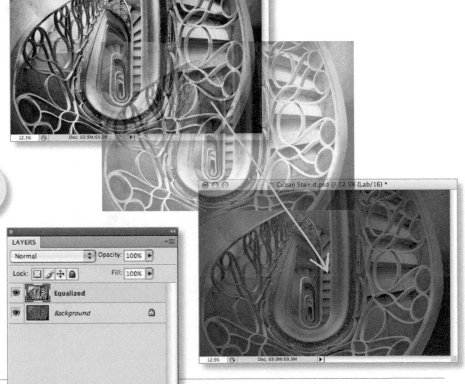

LAYERS

Normal Opacity: 100%

Lock: ☐ ✎ ✛ ⚿ Fill: 100%

👁 Equalized

👁 Background

7 With the "Equalized" layer selected in the Layers palette, click the Blending Mode drop-down list and select Soft Light.

Click here to access the blending modes

8 Set the Opacity for the "Equalized" layer to 10%.

You rarely want to use an equalized layer with the Soft Light blending mode at more than 10–15%. This is because it expands the dynamic range of the image and if you do too much, you're going to get blown out highlights and shadows that are too dark. Also, you may introduce noise into the image

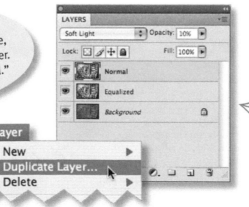

9 With the "Equalized" layer selected in the Layers palette, choose Layer ▸ Duplicate Layer. Name the new layer "Normal."

Here's how the Layers palette looks after duplicating the layer

10

Make sure the "Normal" layer is selected in the Layers palette, and then set the blending mode to Normal. Play with the Opacity slider to see what effect this new layer can have on the image. When you're done playing, set the Opacity at 50%.

Harold sez This was my "Aha!" moment. I got the image to this point and then I could see a glimpse of what the image could become. But, it wasn't quite far enough.

I put my thinking cap on (scratch, scratch) and asked myself: How could I continue with this LAB equalization effect and make it even more pronounced?

I looked at the image to figure out what it was that I really liked about it. Then it hit me—the desaturation. The yellow color in the image was too much...I needed to desaturate the image more, but selectively.

Cuban Stair.d.psd @ 12.5% (Normal, Lab/16) *

12.5% Doc: 69.9M/232.2M

11 Checkpoint

Save and archive this equalized version of the Cuban stairs with all the layers. Then, flatten the layers by choosing Image ▸ Flatten and save the file with a new name.

Next Steps

I wanted to take the desaturation of this image further. And what could take desaturation further than black and white where there is no color?

The challenge was to largely shift the image to black and white while keeping some color in the image.

My strategy for this selective desaturization was to convert a duplicate of the image to monochrome, add it back as a layer to the color image and then selectively paint the color in (pages 51–57).

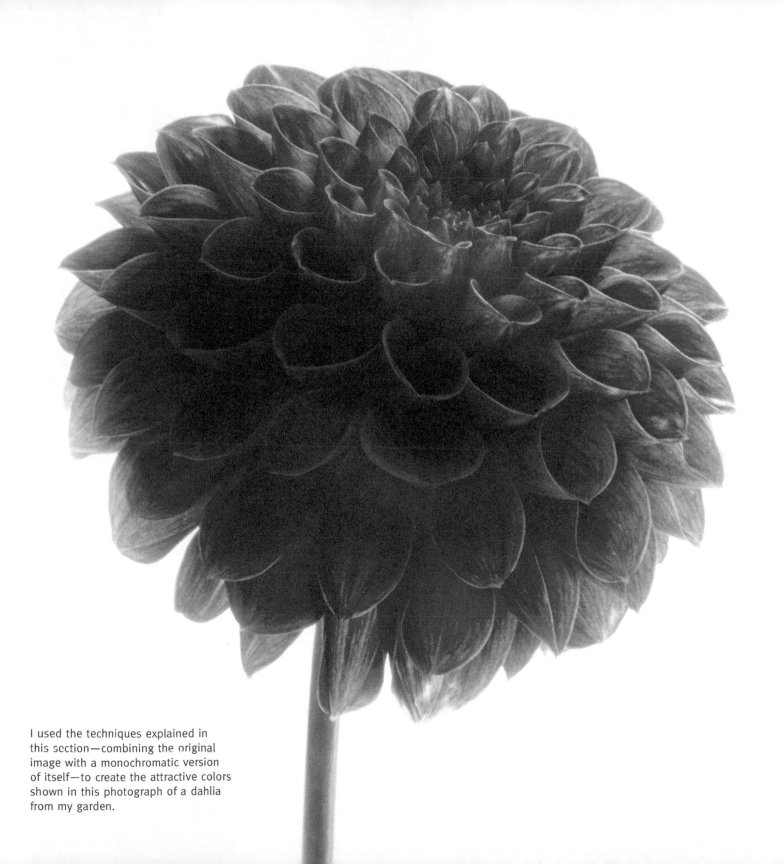

I used the techniques explained in
this section—combining the original
image with a monochromatic version
of itself—to create the attractive colors
shown in this photograph of a dahlia
from my garden.

›› Two, four, six, eight, time to desaturate

Going mono

It seems to me that what the LAB equalization and blending modes are essentially doing is desaturating the image. What I'd like to do is desaturate it more, but selectively in parts. Specifically, the yellow cream color is over the top, but the color of the railing is nice. The right way to make these adjustments is to duplicate the image, create a monochromatic version of the duplicate, copy the monochromatic version over the color image, and selectively paint in the monochromatic effect using a layer mask.

1 Choose Image > Duplicate to create a duplicate of the Cuban stair image. Name the duplicate "Neutral Density"

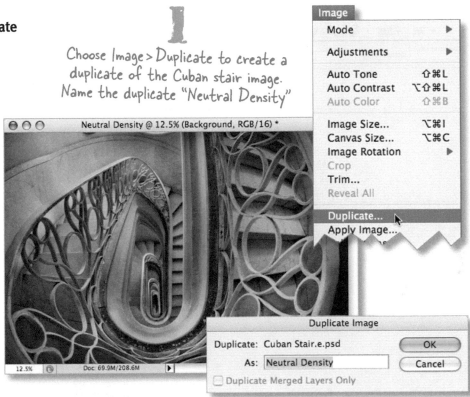

2 Choose Layer > New Adjustment Layer > Black & White

By default, Photoshop names this adjustment layer "Black & White 1" in the Layers palette

Hey, wait a minute HAROLD! You could just duplicate the layer here...why duplicate the image?

Good question! I find it easier to see my black and white conversions as a separate image. In this case, I just used a single Black & White adjustment layer to make the conversion. But many times I need a whole bunch of layers to get the monochromatic conversion right. It's easier for me to see this layer stack as a completely separate image that can be merged down and copied over to the original image.

3 In the Adjustments palette, select Neutral Density from the Black & White drop-down list

Black & White adjustment layers work with the Adjustments palette. If the palette isn't open, choose Window>Adjustments

For more about Black & White adjustment layers, take a look at PD1, pages 92–99

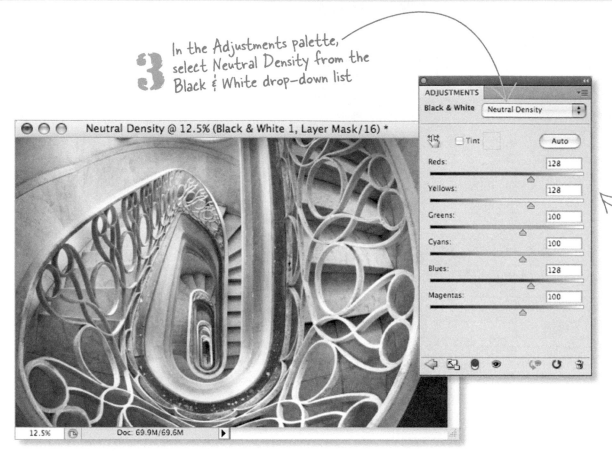

4 Choose Layers>Flatten to merge the Black & White adjustment layer down into the "Background" layer

Since there's only one layer here, you could also choose Layer>Merge Down

5 Hold down the Shift key and drag the monochromatic image onto the color Cuban stair image. Release the Shift key after you release the mouse button to make sure the two versions are aligned

6 Rename the monochromatic layer "Neutral Density"

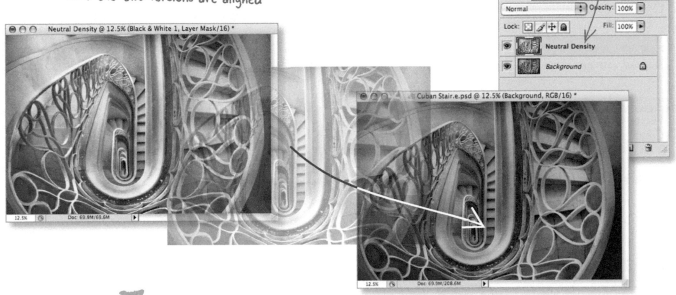

7 The duplicate image that you converted to monochrome in Step 3 has served its purpose, so save and archive it, and then close it

8 With the "Neutral Density" layer selected in the Layers palette, set the blending mode to Hard Light

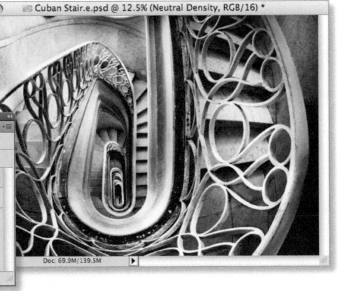

9 Choose Layer > Layer Mask > Reveal All to add a white Reveal All layer mask to the "Neutral Density" layer

The Reveal All layer mask appears as a thumbnail attached to the "Neutral Density" layer

10 Select the Brush Tool from the Toolbox. On the Options Bar, open the Brush Tool Picker and set the brush to 0% Hardness. Also, in the Options Bar, set the Opacity to 40% and the Flow to 40%

Turn to page 23 for details on setting up the Brush Tool

11 Make sure black is selected as the foreground color in the Toolbox

12 With the layer mask selected on the Neutral Density layer, paint in the image window with the Brush Tool to selectively paint color back into the image

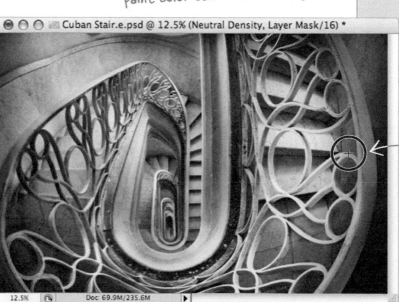

The Brush Tool at work

13 Repeat Step 1 on page 51 and create another duplicate of the Cuban stair image. Name this duplicate "Blue Filter"

14 With the duplicate "Blue Filter" image selected, you'll see that there's a "Neutral Density" layer in the Layers palette. You don't need this layer, so delete the layer by dragging it on top of the trash can icon at the bottom of the Layers palette. There is now only a "Background" layer

Here's the trash

This time use a Blue Filter

15 Repeat Steps 2-4 on pages 51-52, adding a Black & White adjustment layer. This time, though, select Blue Filter from the Black & White drop-down list in the Adjustments palette

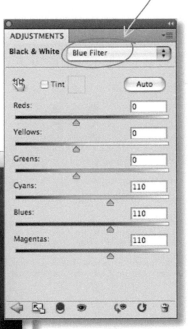

I ran through all the filters and with this image the Blue Filter made a nice, dark, high-contrast black and white version that wasn't too dark

16

Repeat Steps 5 and 6 on page 53, dragging the monochromatic "Blue Filter" image into the color Cuban stair image. Name this new layer "Blue Filter"

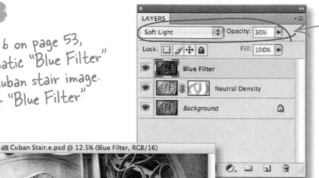

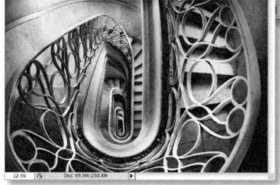

17

With the "Blue Filter" layer selected in the Layers palette, set the blending mode to Soft Light and the Opacity to 30%

Make sure the layer mask on the "Blue Filter" layer is selected before you paint

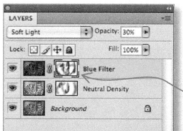

18

Repeat Steps 9–12 on page 54, adding a white Reveal All layer mask to the "Blue Filter" layer, and painting in more color using the Brush Tool on the layer mask

Turn to page 58 to see the final results!

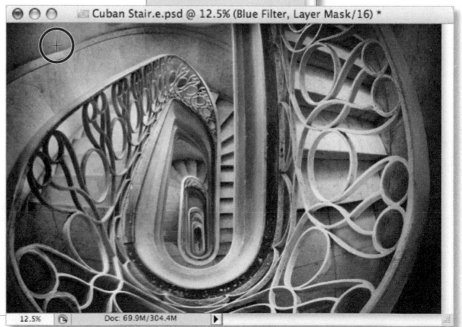

You've come a long way, baby!

This image started out as a dark and nasty RAW capture (see page 14 and the original image below). You can easily see my tripod leg on the lower left. Lightening the image disclosed an additional problem—Ed's feet and legs on the lower right.

In taking this photo, I intentionally underexposed by several f-stops. The reason I did this was to capture the bright center of the stairs without blow-out. It's easier to correct the underexposed, dark, outer areas than it would have been to recover the center if it had been blown-out.

From these unprepossessing beginnings, you've seen how to creatively transform this image in the Photoshop darkroom. First, you used Lightroom to multi-process the RAW file, combining several versions as layers in Photoshop. This lightened the image and also showed the problem with Ed's feet. Next, you cloned out the flaws—no more feet or tripod legs. The final steps involved creative decision making about the overall tonality of the image. The primary tools for enhancing the creative color qualities of the image were to combine the image with a LAB equalization and to selectively desaturate it using two monochromatic versions.

One point here is that you need to look at RAW digital captures as **potential** images. The RAW capture is the starting point, and not the final version of your photo. My philosophy is to make captures knowing what can be done to them, rather than expecting the final image at the moment the shutter clicks.

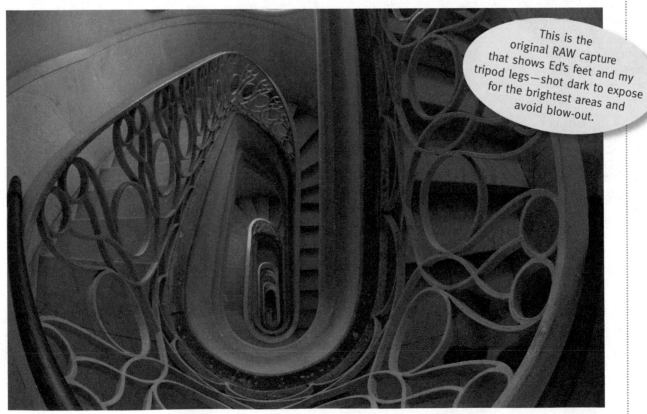

This is the original RAW capture that shows Ed's feet and my tripod legs—shot dark to expose for the brightest areas and avoid blow-out.

Welcome to the Real World

If you've read the text, you'll know that this photograph shows an elaborate art deco staircase in a decaying building in central Havana, Cuba.

In the best of all possible worlds, I would have brought supplemental lighting, rigging gear, and several assistants. However, the reality of traveling in Cuba meant that this was not possible.

I had one chance at taking this photo with the gear that I had with me. I ended up perched on an old toilet tank with my tripod legs on the railings five floors up.

Composing a good photo wasn't easy under these conditions. In fact, the best composition was rather poorly exposed and significantly too dark. In addition, when I got home to my computer, close inspection showed that my tripod legs as well as my companion's feet had made it into the capture.

Welcome to the real world of photography! The choice is to discard the image due to these flaws or to fix them using the techniques I've shown you—including RAW exposure adjustment, contrasting and color manipulation, and last (but not least) cloning out my tripod legs and Ed's feet.

As you can see from the thumbnail below, this apparently flawed capture actually made it to become a book cover—of this book!

The Photoshop Darkroom 2
Creative Digital Transformations

Harold Davis
Phyllis Davis

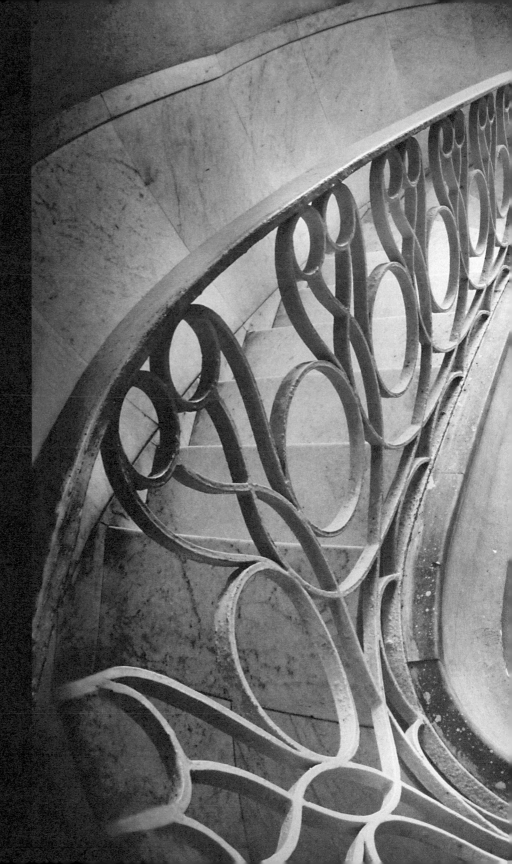

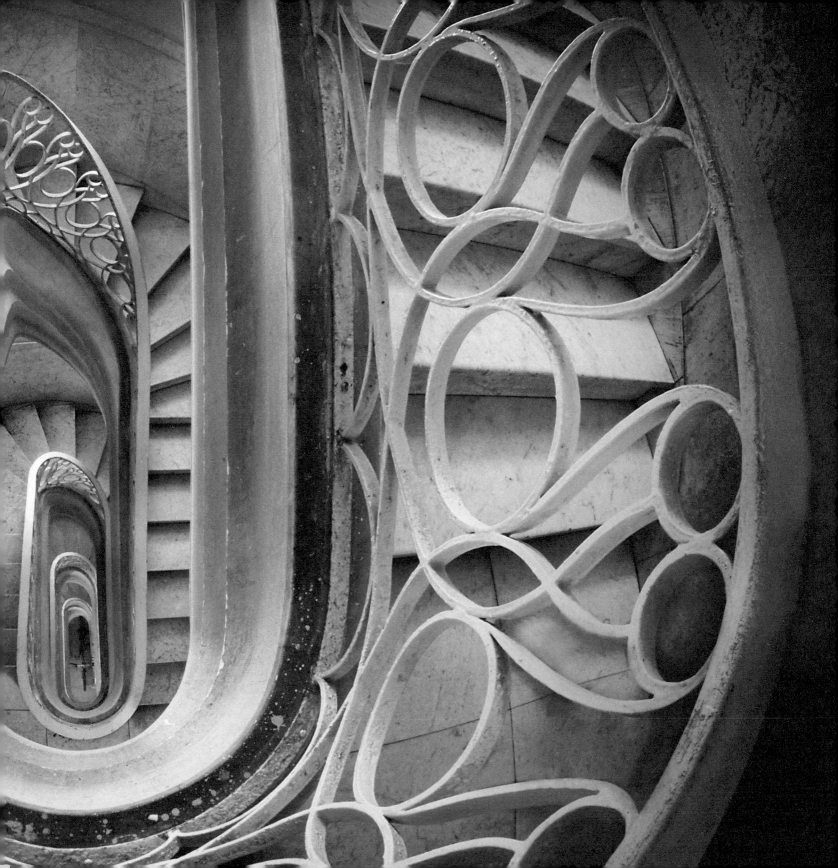

THE VIEW FROM ZABRISKIE POINT in Death Valley, California is pretty spectacular. Looking at this photo, I was reminded of the pattern in some kind of strange aerial quilt. But I could see gaps in the pattern.

Never one to be shy about improving on Mother Nature, I used the Clone Tool and other techniques shown in this book to add folds in the terrain and make the view seem to extend further down the valley than it did in reality.

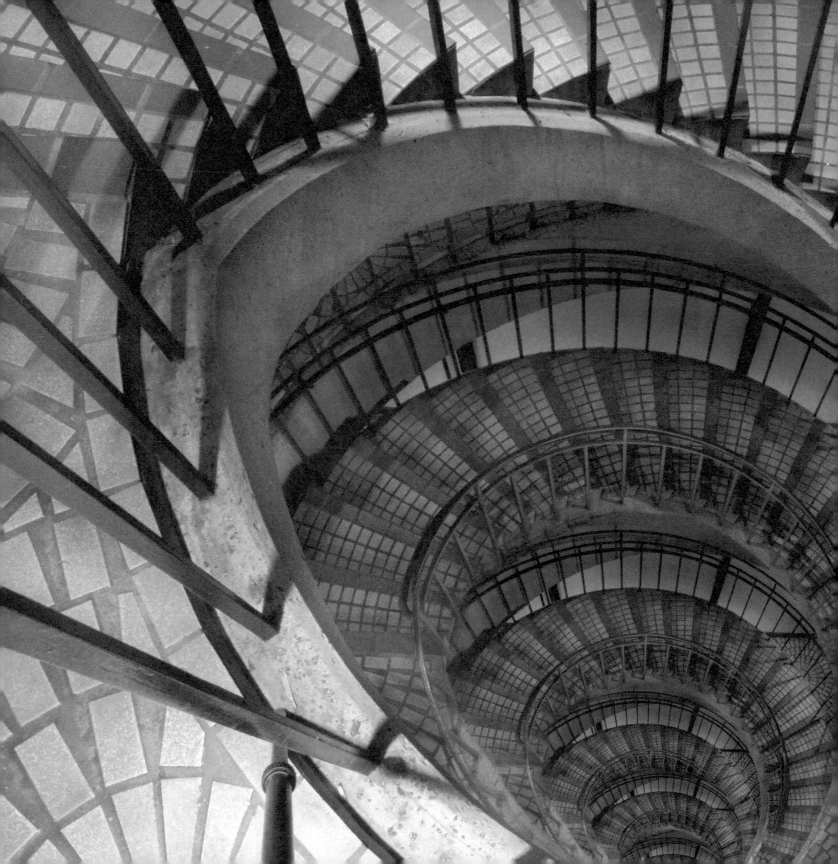

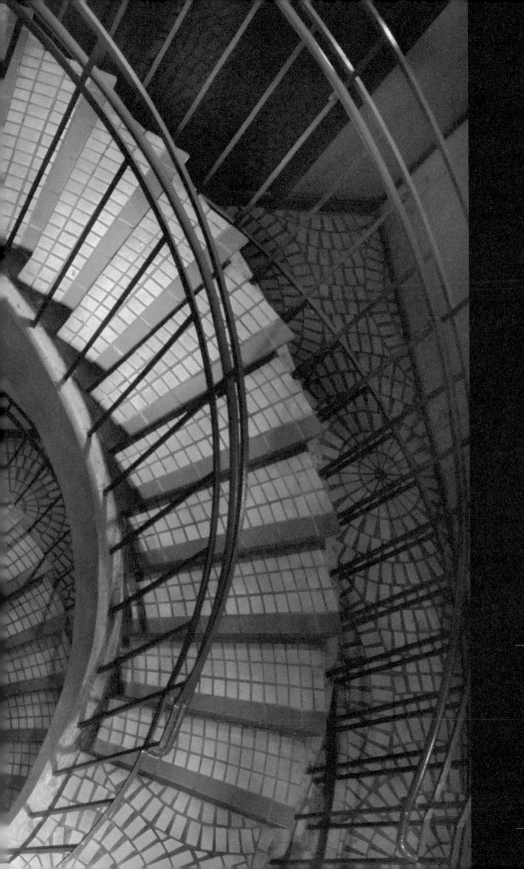

THE SPIRAL STAIRCASE IN the back of the Embarcadero Center in San Francisco, California extended a pretty good distance downwards. But the bottom of the stairwell was dirty, unattractive, and all too finite.

I used cloning and the other techniques I've shown you to extend the stair to cover what had been the bottom of the stairwell—and to make it seem like the stair goes on forever.

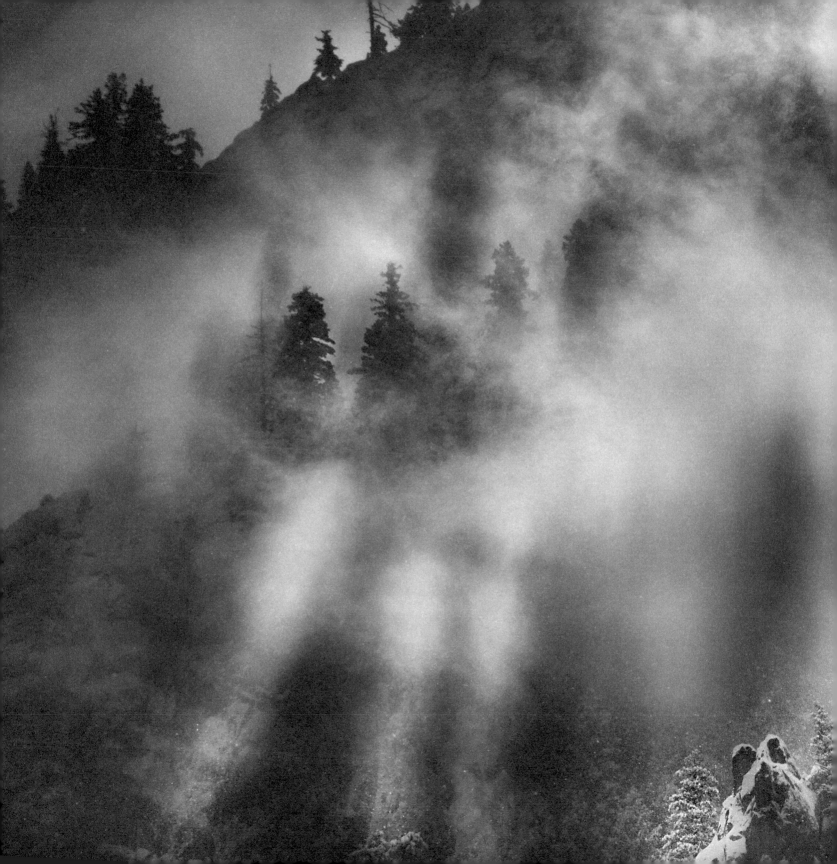

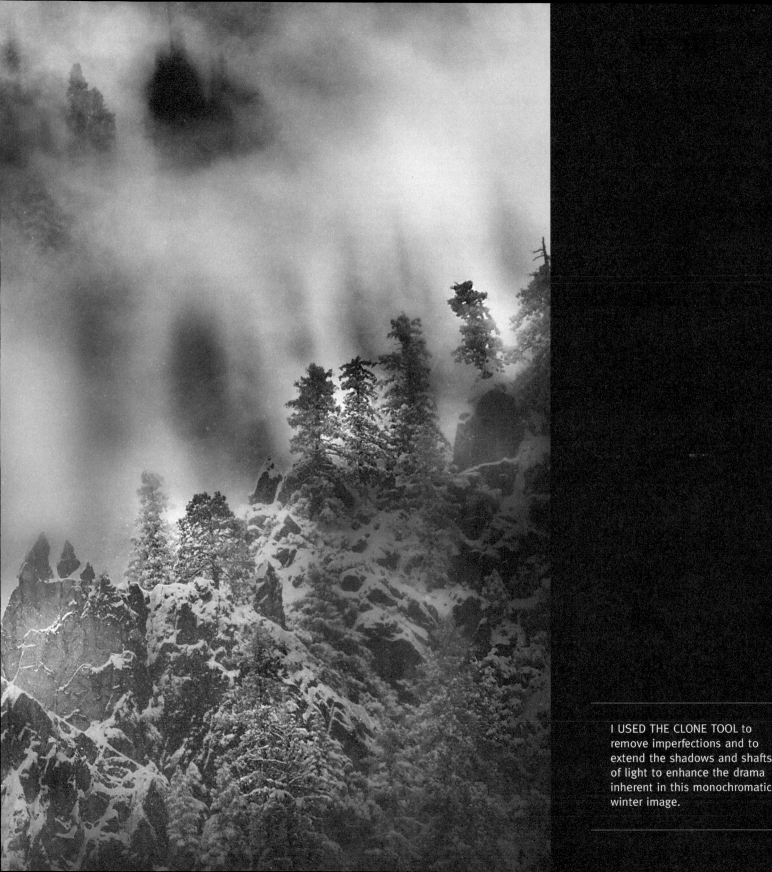

I USED THE CLONE TOOL to remove imperfections and to extend the shadows and shafts of light to enhance the drama inherent in this monochromatic winter image.

>> Transformations are for people, too!

Stylizing the human body

Taking out Ed's feet and my tripod legs was fun. I also use the retouching tools available in the Photoshop darkroom to transform—and hopefully improve—staircases, flowers, mountains, and assorted still-life subjects. Who knew? You can use the same techniques and tools to "improve" people.

It will come as no surprise that when someone wants to put their "best foot forward," they resort to all kinds of cosmetic approaches—applying lipstick, getting hair done, and so on. The same approach applies to the virtual world—but more so.

Many times I find myself giving a model or portrait subject a virtual make-over. This can range from removing wrinkles and blemishes to digital manicures and pedicures to changing body shapes. In other words, just about anything. Hey, I can even add a twinkle to someone's eye!

Just because one can do something doesn't mean one should do it. Overly "airbrushed" portraits look plastic and unreal—but a touch of retouching can add glamour and attractiveness. This is very much a judgement call and depends upon your visual aesthetics, the goals of the photography, and the attitude of your model.

I like to approach portrait and figure photography in the Photoshop darkroom with an objective frame of mind. I look at the image in front of me not as a person, but rather as shapes, forms, color, and light. In other words, the human landscape in all its many aspects from the ugly to the divine.

If it is a landscape in front of me, albeit human, I can apply a set of techniques and workflow aimed at improving the final image in much the way I would with any other landscape. This workflow starts with RAW, multi-RAW, or HDR processing. The next step is to remove obvious flaws. The image is then cropped. I correct for color, and then add tonality and creative effects as desired. As a next step, I take a close look at the photo. Is this the image that my subject and I would like? I usually find that it is desirable to work on skin (see pages 78–79) and eyes (see pages 90–91 for an eye retouching checklist).

The final image may or may not look much like my subject's actual appearance in the world. Depending on the purpose of the photograph, that may be fine. After all, no one in "real life" appears glamorous 24/7—but most people want a spectacular avatar.

Harold sez I often start by duplicating the Background layer of an image and circling the parts that need fixing in red. That way, I have a road map so I can see what needs to be done.

As I work, in the Layers palette, I click the eyeball to the left of this "reference layer" off to make it invisible, or on to check what I need to do next. Usually as I work, I find more things that need editing. I continue to mark these areas on my "reference layer" so that I will have a complete map of what to do.

When I'm done with a photo, I archive this layer road map at my first checkpoint.

I retouch people in much the same way that I work on flower photos

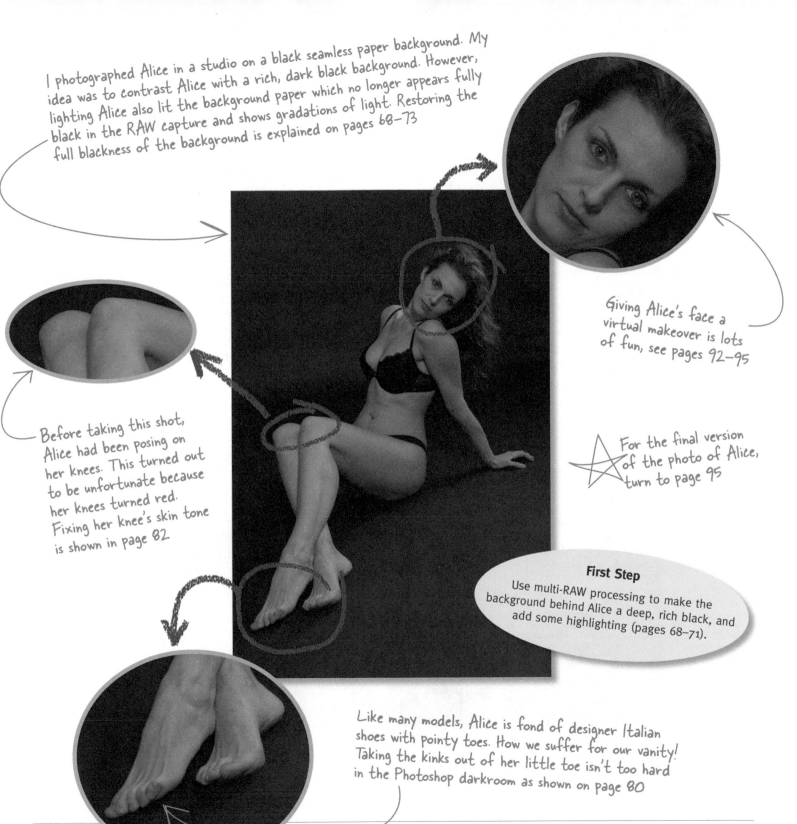

I photographed Alice in a studio on a black seamless paper background. My idea was to contrast Alice with a rich, dark black background. However, lighting Alice also lit the background paper which no longer appears fully black in the RAW capture and shows gradations of light. Restoring the full blackness of the background is explained on pages 68–73

Giving Alice's face a virtual makeover is lots of fun, see pages 92–95

Before taking this shot, Alice had been posing on her knees. This turned out to be unfortunate because her knees turned red. Fixing her knee's skin tone is shown in page 82

For the final version of the photo of Alice, turn to page 95

First Step

Use multi-RAW processing to make the background behind Alice a deep, rich black, and add some highlighting (pages 68–71).

Like many models, Alice is fond of designer Italian shoes with pointy toes. How we suffer for our vanity! Taking the kinks out of her little toe isn't too hard in the Photoshop darkroom as shown on page 80

›› Contrasting a figure with a black background

Portraits and adjustments

If you followed my multi-RAW processing technique in Lightroom (pages 16–19) or Adobe Camera RAW (ACR) (PD1, pages 30–39), you probably know that I'm prepared to adjust the white balance, color temperature, and color related sliders when I process RAW files.

However, when I photograph people using strobes in a studio, I am very conservative about playing with color in the RAW conversion process. Small shifts in color have a big impact on the appearance of skin and you really

don't want to show a glamour portrait looking as green as the Wicked Witch of the West—or purple for that matter. Skin should look like skin, be it light or dark. You don't want skin calling attention to itself because it has an unnatural-looking color cast.

This post-processing restraint simplifies my life. Here's what I do: I set my in-camera white balance to either Auto or Flash. Generally, these white balance settings have close to the same color temperature, but depending upon your studio set-up you may want to do some test shots to see if there is any difference

between the two settings. This can happen when the studio strobes are not exactly white balanced as expected or if there is a lot of non-flash light in the studio.

When I open a studio portrait or glamour shot in Lightroom or ACR, I accept the "As Shot" values for Color Temperature, Tint, Contrast, Vibrance, and Saturation. This means that the only sliders I get to play with are related to exposure: Exposure, Fill Light, Blacks, and Brightness. Fortunately, these four sliders give me a lot to work with.

Here are a few of the photos of Alice from a Saturday morning studio session

This is the image of Alice that I decided to multi-RAW process

Harold sez Alice is a gorgeous woman and a great professional model. Even in an unprocessed RAW file, she looks very attractive. I felt privileged to photograph her. But bringing out Alice's full beauty will take a bit of work in the Photoshop darkroom. (It's not all fun and games on the seamless paper behind the camera!)

» Processing the same capture three times

1 With the capture of Alice open in ACR, drag the Exposure slider to the left and the Blacks slider to the right to make the background really black. Then, hold down the Alt key and open the image as a copy in Photoshop.

This version will be used for the black background. Don't worry about how dark Alice is

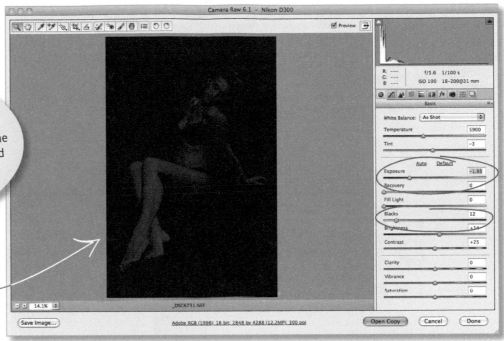

2 Using Bridge, open the capture of Alice a second time in ACR. This time process the image for skin tones, moving the Exposure, Fill Light, and Brightness sliders slightly to the right. When the skin tones are adjusted to your satisfaction, open the image as a copy in Photoshop.

Right now you have two versions of the same image open in different windows in Photoshop. Next, you'll combine them into one image window, and then add a layer mask and "paint" Alice onto the black background (pages 70–71)

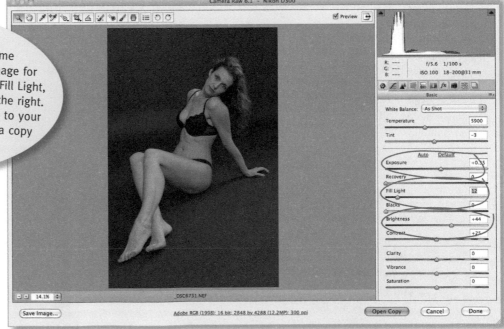

3 Click on the window that was processed for skin tones to make it active. Hold down the Shift key and use the Move Tool to drag the skin tone version onto the window containing the version you processed for the background. In the Layers palette, name the lighter layer that you just dragged in "Skin Tones."

There are now two layers in the Layers palette: "Skin Tones" and "Background"

4 With the "Skin Tones" layer selected in the layers palette, choose Layer ▸ Layer Mask ▸ Hide All to add a black layer mask to the layer. Select white as the foreground color, and then use the Brush Tool to paint Alice in using the layer mask. (For more about layer masks and painting, turn to pages 22–24.)

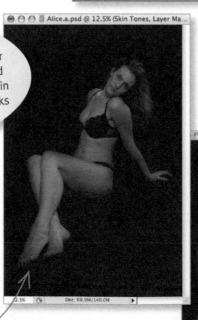

Set the Brush Tool Hardness to 0% for painting on the layer mask. As you paint Alice in, be careful to let the edges of her body fade in to the black background. This is a good way to start fixing the little toe on her right foot. (Remember this squooshed looking toe from page 67?)

This is how the layer mask looks after you've painted on it. Notice that the white and gray areas have a fuzzy edge—this makes for a soft blend between Alice and the black background

 Make sure the "Skin Tones" layer is selected in the Layers palette, then choose Layer ► Duplicate to copy the layer. Name the new layer "Lighten."

 Remove the duplicated layer mask on the "Lighten" layer by choosing Layer ► Layer Mask ► Delete. Then, add a new Hide All layer mask to the layer by selecting Layer ► Layer Mask ► Hide All.

7 With the "Lighten" layer selected in the Layers palette, select the Screen blending mode in the Layers palette. (See pages 25–26 for info about dodging with this blending mode.)

8 If you need to, select white as the foreground color, and then use the Brush Tool to carefully paint in lighter areas on the layer mask where you think the image needs them on the hair, face, hip, and knees.

Now you have three layers in the Layers palette. Next, you'll go back to ACR and process a third version of Alice, this one for highlights. Then, you'll add it to the layer stack with a layer mask (pages 72–73)

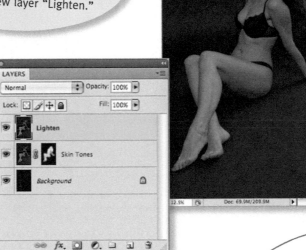

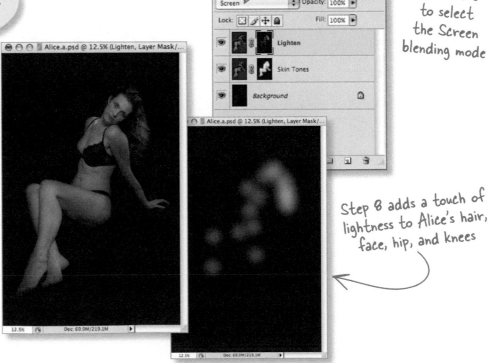

Click here to select the Screen blending mode

Step 8 adds a touch of lightness to Alice's hair, face, hip, and knees

9

Open the original RAW capture *again* in ACR. This time expose the capture for hair and face highlights. Move the Exposure, Fill Light, and Brightness sliders to the right until you are pleased with the look of Alice's hair. When you are finished adjusting the sliders, hold down the Shift key and open the image as a copy in Photoshop.

This version is just for highlights, so don't worry about the background color or skin tones

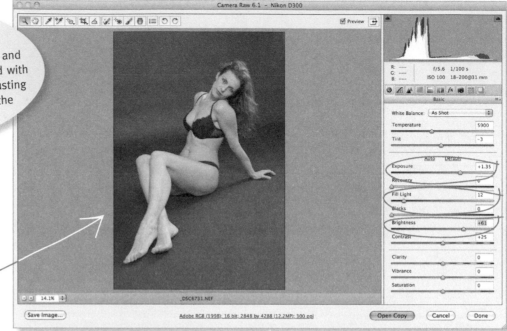

10

Click on the window that you just processed for highlights to make it active. Hold down the Shift key and use the Move Tool to drag the highlights version onto the window containing the three layers. In the Layers palette, name the new layer that you just dragged in "Highlights."

You now have four layers in the Layers palette

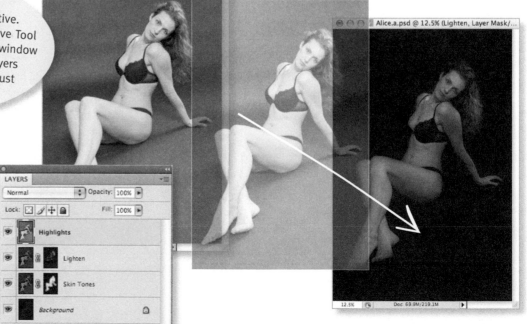

11 With the "Highlights" layer selected in the Layers palette, choose Layer ▸ Layer Mask ▸ Hide All to add a black Hide All layer mask. Select white as the foreground color, and then use the Brush Tool to paint on the layer mask, painting in highlights.

Painting in the eye area on the "Highlights" layer makes the whites of Alice's eyes whiter. You'll work more on her eyes starting on page 90

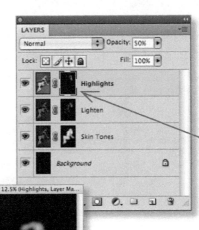

As you can see from the layer mask, highlights were added to the hair, eyes, and cheeks

12 **Checkpoint**
Now that the multi-RAW processing is done, save and archive a version of the image with all the layers. Then, flatten the layers by selecting Image ▸ Flatten and save the file with a new name, ready for further adjustments.

Next Step
You've used multi-RAW processing to create a great base rendition of Alice. Now it's time to take a close look at the features that may need to be digitally transformed to create a glamorous look (pages 80–83).

Beauty and the Retouching Beast

Most published photographs of beautiful women are extensively retouched. It probably should be obvious that this retouching takes place, but the extent of it is a kind of industry secret.

As one professional glamour photographer told me, "It's 90% Photoshop!" We've cleaned up enough eyebrows at 2 a.m. to know that these models, as perfect as they may seem in photos, are actually just human beings.

So starting on page 78 we reveal some secrets of glamour retouching!

"Background" layer—6 second exposure

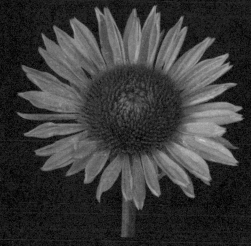

"Flower" layer—20 second exposure

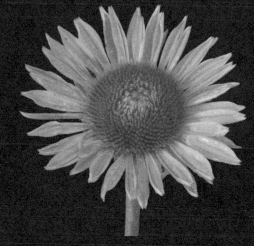

"Core" layer—30 second exposure

Layers palette showing
the layers and their masks

Mask for "Flower" layer

Mask for "Core" layer

Using Hand-HDR to Get a Completely Black Background

When I'm shooting something that doesn't move—such as a flower in my studio—I can use multiple captures to create an extremely black background. This technique puts together different images using Hand-HDR.

I start by making a very, very dark capture for the background. The idea is to vary the shutter speed (not the f-stop because this might effect the depth-of-field), so I bracket captures using longer shutter speed times. Usually each successive shutter speed is twice as long as the last one. I find it is easiest to use this technique with my camera in Manual exposure mode rather than using the automated in-camera bracketing feature.

Each of the captures shown above was taken with an 85mm perspective-correcting macro lens, at f/64 and ISO 100 with shutter speeds ranging from 6 to 30 seconds.

I shot this Echinacea on a black velvet background. The light source was natural sunlight. Black velvet is a great background because it is non-reflective and seems very dark. But at reasonable exposures, some light spills out on the velvet and it doesn't render as entirely black.

I started by processing the darkest version for the black velvet background to make it extremely dark. If this layer were to stand alone by itself, you would hardly be able to see the flower at all (above left).

Next, I switched to a lighter version for the flower itself. After opening the lighter version in Photoshop, I popped it on top of the black background and added a black Hide All layer mask and carefully painted the flower in (above middle).

A still lighter version was perfect for the dark areas of the flower, such as the relatively dark flower center. Using Hand-HDR enabled me to bring out the striking green color of the flower's core while maintaining a rich black background (above right).

This is a dynamic range spread that could not easily be obtained using a single capture. To find out more about the Hand-HDR process, take a look at PD1, pages 106–119.

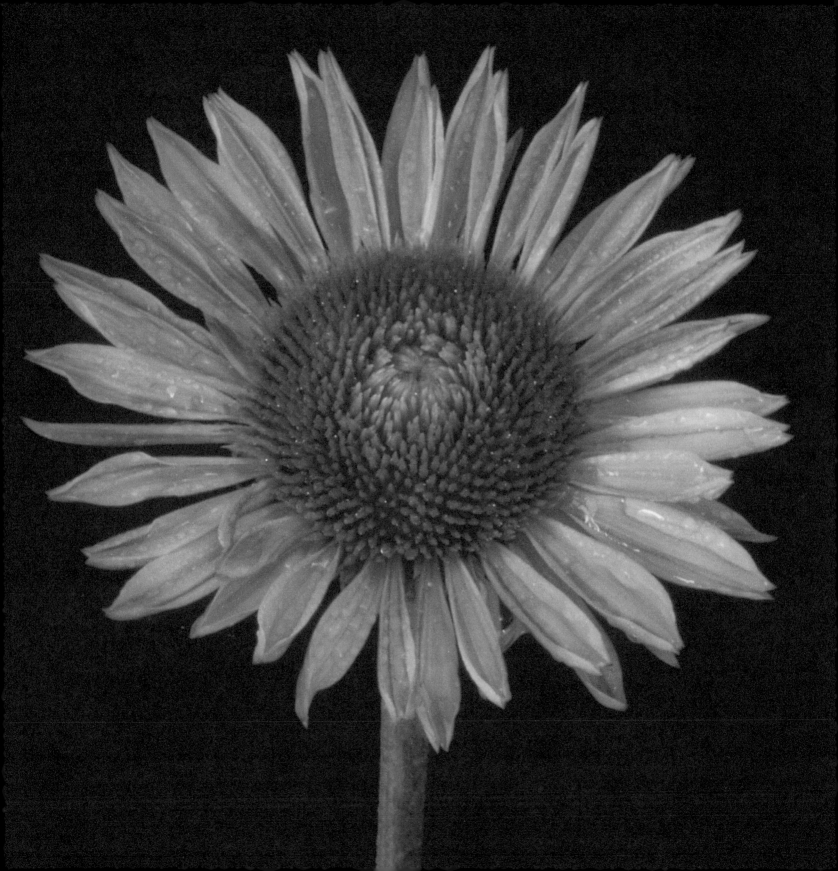

Photographing Kids on a Black Background

I captured Emily, Nicky, and friends on a black background using studio lighting. When I processed the image in the Photoshop darkroom, I created three layers: a really dark version to make the background go black (below left), a more or less normal version to show the kids (below middle), and a lighter version (below right) to provide visual separation between Emily's dark hair and Nicky's black shirt and the background.

Normally, in studio portrait lighting, this visual separation is achieved using a hair light—a light behind the subjects specifically intended to provide visual separation between the subjects and a dark background. In this case, I didn't have the luxury of a hair light, so the task had to be accomplished in post-processing.

It's interesting that the same Photoshop darkroom techniques used to create the glamorous image of Alice (pages 68–73) can also be used effectively to make casual portraits like this one of two charming children.

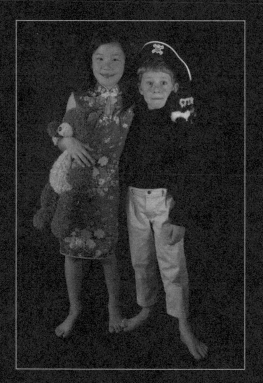

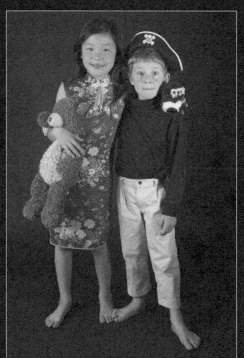

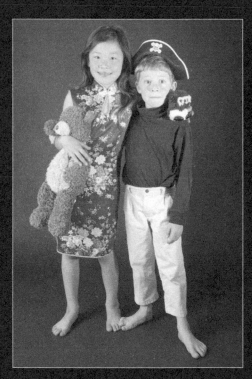

This was the first version I processed. My idea was to convert a dark version to use as a rich, black background. Since this version was only to be used for the background, I made sure it was dark enough and didn't worry about how the children were rendered.

The second version that I processed was intended to be essentially a normal rendition of the children. I paid no attention to the background because the first version would supply the black background. I tried to make sure that this version captured the full tonal range of the children and their clothing.

I processed a third version with the idea of lightening a few specific areas. For example, in the second version Nicky's shirt is still too black and will blend into the dark background if not corrected. It's very easy to add some lightness to the black shirt using this version that has been processed from the RAW—creating the same kind of visual separation that an additional light in the studio might have provided.

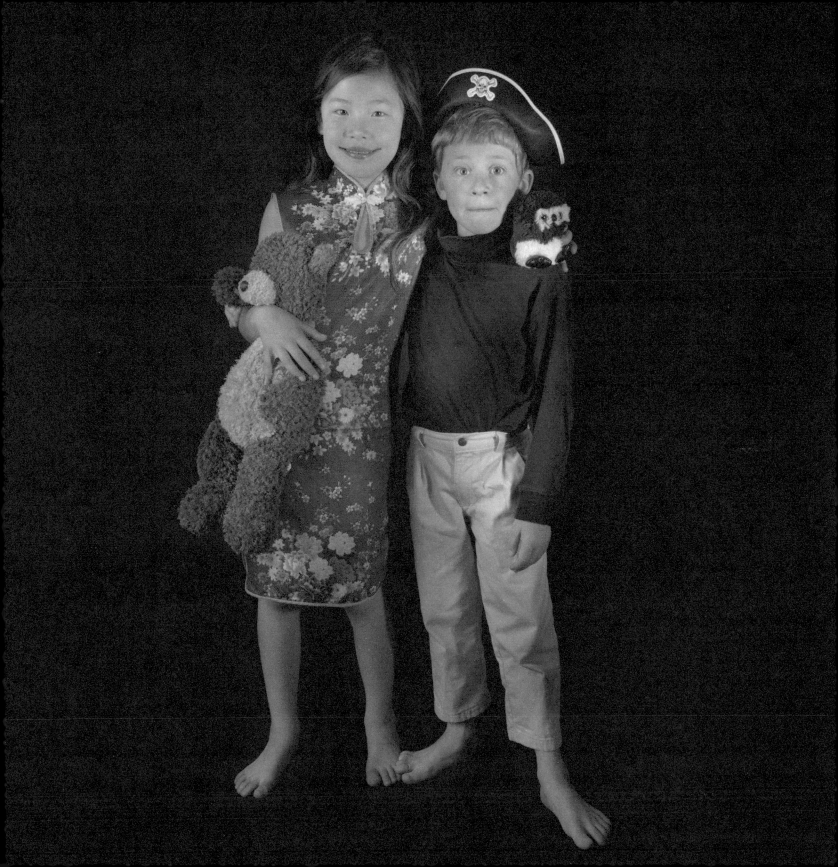

Being a natural redhead, this model has a lot of freckles. I removed some freckles using the Clone Tool (pages 30–35).

Since the viewer looks at eyes first, they are crucial. Most eyes need a lot of work (pages 90–91).

Even when lipstick is carefully applied, there are blemishes and blown-out highlights that need to be fixed (pages 92–93).

THE MORE I PHOTOGRAPH beautiful women, the more I realize that everyone has some skin challenges. Perhaps the only perfect skin on the planet belongs to kids before hormones hit—and by definition, these kids are not glamour models. Also in my experience, glamour models don't always lead the healthiest of lifestyles. This inevitably impacts skin condition. It may not show in publicity photos that have been retouched, but it certainly shows when you look at original captures in Photoshop.

Having good make-up helps a great deal, but cosmetics can be overdone and look artificial. When make-up is used to cover poor skin, it can look like a cover-up is in process—as is indeed true.

In any case, I always plan to spend some time "improving" skin on models I shoot. This involves two phases. The first is to remove obvious flaws and blemishes, using the Clone, Healing Brush, and Patch Tools in Photoshop. The second phase is to use an arsenal of tools to smooth and add a healthy glow.

These tools include the Dust & Scratches filter and the Gaussian Blur filter in Photoshop, as well as Noise Ninja by Picturecode (www.picturecode.com) for smoothing. I like to use Noise Ninja with the settings applied at a very high level. Other smoothing and enhancing tools that I use are the Glamour Glow filter that comes with Nik ColorEfex Pro (www.niksoftware.com), and the Smoothing filters that come with the Portraiture plug-in by Imagenomic (www.imagenomic.com).

These softening and enhancement effects should be used on duplicate layers. That way, you have the flexibility to selectively apply the effects to portions of an image—for instance, you don't want to soften a model's eyes. Also, if the effect is too strong, you can reduce the Opacity of the layer to decrease the effect.

Here's a close-up of the model's right cheek before retouching (left) and after (right). You can see in the final image that the freckles and blemishes have been removed and that the skin overall seems smooth and glamorous. Generally, skin that has been retouched for glamour no longer looks entirely human—this is not an epidermal layer with pores or small hairs. Rather, it is something beautiful but artificial that you might see on an airbrushed illustration rather than a photo.

Cheek before

Cheek after

>> Head, shoulders, knees, and toes... ✳

Creating a fantasy

In real life, people get face lifts, tummy tucks, and even new artificial hips and knees. In the Photoshop darkroom, any body part can also be improved—or replaced.

There's a fine line between improving and over-doing. The goal, when you retouch an artistic or glamorous figure photo, should not be to remove all individuality from someone's body. The differences and idiosyncrasies are part of character and part of what we love about people.

The best way to take stock of a body for possible enhancement of reality is to see if there are body parts that stick out awkwardly, call attention to themselves, or in some way look painful.

Glamour photography is itself an exercise in fantasy. It's usually an attempt to create an impossibly gorgeous, iconic vision. You don't want this vision looking like they were suffering even though they are wearing five-inch stilettos. You want to keep the individuality of your subjects and the glamorous fantasy at the same time.

Back on page 67, you saw a "road map" showing a few areas of Alice's body that could use virtual enhancement. Working from the bottom up, you'll find out how to fix her toes, smooth the skin on her knees and legs, and finally enhance her face and eyes.

Toes

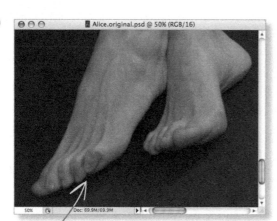

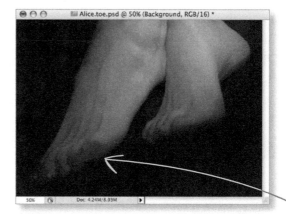

This is the way Alice's little toe looked back in the original capture shown on page 67

Painting in the black background with a soft brush in Step 4 back on page 70 did a good job of fading the hard edges of Alice's feet. But the little toe on her right foot is still noticeably squooshed and needs to be fixed

Painting a Toe

To fix the little toe, you're going to use the Brush Tool to paint over the toe area on a duplicate layer.

✳ ...and eyes, and ears, and mouth, and nose...

1

Start by taking a look at Alice's right foot. Zoom in so you can really see what's going on. (You can use the Navigator as you paint to zoom in and out, turn to page 34 for info.)

Notice that the middle joints on Alice's first four toes create a line. The squooshed little toe interrupts that line. That's where you're going to paint. When you paint, you'll want to try to continue that line.

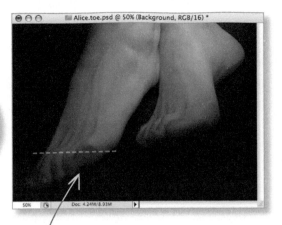

The joints on Alice's foot create a line that needs to be continued

2

Choose Layer ▸ Duplicate to copy the "Background" layer. Name the new layer "Fix toe."

3

Select the Eyedropper Tool from the Toolbox and sample the skin tone color from right above the area where you are going to paint.

Sample from the lighter skin area just above the darker, shadowed area

4

Choose the Brush Tool from the Toolbox and use the Brush Picker to select a small round brush with 0% Hardness. Then, use the Options Bar to set the Opacity and Flow down to 20%. (Turn to page 23 for directions on setting up the Brush Tool. Also, see PD1, pages 48–49.)

5

Carefully paint in on top of the little toe to move the shadowed toe-joint line down to where it should be. Next, use the Layers palette to soften the painting by reducing the "Fix toe" layer's Opacity down to 75%.

Zoom in so you can see what you're doing

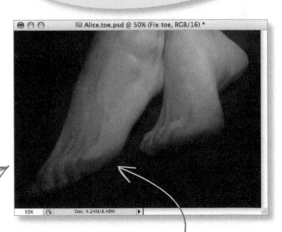

Don't worry about being anatomically correct. You are creating an illusion for the viewer that has more to do with shadows and lighting than it does with anatomy

Knees

Alice's knees are a bit red because she had been posing on her hands and knees before I took this photo

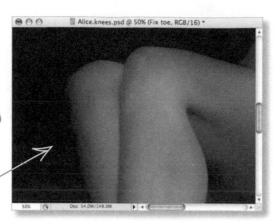

Removing Red Marks

To remove the red marks from Alice's knees, you're going to paint on the legs on a duplicate layer, and then use a Hide All layer mask to blend the painting in.

3 Choose the Brush Tool from the Toolbox and use the Brush Picker to select a medium round brush with 0% Hardness. Then, use the Options Bar to set the Opacity and Flow to 50%.

1 With the "Fix toe" layer selected in the Layers palette, choose Layer ► Duplicate to copy the "Fix toe" layer. Name the new layer "Fix Knees."

Next, use the Layers palette to change the Opacity of the "Fix Knees" layer to 100%.

4 Use the Brush Tool to paint over Alice's knees and calves. Don't worry about blending the painting in to the surrounding areas.

As you can see, the painting doesn't blend into the skin areas of Alice's knees and calves... don't worry about it! You'll take care of the blending using a layer mask in Step 7

2 Choose the Eyedropper Tool from the Toolbox and sample the skin tone color from Alice's upper left calf.

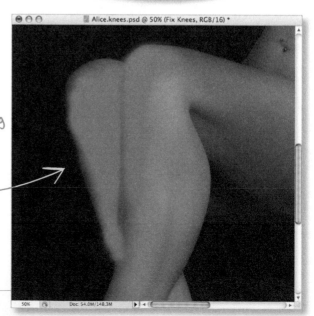

5 With the "Fix Knees" layer selected in the Layers palette, choose Layer ▸ Layer Mask ▸ Hide All to add a black Hide All layer mask to the layer.

When you add the layer mask to the "Fix Knees" layer, the layer will become invisible, hiding the painting you did on the layer. You'll selectively paint it in using the layer mask in Step 7

6 In the Toolbox, set the foreground color to white. Then select the Brush Tool and use the Options Bar to set the Opacity and Flow down to 10%. Make sure the Brush Tool is set to 0% Hardness.

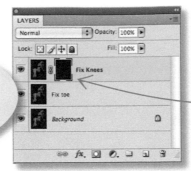

7 With the layer mask selected on the "Fix Knees" layer, gently paint over the red areas on Alice's knees.

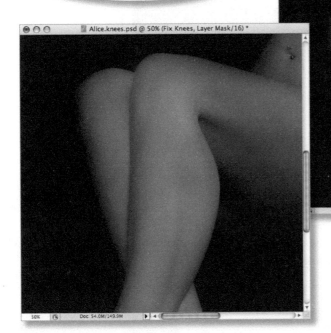

The painting on the layer mask is very subtle and light

If you feel like you've painted too much on the layer mask, you can always lower the Opacity of the layer to decrease the painting on Alice's knees or you can delete the layer mask, add a new layer mask, and try again

8 **Checkpoint** It's time to save and archive the work you've done before continuing to perfect Alice's body parts. So save a copy of the image with all the layers. Then, flatten the layers by choosing Image ▸ Flatten and save the file with a new name.

Legs

Like any normal mortal, Alice has bumps and hair follicles on her legs. To lift Alice from the mortal realm, a little skin smoothing magic is in order...

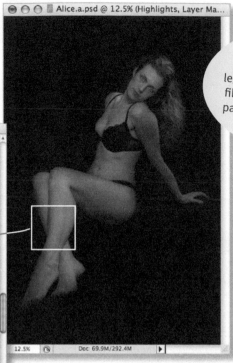

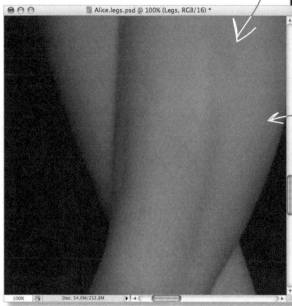

Glamorous Gams

To smooth the skin on Alice's legs, you'll apply the Gaussian Blur filter to a duplicate layer and then paint in the smoother skin using a layer mask and brush.

You can use these steps in your photos to smooth skin (or any other surface that needs smoothing)

Duplicate the "Background" layer by choosing Layer ▸ Duplicate. Name the new layer "Smooth Legs."

At the checkpoint on page 83 in Step 8, you saved the image with a new name and flattened the layers down to a "Background" layer. So at this point, there should be two layers in your image—the "Background" layer and the "Smooth Legs" layer you just added

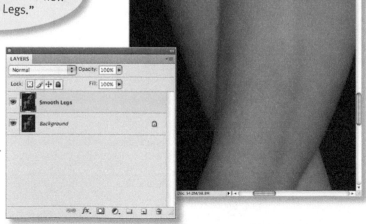

2

With the "Smooth Legs" layer selected in the Layers palette, select Filter ► Blur ► Gaussian Blur

Filter

Last Filter	⌘F
Convert for Smart Filters	
Filter Gallery...	
Liquify...	⇧⌘X
Vanishing Point...	⌥⌘V
Artistic	►
Blur	►
Brush Strokes	►
Distort	►
Noise	►

Average
Blur
Blur More
Box Blur...
Gaussian Blur...
Lens Blur...
Motion Blur...
Radial Blur...
Shape Blur...
Smart Blur...
Surface Blur...

When you select Gaussian Blur, the Gaussian Blur dialog box opens

3

In the Gaussian Blur dialog box, play with the Radius slider until you are pleased with the smoothness of the skin. A setting of 2.5 works about right.

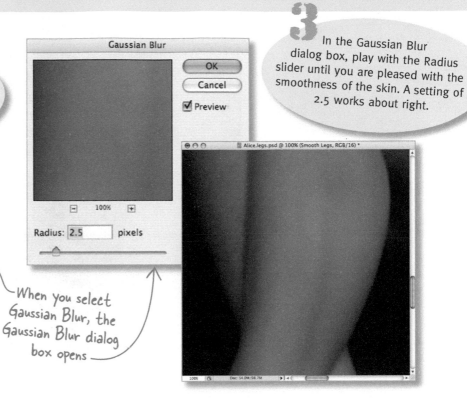

4

With the "Smooth Legs" layer selected in the Layers palette, choose Layer ► Layer Mask ► Hide All to add a black Hide All layer mask to the layer.

5

In the Toolbox, make sure the foreground color is white. Next, select the Brush Tool and use the Options Bar to set the Opacity and Flow down to 20%. The Brush Tool should be set to 0% Hardness.

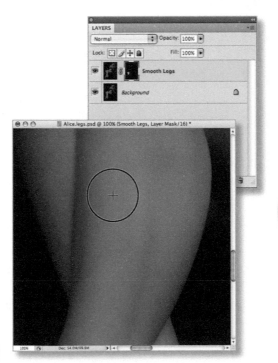

6

Paint on the layer mask on the "Smooth Legs" layer to reveal the blurred areas of the layer and make Alice's skin appear smoother.

7 **Checkpoint**

Save and archive the work you've done on Alice's skin before continuing on. Save a copy of the image with all the layers. Then, flatten the layers by choosing Image ► Flatten and save the file with a new name.

Muscle Definition

Since the skin on Alice's calves and thighs was smoothed using the Gaussian Blur filter, some muscle definition in the calf was lost. (You can compare with the original photo shown on page 67.) The appearance of muscle definition is created by this shadow here

☆ When working on your own portraits, think about the way shadows define shapes on the body. You can use the technique shown here anywhere you need it.

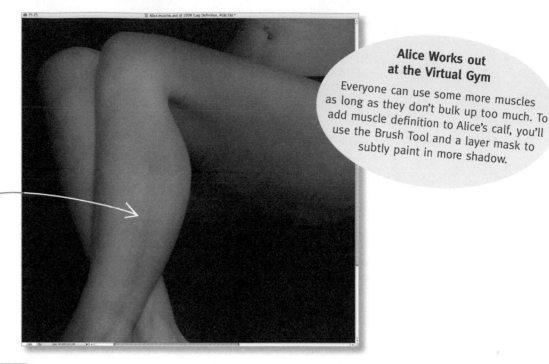

Alice Works out at the Virtual Gym

Everyone can use some more muscles as long as they don't bulk up too much. To add muscle definition to Alice's calf, you'll use the Brush Tool and a layer mask to subtly paint in more shadow.

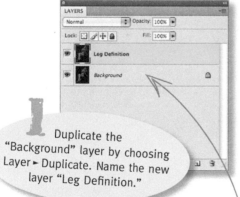

Click here to open the Picker

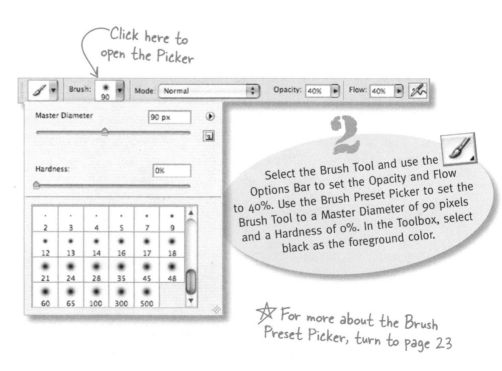

1 Duplicate the "Background" layer by choosing Layer ▸ Duplicate. Name the new layer "Leg Definition."

At the checkpoint on page 85 in Step 7, you flattened the layers down to a "Background" layer. So there should be two layers in your image—the "Background" layer and the "Leg Definition" layer you just added

2 Select the Brush Tool and use the Options Bar to set the Opacity and Flow to 40%. Use the Brush Preset Picker to set the Brush Tool to a Master Diameter of 90 pixels and a Hardness of 0%. In the Toolbox, select black as the foreground color.

☆ For more about the Brush Preset Picker, turn to page 23

3

Use the Brush Tool to draw a soft, dark line along the shadowed area on Alice's calf.

Don't worry about how gigantic and out of place this dark shape looks! You'll use a layer mask in Step 5 to gently paint in what looks right

4

With the "Leg Definition" layer selected in the Layers palette, choose Layer ▸ Layer Mask ▸ Hide All to add a black Hide All layer mask to the layer.

Take the Opacity down to 15%

5

Set the foreground color to white. Next, choose the Brush Tool from the Toolbox and set the Opacity and Flow down to 10%. Start with a Master Diameter setting of 20 pixels. (While you paint, vary the diameter of the brush.)

6

Paint the definition shadow up Alice's calf. When you are finished painting, reduce the "Leg Definition" layer Opacity to 15% in the Layers palette to soften the shadow.

Next Step

Now that Alice's body has been smoothed and enhanced, it's time to apply virtual make-up in the Photoshop darkroom (pages 88–91).

Eyebrows

If the eyes are the windows of the soul, then the eyebrows are the window treatment. An eyebrow frames the eye and is an extremely important decorative aspect of the face. The viewer's initial impression of almost anyone's face depends immensely upon the eyebrows. Have you ever seen someone with a mono-brow? I'll bet you probably formed an impression of the person right away.

Eyebrows are plucked, waxed, dyed, drawn, painted, and tattooed. Despite this near industrial-scale effort to manage eyebrows, you may be surprised to learn how many professional models' eyebrows need work.

If you are photographing a professional model, try to get them to fix eyebrow problems before you take photos. Sometimes, though, there is no make-up artist handy or the model's skill with cosmetics doesn't match his or her looks. Or, you simply don't notice the problematic eyebrow(s) until you are at your computer, hours or days after the photo shoot.

In this case, it's time for a Photoshop darkroom eyebrow makeover. The key tools for fixing brows are the Clone, Patch, and Brush Tools. The Clone Tool (pages 30–31) works really well at removing small brow hairs and tiny bits of make-up that fall on the cheeks. It works wonders on dark circles under the eyes. The Brush Tool (page 23) is great for painting in fine details such as eyelashes and missing brow hairs. And the Patch Tool (page 35) can be used to replace areas with texture such as the skin right above or below the eye—Photoshop automatically (and almost magically) blends the patch into the area that needs attention.

This professional model's eyebrows needed some cleaning up. I used the Clone Tool to remove the unwanted brow hairs. (For info about the Clone Tool, turn to pages 30–35.)

Eyebrows can really make or break a photo. Here's the cleaned up eyebrow.

The Eyes Have It

Eyes are crucial to our evaluation of people. When you look into someone's eyes, you may be seeing directly into their soul. If someone will not meet your gaze, then you may not feel that they are trustworthy. Furthermore, eyes are beautiful.

For these reasons, the treatment of eyes in the Photoshop darkroom is a crucial aspect of creating a glamorous image (or a portrait).

The general principles of working on eyes are the same as with retouching any body part: you want to fix flaws and gently enhance. It's important that enhancement not be so over the top that it calls attention to itself.

The tools used to accomplish this illusionist act are the same tools you've used for most of the work in this book so far: the Clone and Brush Tools, layers, and masking.

Once again, the idea is to create a plausible illusion. Retouching in the Photoshop darkroom combines photography with digital painting to create a gently alternative reality.

When I work on someone's eyes, I usually start with the same kind of analysis that I use for an entire body. There will likely be half a dozen features that need to be fixed or improved. Here's my eye checklist.

EYE CHECKLIST

☐ **Eye shape** Often there are irregularities with eye shape that need to be corrected.

☐ **Eye color** While the pupil of the eye appears mostly black, the surrounding iris is beautifully colored and variegated. This color can often be enhanced.

☐ **Reflections, tears, and film on the surface of the iris** Retouching techniques—cloning and painting—need to be used to remove these flaws.

☐ **Catch lights** I use the Brush Tool to slightly exaggerate the catch light (reflection from the prevailing light source) that shows in any eye (page 94).

☐ **Eye whites** Depending upon how much sleep a model has had and lifestyle issues, eye whites can appear pretty red. Almost everyone's eyes need some retouching of the white areas. I use the Brush Tool with white on a duplicate layer. Since eyes with all the red veins painted out look unnatural, I lower the Opacity setting of the duplicate layer to make sure that the eye white still looks realistic.

☐ **Eye lashes** Usually there are some lashes that appear split, broken, or bent. These lashes should be fixed using the Brush Tool set to the width of an eyelash (usually about 2 pixels), with the Hardness set to 50%. In addition, when mascara is on the lashes, any flakes or smudges need to be removed.

☐ **Selective sharpening** Sharpening eyes selectively is a very effective way to add a sparkle and to direct the viewer's attention. (See PDI, pages 198–201 for more about selective sharpening.)

This model's eyes were quite red and lacked sparkle...

...But after working my way through the checklist, you can see how pretty her eyes really are

❯❯ Finishing the portrait

Hair, face, and eyes

You've worked your way up from Alice's toes, using techniques that have smoothed and defined her body. Now, you'll use those same techniques (and a few more) to finish the portrait.

Here's Alice's face and hair as shown in the original capture on page 67

Extra Credit: Experiment with the third-party plug-ins described on pages 78–79. Try a little Glamour Glow from Nik's ColorEfex Pro or the Smoothing filters that come with Portraiture by Imagenomic. Use them on a duplicate layer and apply them to Alice's face and body; wherever you think they look great!

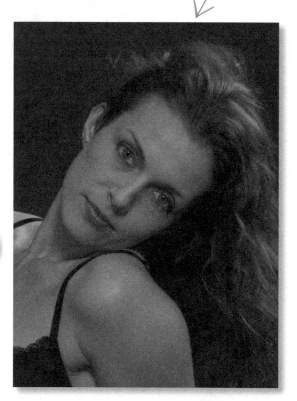

 Add highlights to Alice's hair using the Screen Blending mode techniques that you used on the Cuban stairs on pages 25–26.

 Remove any blemishes on Alice's face with the Clone and Patch Tools. (For info about these tools, turn to pages 30–36.)

 Smooth the skin on Alice's forehead, cheeks, and chin using the same Gaussian Blur technique that you used to smooth the skin on her legs on pages 84–85.

Paint in cheekbone shadows with the same steps you used to define Alice's calf muscle on pages 86–87.

Remove the shadows around Alice's temples by painting and masking. Go to page 93.

Fix Alice's eyebrows using the techniques described on pages 88–89.

Make Alice's eyes gorgeous using the checklist on pages 90–91.

 Enlarge the catch lights in Alice's eyes to make the viewer immediately focus on them. Turn to page 94.

›› Enhancing facial structure

Face painting

I painted on Alice's face to improve the way the shadows looked using the techniques explained on pages 82–83. It doesn't really matter what body part you are working on—using the Brush Tool to improve the overall look and color involves pretty much the same idea.

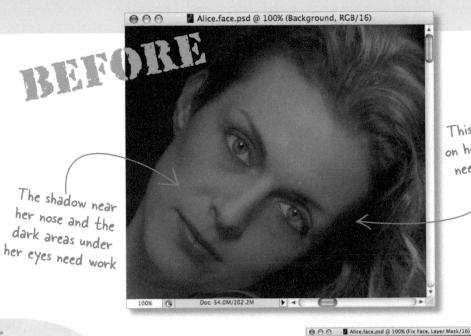

BEFORE

This shadow on her temple needs to go

The shadow near her nose and the dark areas under her eyes need work

1 After duplicating the layer, use the Eyedropper Tool to sample the various skin tones on Alice's face as you paint with the Brush Tool.

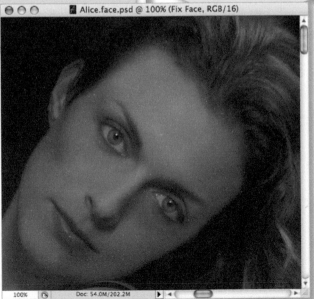

AFTER

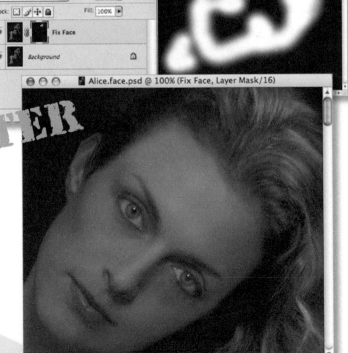

2 Add a black Hide All layer mask and paint with the Brush Tool on the layer mask to soften the edges of the painting.

❯❯ Painting catch lights

Eyes are reflective

A catch light is a reflection in the eye of a bright light source such as a studio strobe. Since viewers are drawn to bright areas in a photo, enlarging catch lights draws the viewer's attention to the eyes and face. In addition, ramping up the existing catch light adds apparent sparkle and charm to anyone's eyes.

There is a circular catch light in each of Alice's eyes that is a reflection of the studio key light

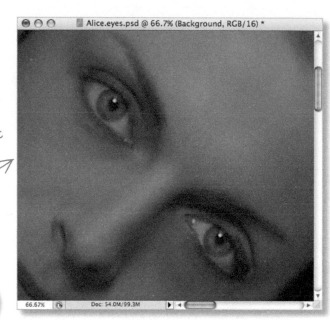

1 Select Layer ▸ Duplicate to copy the "Background" layer. Name the new layer "Catch Lights."

2 Select the Brush Tool from the Toolbox and set it to a Master Diameter of about 6 pixels and a Hardness setting of 50%.

3 Set the foreground color to white and then paint on the catch lights, enlarging them slightly.

4 In the Layers palette, set the Opacity of the "Catch Light" layer to 80% to soften the effect.

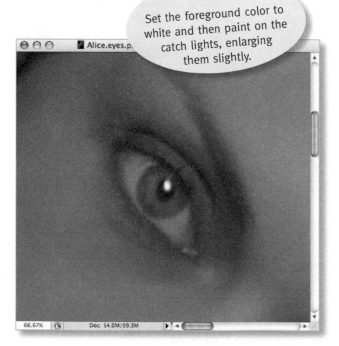

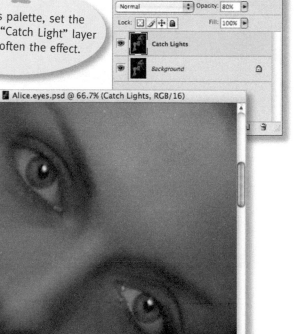

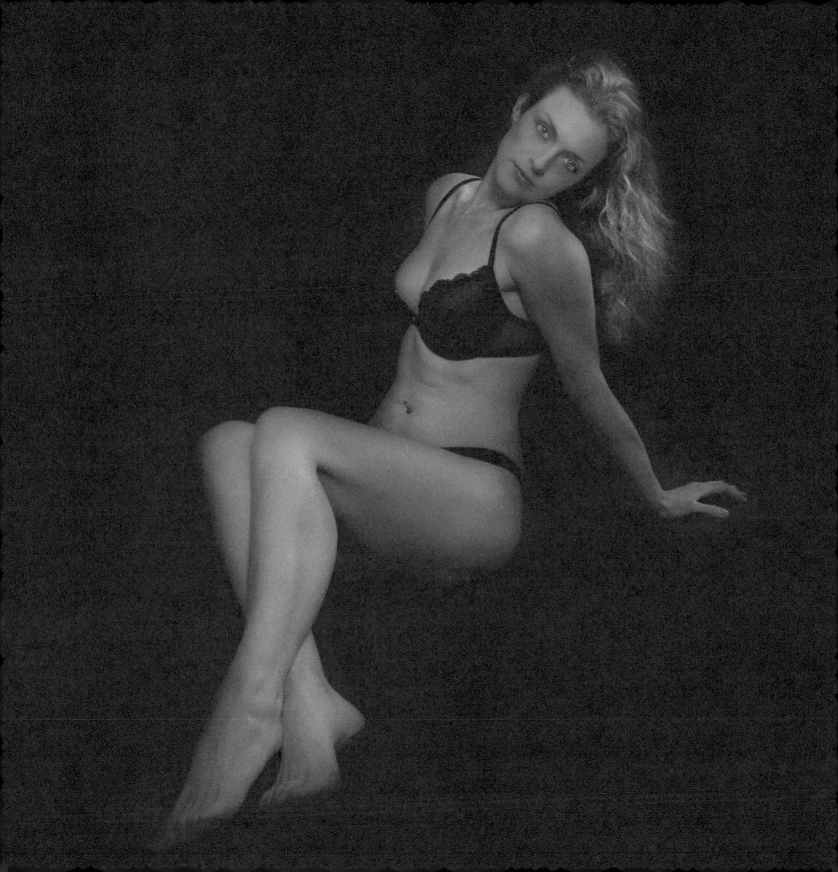

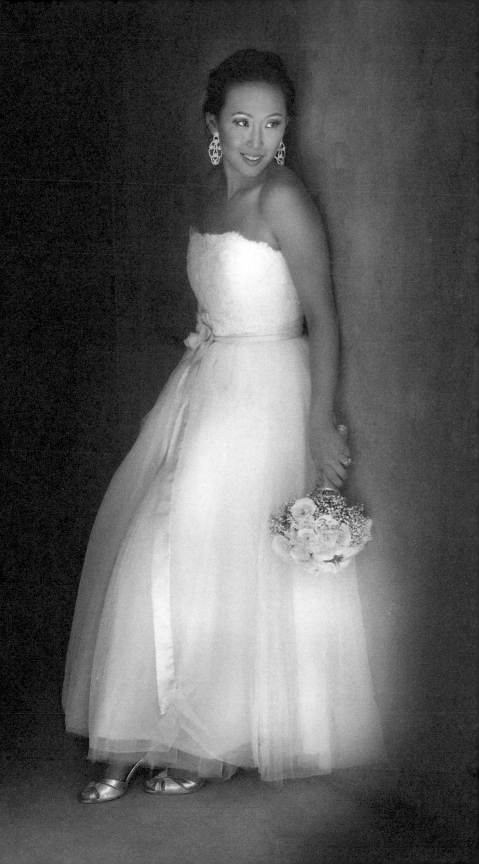

POSITIONED THIS BRIDE (near right) in a dark underpass and radically underexposed the image (1/250 of a second at f/4.8 and ISO 100). My idea was to make sure that the background details in the tunnel—graffiti, dirt, and rubble—went almost completely black. In multi-RAW processing the image, I lightened the areas where the bride appeared so I could capture her luminous dress and happy face.

EVEN WITH CAREFUL CONTROL of studio lighting (far right), this model's cheeks and chin were somewhat over-exposed, and the beautiful eyes, deep within the mask, were too dark. I used ACR and Photoshop's exposure compensation capabilities to bring back some of the detail in the cheeks and chin.

The eyes were a more significant issue because without this detail, the photo would have lost most of its interest. So I worked hard to layer in a significantly brighter version, zooming in on the eyes as I worked to be sure that I left the black lace mask on her face as dark as possible.

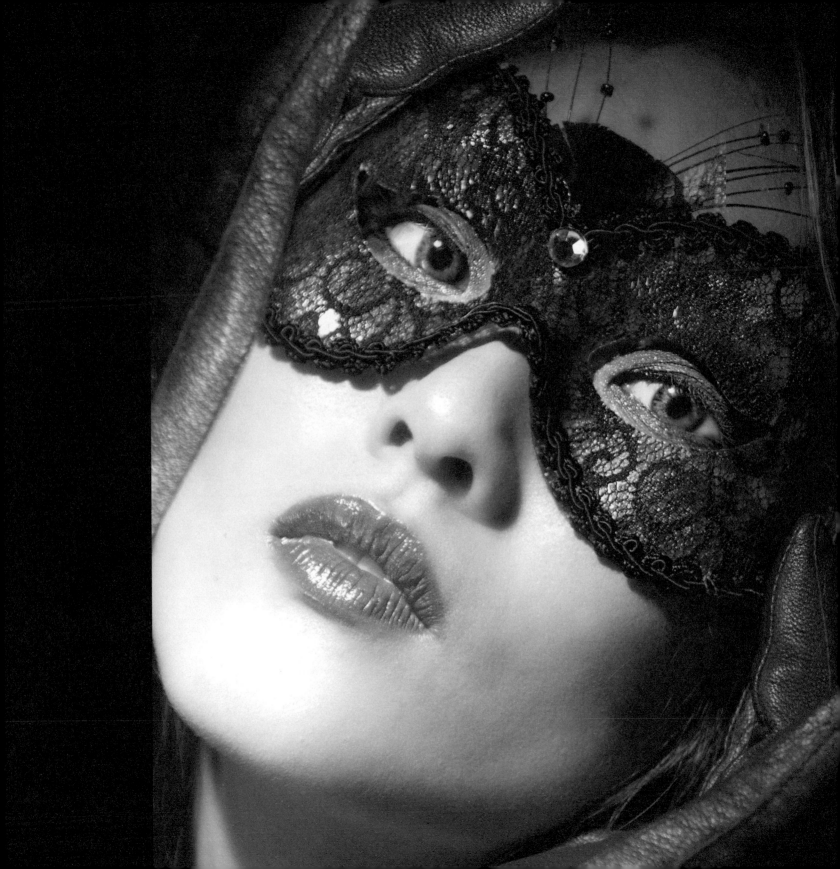

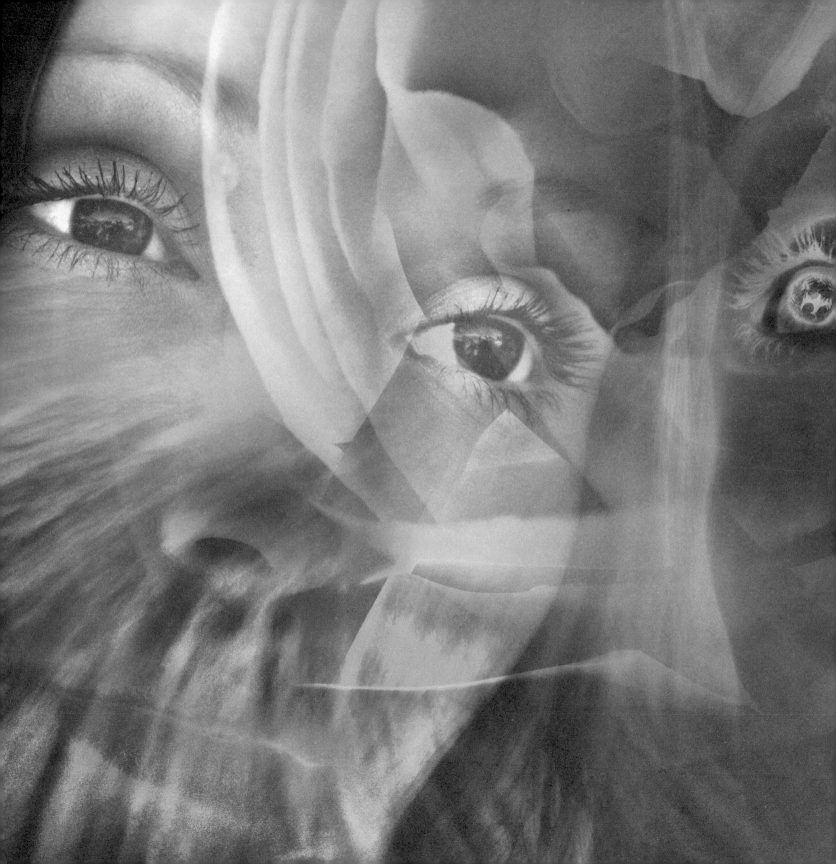

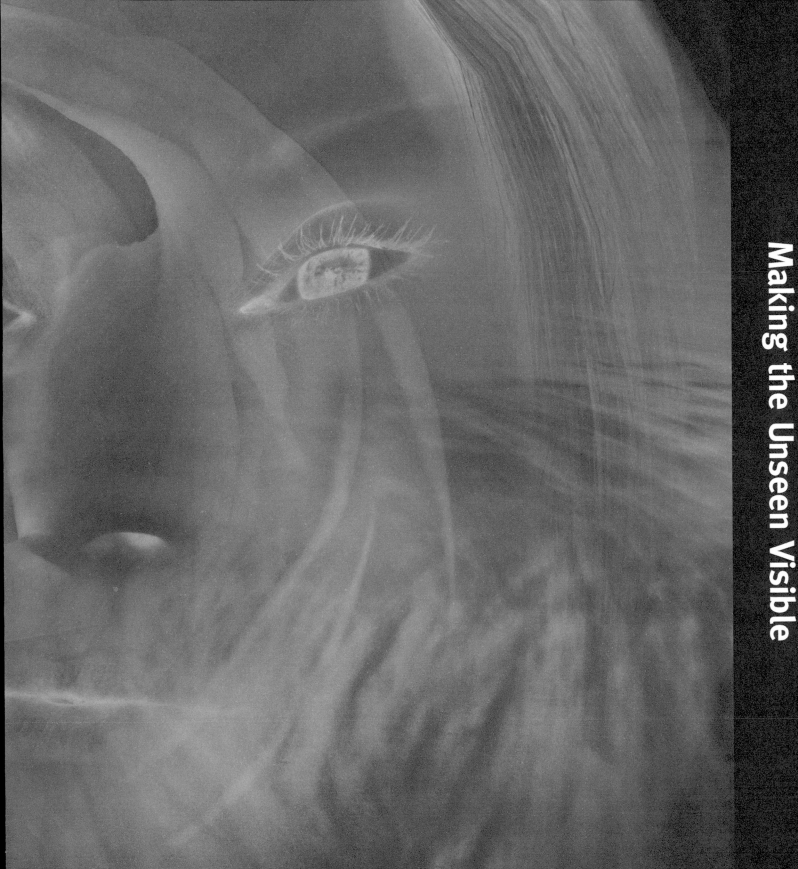

Making the Unseen Visible

"ARTS & CRAFTS" PROJECT:

Photographing Flowers in Water

The Goal: You want to photograph a flower straight down without squashing or misshaping the flower.

PROBLEM

1) If you put the flower in a vase and look down at it, the flower will probably be at the wrong angle. Also, you won't have a neutral background—you'll be able to see the vase, the table, etc.

2) If you place the flower with the stem intact on a neutral background such as black seamless paper, then the flower will angle this way and that way, and will never be at the correct angle for a full-on downward view.

In my first attempt to deal with this problem, I cut the stem off of the blossom and then tried to place the blossom directly on a black background. It wiggled. It wobbled. It wouldn't stay in place. Hours of experimenting with pins, museum gel, and other sticky mediums convinced me that there had to be a better way. Aha, water!

SOLUTION

Float flowers in water! How simple can you get??!!

1) Cut the stem off a blossom, making sure not to damage the flower.

2) Fill a pan, bowl, or other container with water. A black plastic pan works really well.

3) Gently place the flower on the water in the container. Voilà! The flower floats with its "face" straight up—perfect for a full-on shot.

These Lenten roses were photographed in a square cake pan, floating on water. I took a black 3-ring binder and cut off the plastic cover. Then I cut it to exactly fit the bottom of the pan

The solution: photographing blossoms in a tray of water

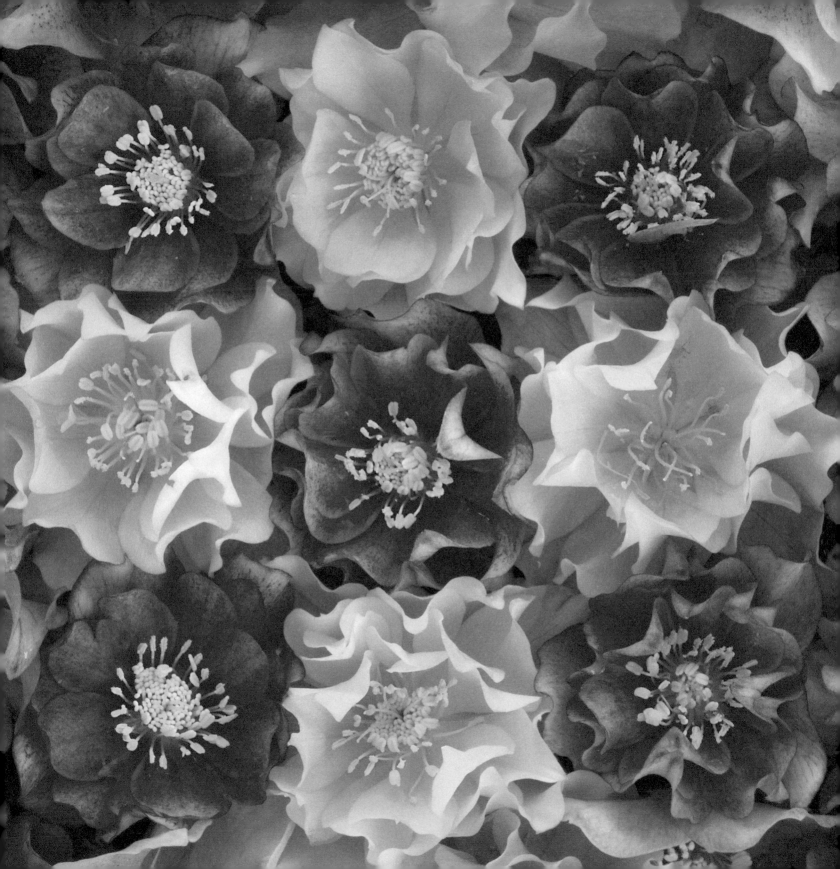

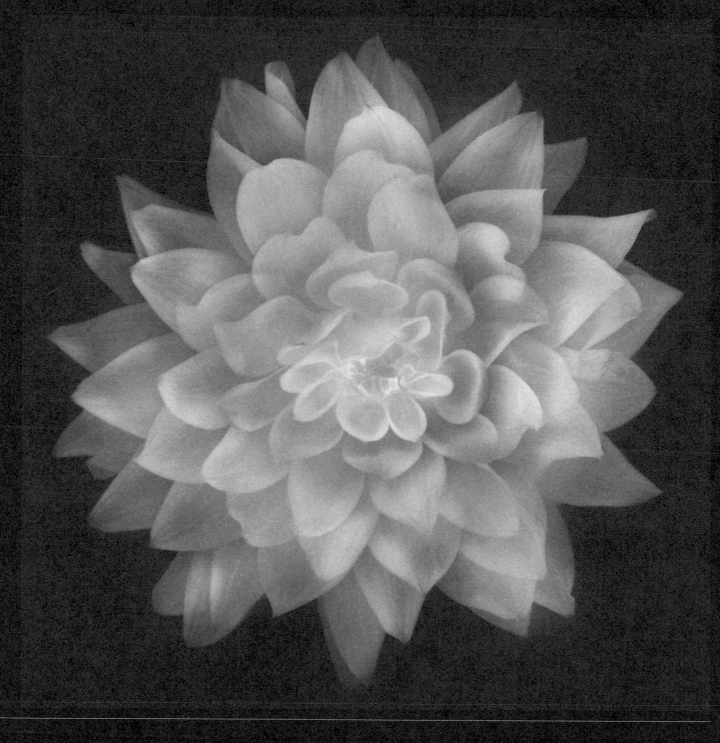

I PHOTOGRAPHED THE DAHLIA above floating in about an inch of water in a bowl with a dark interior. The original version of the flower was processed to present a very dark, neutral background. I then left the flower in the bowl with the water and waited a few days. As the flower aged and fell apart, the water evaporated a bit. I photographed flower and bowl again. This time, I processed the photo to show the flower in context: floating in a bowl of water on a rough plank of wood as shown to the right.

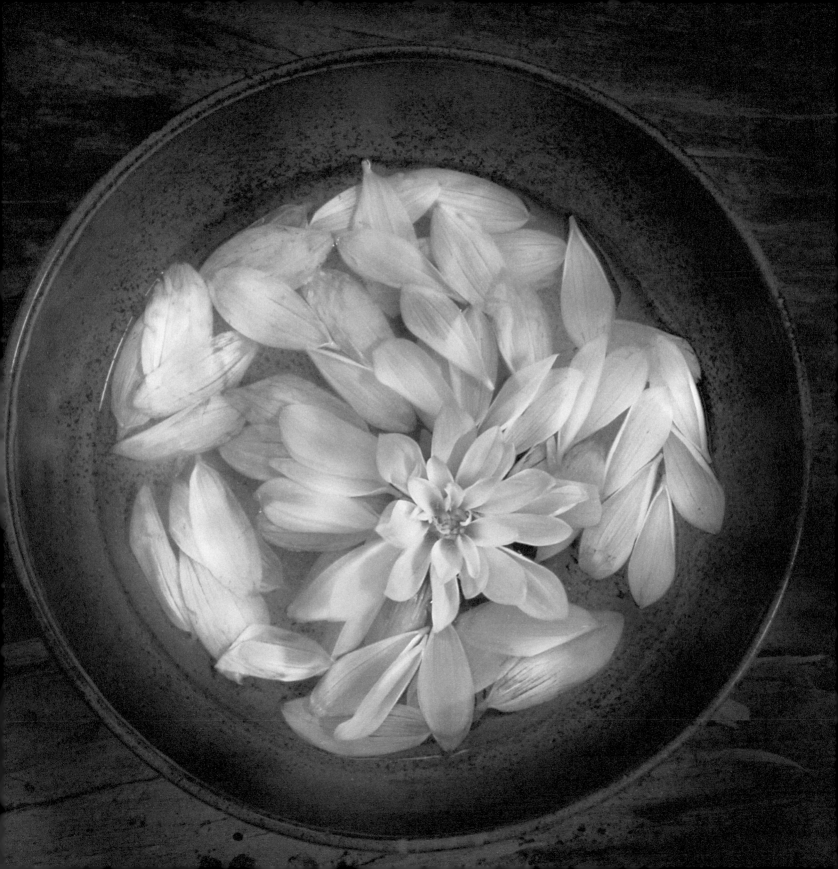

›› Photographing on a lightbox

Light and a spray bottle

I often get asked how I create my transparent images of flowers and petals. These are high-key images, meaning that they appear over-exposed in relation to a "proper" exposure. You can see this relationship if you looked at an exposure histogram. For a high-key image, the histogram would be bunched over to the right side (meaning overexposure) in every one of my transparent flower images. (For more about histograms, take a look at PD1 on pages 56–57.)

Creating these images involves both photographic technique and work in Photoshop. To start with, I place a flower on a lightbox as shown below. This kind of lightbox is pretty inexpensive. You can buy it at most art or photo supply stores or on the internet. Sometimes I increase the transparency of the flower by gently spraying it with water. Occasionally, I also place a 1/2" thick piece of plate glass carefully over the flower to press it flat. I then remove the glass before photography.

With the flower on the lightbox, I place the camera on a tripod, firmly locking it in place so there will be no camera motion. I use a macro lens with the aperture stopped down to between f/11 and f/64 (depending upon the situation) so that the entire flower is in focus.

Using manual exposure mode, I then make five or six captures without moving the camera. The captures are bracketed with only the shutter speed varying. The darkest capture is typically about what the camera's light meter says is the "correct" exposure. With each successive capture, I set the shutter speed to twice as long as the previous exposure (for instance, 1 second and then 2 seconds).

The next step is to put the bracketed captures together using ACR and Photoshop in a Hand-HDR process. (See pages 108–121.) I start with the lightest, longest-exposed version for a completely white background and layer darker versions on top until I achieve the desired transparent effect.

How I photographed this poppy

1. I took six captures using a 50mm macro lens with each exposure set to f/32 at ISO 640. The shutter speeds ranged from 0.8 to 1/25 of a second.

2. In ACR, I started by converting the lightest exposure (the one at 0.8 of a second). This exposure was mostly white and was processed for the background.

3. Next, I processed the successively darker captures in ACR and added them as separate layers, blending them in by painting on layer masks in Photoshop. I worked to get the details of the flower petals while still keeping the transparent effect.

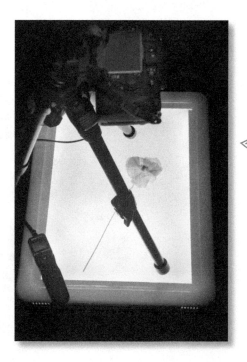

I photographed this poppy from my garden on a lightbox using the setup shown here

To render an image that folks will perceive as "true white," you need to use a rear projected white background that is brighter than a typical piece of white paper illuminated using reflected light

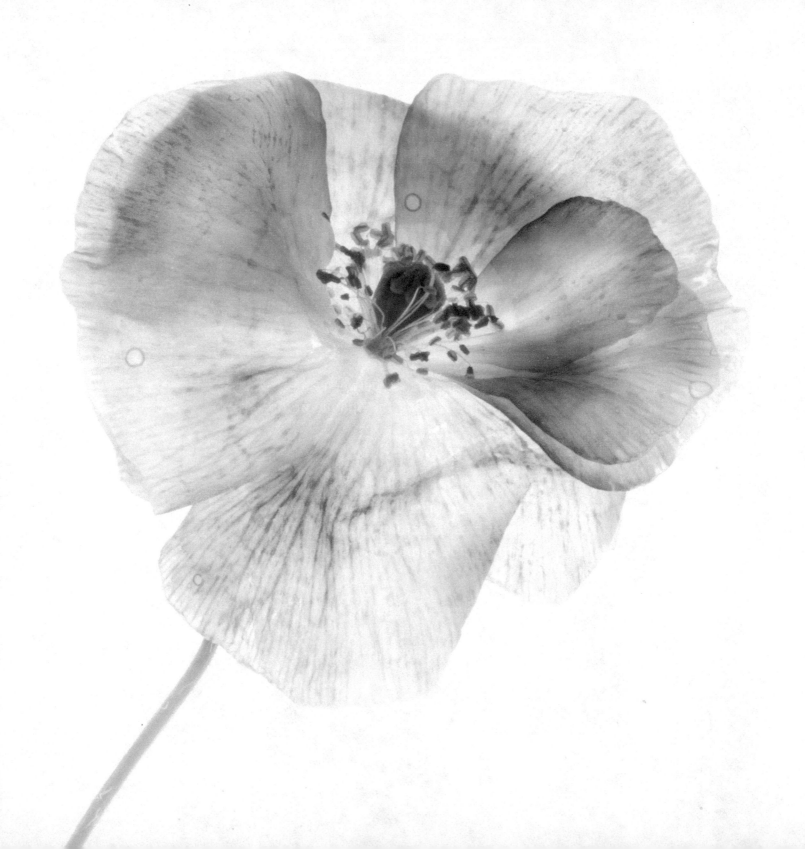

›› Hand-HDR Imaging for Transparency

ONE OF THE MOST beautiful things about many species of flowers is the transparency of their petals. But this transparency is surprisingly difficult to capture. It's a transient beauty that requires backlighting and that cannot be rendered without work in the Photoshop darkroom.

THE CHALLENGE: To capture the full dynamic range between an extremely white background, transparent flower petals, and the opaque portions of the flowers such as stems and stamens.

THE SOLUTION: Shoot the flower on a lightbox for backlighting. None of the exposures should be very dark. Combine the mulitple exposures in Photoshop using layers and layer masks, starting with the lightest exposure. This is an example of the hand approach to HDR imaging.

YOU SHOULD: Bracket using shutter speed, not aperture. Plan to have the darkest exposure be about what your camera thinks is the "correct" exposure. Start your layer stack in Photoshop with the lightest exposure to get a very white background.

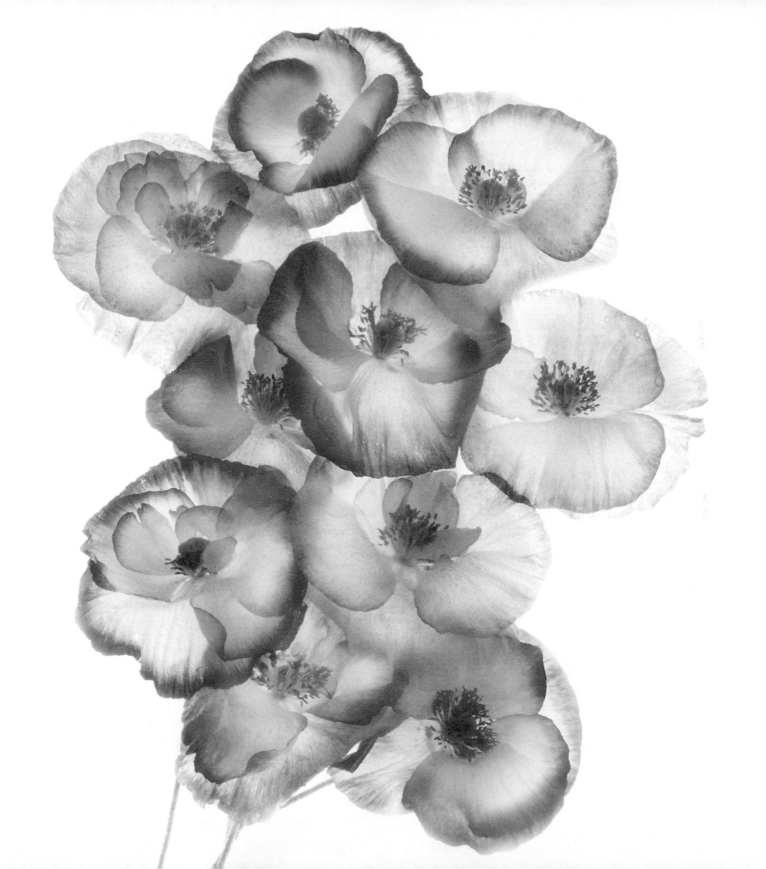

›› Creating a transparent poppy medley

Combining exposures

I shoot a wide range of exposures in order to create a transparent effect using Hand-HDR. Often this exposure range is as much as 30 or 40 times from the longest exposure to the shortest exposure. Note that shutter speed should be varied rather than the aperture so that there are no depth-of-field changes between the captures.

I normally make my first exposure at about the settings that my camera's light meter tell me are about "correct." From there, I go lighter by a factor of two or three for each subsequent capture. For example, if I made my first, darkest exposure at 1 second, I would make my next exposure at 2.5 seconds. Often, as in the case study example here, I don't even use the darker exposures—I take them anyhow just in case I need them later.

The process in Photoshop starts with the lightest capture. This is used to create a very white background. In this capture you probably hardly see the flowers—that's the idea!

Next, I layer the details of the flower on top using successively darker captures, taking care not to make any portion of the flower too dark. I use layer masks and hand painting to get the mix of flower petal opacity the way I want it.

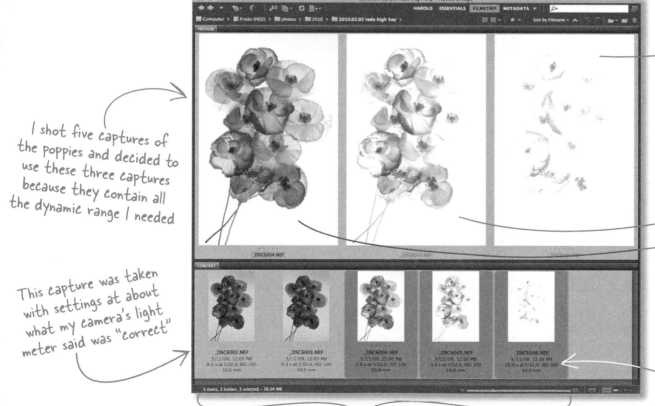

I shot five captures of the poppies and decided to use these three captures because they contain all the dynamic range I needed

This capture was taken with settings at about what my camera's light meter said was "correct"

You can read the camera settings from the meta data here

Photos taken at shutter speeds ranging from 1/3 of a second to 10 seconds

This capture is used for the white background

Use manual exposure settings to bracket because in-camera bracket programs do not give enough exposure range for this technique. Keep the aperture the same but vary the shutter speeds.

Shutter speed: 10 seconds

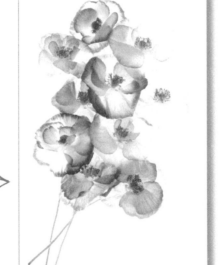

This capture is used for the overall look of the flowers

Shutter speed: 3 seconds

 Harold sez All photos were taken at f/32 for maximum depth-of-field.

If the camera is positioned directly above the center of flattened flowers, then you don't need all this depth-of-field—but usually the camera is positioned at an angle, and the flowers do themselves have depth, so you need to use a small aperture.

Shutter speed: 1 second

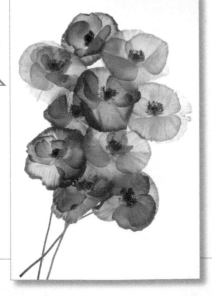

This capture looks pretty good, but if I just used it to make my final image, the white background wouldn't seem really white and I would lose transparency. So I used this version to add opaque areas such as the flower centers, petal edges, and stems.

›› Converting the RAW images

Using ACR or Lightroom

You can open these images in either ACR or Lightroom. Make sure you accept the "As Shot" defaults and don't change the settings. If you start playing with the sliders in ACR, the white background will become tinted.

If you are working in ACR, open the images as copies by holding down the Alt key and then clicking Open Copies (for more about this turn to page 23 in PD1). Each capture will open in its own image window in Photoshop.

If you are working in Lightroom, you can open all three layers as a layer stack in Photoshop by selecting Photo ► Edit In ► Open as Layers in Photoshop (see pages 16–19 for more details).

For a detailed discussion about histograms and what they mean, take a look at PD1 pages 19 and 56–57

Click here to select all three images and apply the same settings to each one as they are processed

For this case study, I'm going to process the poppy captures in ACR

Take a look at the histogram. It's bunched up on the right which indicates "overexposure." I did this on purpose!

Here are the three images I decided to use

Hold down the Alt key and the Open Objects button changes to Open Copy

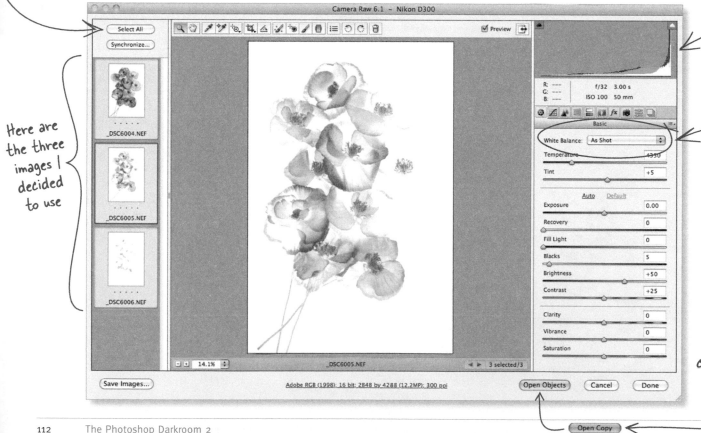

BACKGROUND

This photo will be used for its super-bright white background. Even though it looks totally blown-out, it will make a great base for this transparent image

Automated HDR vs. Hand-HDR for Transparency

Automated HDR software such as Photomatix and Photoshop Merge to HDR Pro has its place. For instance, I used Photomatix to create the high-dynamic range forest image shown on pages 124–125.

However, automated HDR software doesn't give results that work for the kind of transparent image shown in this case study. The problem is that these programs are not telepathic. They can't read your mind and they don't know the artistic effect that you want to achieve. Essentially, automated HDR programs are sophisticated pixel-combiners that allow you to do some tweaking after the fact.

The transparent effect created in this example is subtle and a "one-off" that cannot be generated by any existing automated process.

FLOWERS

This capture will be layered on top of the super-white background and will be used to create the overall look of the poppies

To create a transparent effect, I make sure that the White Balance drop-down box is set to "As Shot." (This assumes that the images were shot with the camera set to "auto white balance.") Any other setting risks tinting the white background.

DETAILS

This photo will be layered on top of the other two images and will be used to add details and vibrant color to the flowers

Next Steps

Combine the three captures using layers, layer masks, and painting (pages 118–121).

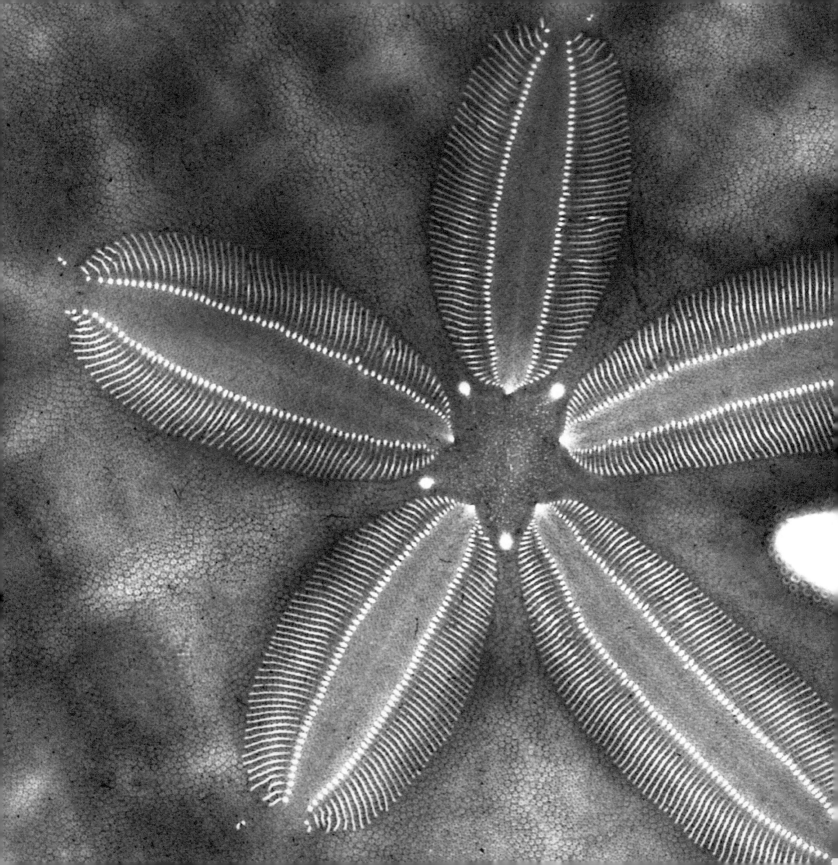

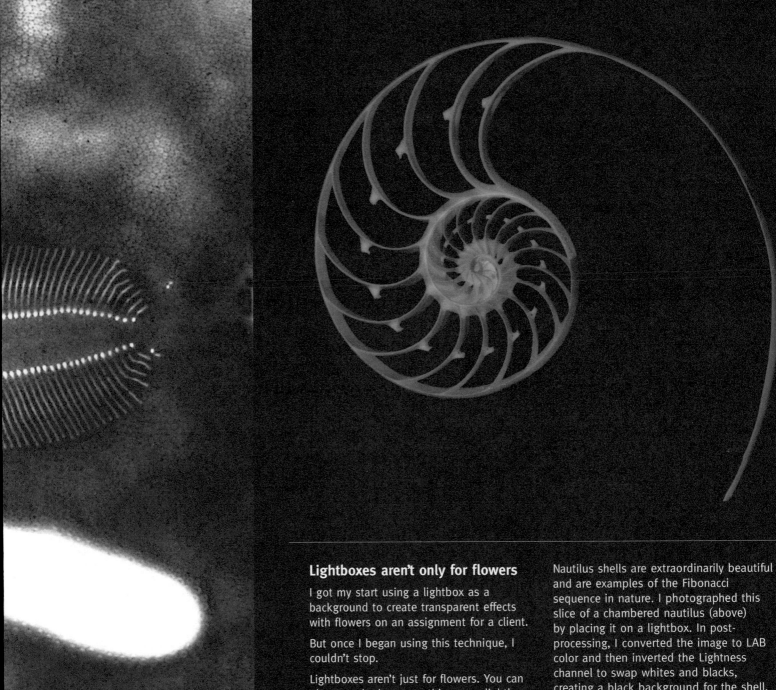

Lightboxes aren't only for flowers

I got my start using a lightbox as a background to create transparent effects with flowers on an assignment for a client.

But once I began using this technique, I couldn't stop.

Lightboxes aren't just for flowers. You can

Nautilus shells are extraordinarily beautiful and are examples of the Fibonacci sequence in nature. I photographed this slice of a chambered nautilus (above) by placing it on a lightbox. In post-processing, I converted the image to LAB color and then inverted the Lightness channel to swap whites and blacks, creating a black background for the shell.

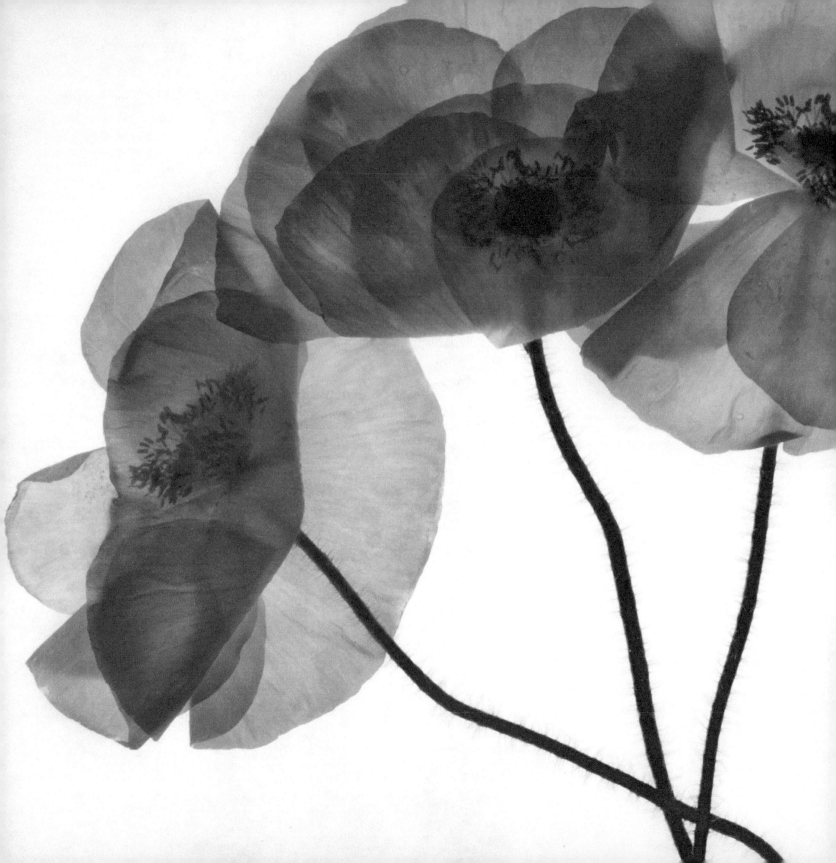

Variations and Inversions

I photographed these Dawn Chorus poppies (Papaver rhoeas) using the lightbox technique explained on pages 106–111. This photo and its variations have become among my most widely licensed images. However, I had no idea this would be the case when I made the photo. I just wanted to create simple, sumptuous flower imagery that was unusual because of its transparency.

One variation of the original photo presents the poppies on a black background. To create this black background, I converted the image to LAB color and then inverted the Lightness channel. This inversion swapped the white and black information in the image, making the white background black. The inversion also swapped color values in the poppies' cores changing the predominantly dark tones of the pistils and stamens to much lighter colors. (For more details about LAB color, see page 46 and PD1 pages 151–161.)

Overall, both variations of this image are interesting. Being able to invert a transparent image on a white background and present it on black gives me a "twofer": I get two beautiful images out of one original set of captures.

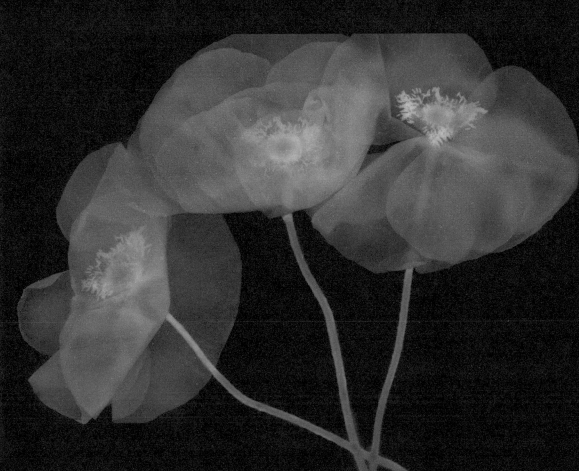

›› Combining layers for transparency

Starting with the lightest layer

It's essential for the transparent effect that you start with the lightest layer. This layer doesn't look like much! In fact, it looks pretty white—which it's supposed to—with a couple of dashes of light color areas. If you just saw this layer by itself, you probably wouldn't even recognize the flowers.

Even so, this enigmatic layer is the key to creating transparency. Once you have made the lightest layer the "Background" layer, you can add darker versions as needed to render the flowers using layer masks. This ensures that the transparency and white background are maintained.

If you processed the three captures in Lightroom and used the Open As Layers menu command as described on page 112, then you already have a layer stack in Photoshop. What you need to do is rename the layers as directed in Steps 1 & 2 and then continue on in Step 3 with the layer mask and painting

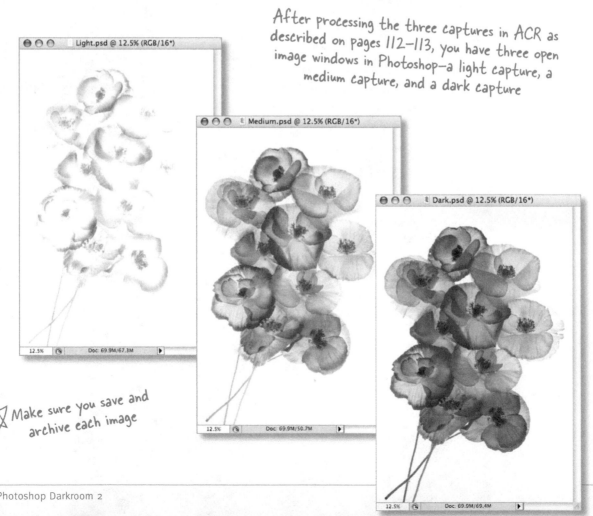

After processing the three captures in ACR as described on pages 112–113, you have three open image windows in Photoshop—a light capture, a medium capture, and a dark capture

Make sure you save and archive each image

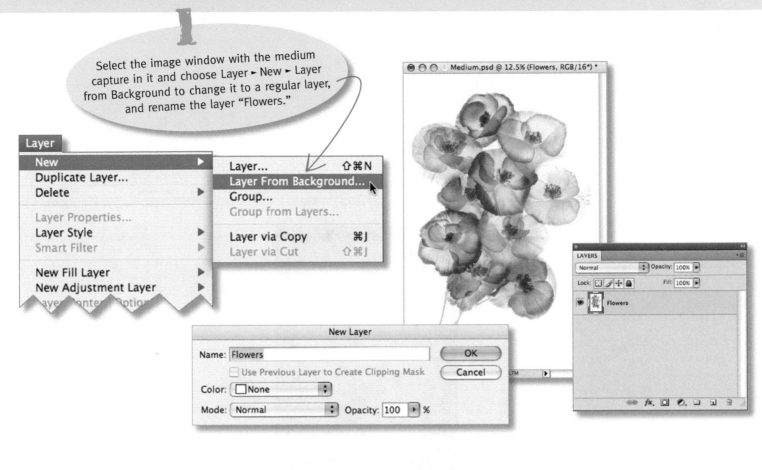

Select the image window with the medium capture in it and choose Layer ▸ New ▸ Layer from Background to change it to a regular layer, and rename the layer "Flowers."

Medium.psd @ 12.5% (Flowers, RGB/16*) *

Layer

New	▸	Layer... ⇧⌘N
Duplicate Layer...		Layer From Background...
Delete	▸	Group...
		Group from Layers...
Layer Properties...		
Layer Style	▸	Layer via Copy ⌘J
Smart Filter	▸	Layer via Cut ⇧⌘J
New Fill Layer	▸	
New Adjustment Layer	▸	

New Layer

Name: Flowers

☐ Use Previous Layer to Create Clipping Mask

Color: ☐ None

Mode: Normal Opacity: 100 %

OK Cancel

LAYERS

Normal Opacity: 100%

Lock: ☐ ✎ ✛ 🔒 Fill: 100%

👁 Flowers

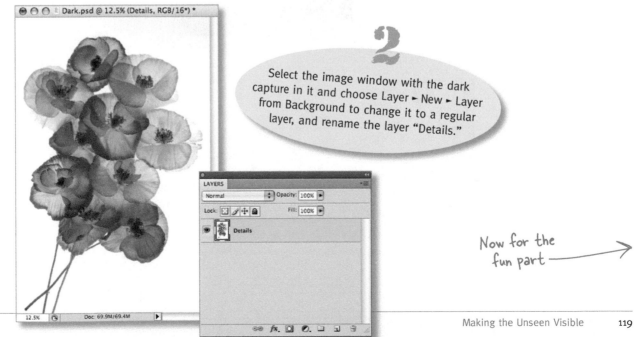

Dark.psd @ 12.5% (Details, RGB/16*) *

Select the image window with the dark capture in it and choose Layer ▸ New ▸ Layer from Background to change it to a regular layer, and rename the layer "Details."

LAYERS

Normal Opacity: 100%

Lock: ☐ ✎ ✛ 🔒 Fill: 100%

👁 Details

12.5% Doc: 69.9M/69.4M

Now for the
fun part ⟶

3 Select the Move Tool from the Toolbox, hold down the Shift key and drag the medium "Flowers" layer onto the window containing the light capture. Add a black Hide All layer mask to the "Flowers" layer and paint in the flowers, being careful not to paint on the white background area.

For more about setting up the Brush Tool and using it to paint on a layer mask, turn to pages 23–24

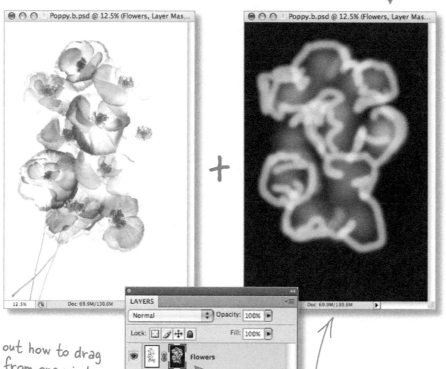

To find out how to drag an image from one window to another, take a look at Step 4 on page 47

The steps for adding a Hide All layer mask are on page 22

Notice the different brush strokes on the layer mask. The larger "puffs" are quite light and soft (Opacity and Flow settings of 15% and a Hardness setting of 0%). These puffs are located at the center of the flowers. Other strokes are smaller, whiter, and have harder edges (Opacity and Flow both at 45% and Hardness at 50%). These bolder strokes follow the edges of the poppy petals

4

Click the image window containing the dark "Details" capture, and then select the Move Tool, hold down the Shift key, and drag the dark "Details" layer onto the composite photo. Add a black Hide All layer mask to the "Flowers" layer and paint in the flower details, including the centers and vibrant colors.

Finished Transparent Image

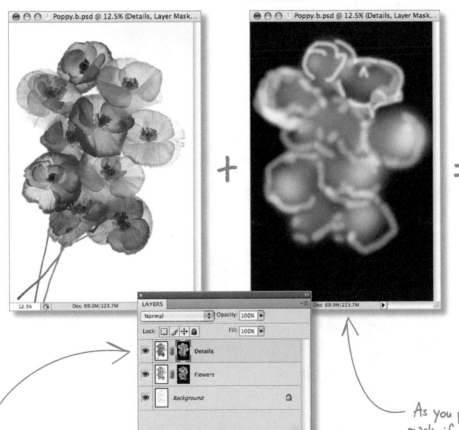

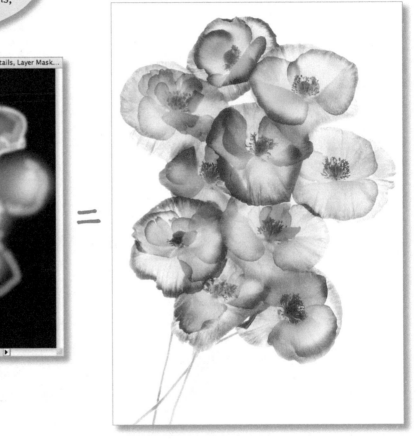

As you paint on the "Details" layer mask, if you think the colors are too bright, you can always tone it down by lowering the layer's Opacity setting

If you don't think you are getting the dark saturated colors you want as you paint on the layer mask, you could duplicate the "Details" layer, change the blending mode of the new duplicate layer to Multiply, add a new black Hide All layer mask, and then paint in more color

Using HDR to Create Complex Imagery

I've shown you how to use Hand-HDR to create a transparent effect of a flower with light coming through it. The fact is that I use Hand-HDR more than Merge to HDR in Photoshop or third-party HDR products because I appreciate a natural HDR look, and because I like to keep full control of how my images are processed.

Sometimes subject matter with extremely complex patterns of light and dark is best tackled using HDR software. For instance, I was driving along and came across this forest scene. It was towards the late afternoon of a bright overcast day. The forest floor was very dark, but the top of the hillside was very bright.

I wanted to create an image that showed detail both in the forest floor and higher up the hillside. To achieve this goal, I placed my camera on a tripod and shot five exposures, bracketing the shutter speed on each by about two f-stops. Between the five exposures, I captured a truly extended dynamic range.

To process the image, I loaded the RAW files into Photomatix. Photomatix is a stand-alone program designed for processing HDR images. (You can download a trial version from www.hdrsoft.com and play with it yourself.) After processing the files in Photomatix, I loaded the newly combined HDR image into Photoshop and used some of the original RAW captures to layer in details.

I added additional effects by selectively layering in a monochromatic version of the image. Also, I used Mystical Lighting from AutoFX Software to exaggerate the existing lighting effects.

This is an image that would be impossible to create without HDR technology. In a single shot a camera cannot render the level of detail shown on the forest floor while capturing the brighter areas of the image. The image works in much the way a painting might—this is a magical scene showing forest light and you can just imagine fairies dancing along the forest paths.

Revealing Details at Night

Photographing by moonlight on the glorious beach at Pfeiffer Big Sur State Park in California, I was chastened by an exposure problem inherent in photography. The moon, setting behind the offshore sea stack, was an order of magnitude brighter than the dark foreground.

I knew that I could not expect to capture detail in the moon itself, however I did want to show the stars in the sky as well as the comparatively dark surf in the moon shadow cast by the sea stack. So I exposed the image for the sky at 2 minutes, f/5 and ISO 200.

Naturally, when I looked at the image on my computer, the foreground was very dark. To correct this problem, I used multi-RAW processing to create two versions of the image. One version was exposed for the moon. The other version was exposed for the surf—I lightened the foreground using the Exposure slider. I then copied the lighter version over the darker version and combined them using a layer mask and gradient. (This technique is explained in detail in PD1 on pages 30–39.)

Blending in the Moon

It took a bit of planning, timing—and yes luck!—to be positioned at the right time and place with a long telephoto lens (400mm). I was standing on Battery Yates in Fort Baker on the Sausalito, California side of the Golden Gate straits. Across the water, the full moon was rising over the San Francisco skyline with the Transamerica tower neatly framed in the center of the composition.

However, it quickly became apparent that a single exposure could not possibly render detail in both the skyline and the far brighter moon. So I made two exposures—one of the moon at 1/30 of a second at f/5.6 and ISO 400, and one of the skyline at 1/2 of a second at f/5.6 and ISO 400. Doing the math, according to these exposures, the moon was 15 times brighter than the cityscape.

In the Photoshop darkroom, I combined the two exposures using layers and a layer mask to blend in the moon.

Faking star trails

All current editions of Photoshop ship with an action that simulates the motion of stars at night. The theoretical good news here is that you can add the effect of stars in motion to your photos without putting in those long, cold, (possibly) boring hours making untold numbers of captures of the stars wheeling in the heavens.

The could-be-good-could-be-bad news is that the simulation created by the Photoshop action is imperfect. Essentially, the action curves the stars around the center of the photo. This would only be accurate if you were using a perfectly rectilinear lens pointed at celestial north or south. As a practical matter, the fake star trails look reasonably good if the north star is included somewhere near the center of your composition—although the fake star trails themselves do not look exactly like the real thing if you look closely enough. Many times, they have a jagged, thick look.

The bad news is that you don't get to spend countless hours watching the magnificent stars in their cosmic dance across the heavens.

But I digress.

The final question: Is it better to spend hours relaxing under the stars with your sweetie while your camera takes photos with an interval timer, and then stacking them into a "real deal" star trail composite? (See pages 132–133.) Or to spend time in the Photoshop darkroom creating a "fake" star trail image? You decide. I know which one I prefer: I love the Photoshop darkroom, but in this particular ballet with reality, I'll take the real deal.

1 Start with an image that points north. You can tell the image to the right is pointing north because it shows both the Big Dipper and Polaris.

2 Choose Window ▸ Actions to open the Actions palette.

3 Click the tiny arrow to the right of the Action tab at the top of the palette and select Star Trails from the Action palette menu.

You need to add the Star Trails action to the palette because it is not loaded in by default

4 Click the tiny arrow to the left of the Star Trails folder icon to open the Star Trails action group and select "Star Trails Rotation."

5 Click the Play button.

When the action is finished, you will have an image with curved star trails including some in places you don't want (on land or through trees, for instance). So in this image, I had to use a layer, layer mask, and gradient to replace the boat and remove the star trails from where I didn't want them

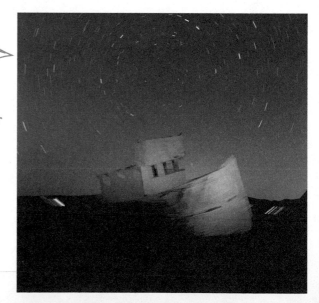

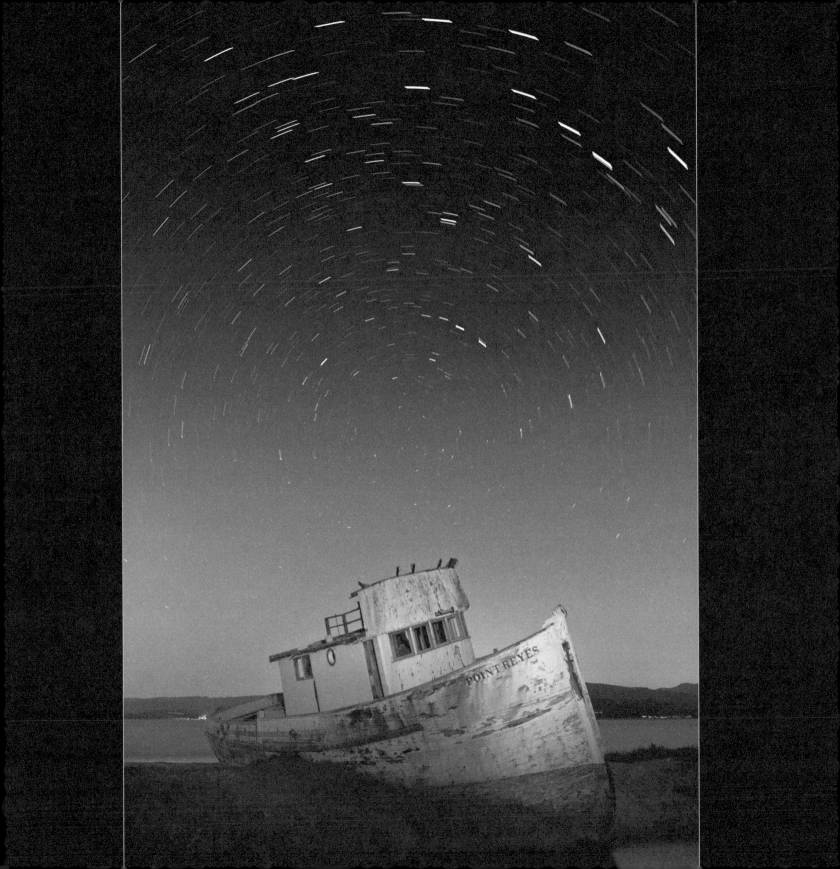

Stacking Star Trails—The Real Deal

To create this composite stack of star trails, I shot 40 images, each image a 4 minute exposure at f/3.5 and ISO 200. I combined the RAW images using the Photoshop Statistics action with the Mode set to Maximum. The Statistics action ships with the Extended Edition of Photoshop CS3 and later. You'll find detailed directions for how to use it in PD1 on pages 134–143.

The foreground of the stack was way too dark after the Statistics action finished. So I layered in a special version of the foreground that I had shot at 8 minutes rather than 4 minutes with this purpose in mind.

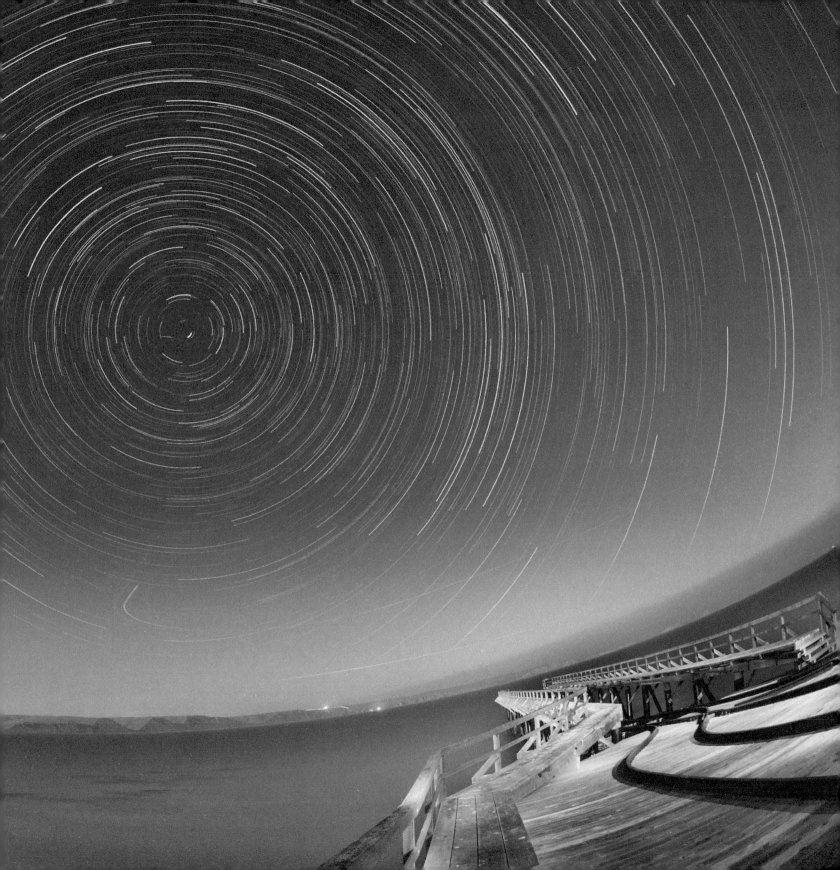

ONWARD & UPWARD

Beyond Reality

Using multiple captures and layers to create a transparent flower image is a matter of "improving" the beauty of our world. But what about taking things a step further? Suppose you want to use photography and the Photoshop darkroom to create worlds of your own? The techniques used for capturing and modifying the transparent flower image (pages 106–113 and 118–121) can be used to create entirely new worlds.

In folk tales and mythology, shadows have a special place. When Peter Pan loses his shadow, he has effectively lost his soul. Shadows can represent the dark side that is inherent within all of us. A shadow is a potent symbol for the magic that can lurk within everyday objects. The case study that starts on page 136 uses a marble and its shadow as a magical link to another world.

I worked hard with the very simple studio lighting setup shown on page 138 to create photos of marbles and their shadows. The photos were interesting in and of themselves. But when I looked at them in Adobe Bridge, I decided that the shadows of these marbles would be ideal for the insertion of otherworldly elements.

Part of the trick in compositing into a shadow is to make sure that the natural contours of the shadow match the shape of what you want to insert. For example,

when photographing the blue marble used in the case study, I noticed a whitish flaw in the marble's glass. This flaw casts a "flare" in the shadow. It's important that this flare works well with the inserted content around it.

The first part of this book, *A Ballet with Reality* (pages 8–97), is concerned with gently improving the appearance of things that are "real" by removing flaws and enhancing what is actually there.

This second part, *Making the Unseen Visible* (pages 98–149), takes the ballet with reality one step further—for example, by revealing the transparency inherent in flowers or by showing the circles that stars make over time.

The final part of this book, *Building the Impossible* (pages 150–201), is about creating inherently unreal images by compositing photographs in the Photoshop darkroom.

So in a sense the case study starting on page 136, which inserts a seascape in a marble's shadow, is a bridge between revealing something that is unseen and building a new world. The marble and its shadow are real, although most people wouldn't normally look at them as something special. Combining the shadow with a seascape takes you well on the road to building something that is not possible—but is still plausible.

Collecting Pieces for Photo Compositing

I'm often asked where my ideas for creating alternative worlds and compositions made up of multiple photos come from. There are three approaches that I use. First, it makes sense to look at work that artists have done in this genre. I particularly suggest checking out the surrealist painters, including Salvador Dali and René Magritte. The etchings of M. C. Escher are always an inspiration, as are the photographs of Jerry Uelsmann and Man Ray. I'll bet that if you look at the work of these artists, you will come up with many ideas for new photo collages.

The second thing that I do is to collect bits and pieces that I might use as part of a photo composite at some future time. When I have a photo that I've taken that I think might be useful as part of a composite, I make a copy of the photo. I then save it in a folder with other bits that I think might work with it. I try to group these archives roughly by subject matter. For example, I have a folder that I just use for elements that I suspect may come into play in architectural composites.

Often, it takes me a long time to actually see how the elements that I've collected will come together to make an interesting photo composite.

My final approach when building new worlds is to start with a concept or story to illustrate. Sometimes this is client-driven. Other times, it is a self-assignment that can be quite simple. For instance, to illustrate the concept of infinity or to mimic a work of art by a surrealist painter, such as my homage to René Magritte's *The Wrestler's Tomb* shown to the right. Yes, I know, it's an odd title for a flower in a small room—but Magritte chose apparently irrelevant titles on purpose just, he said, to make people think.

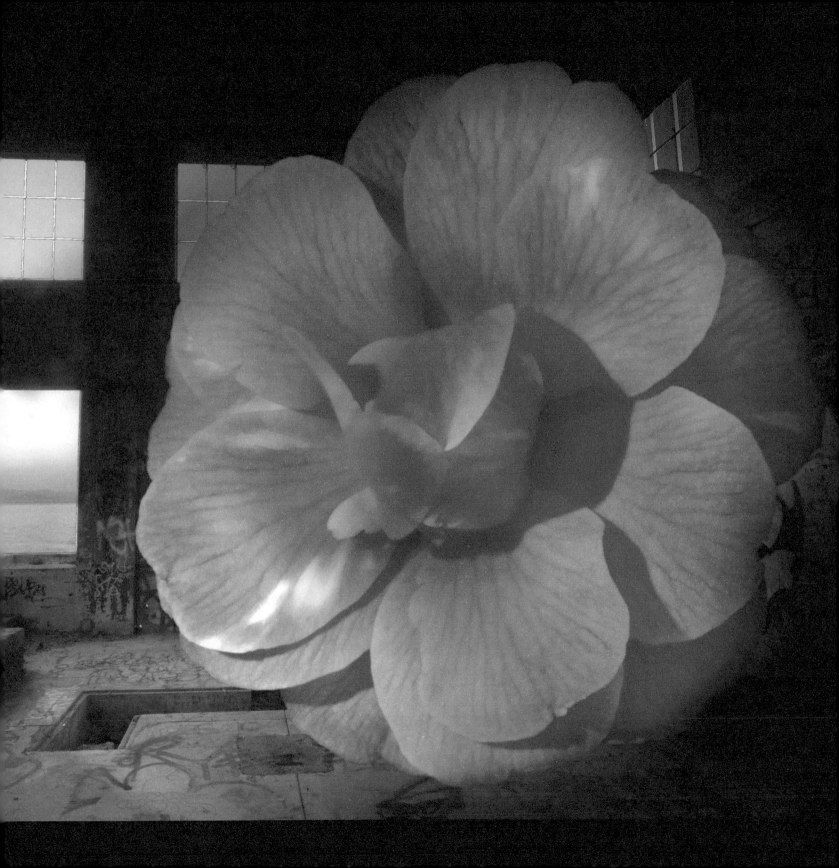

›› Photo Compositing to Create a World in a Shadow

PHOTO COMPOSITING MEANS TO blend multiple images together to create a new image. While compositing was possible in the film darkroom—witness the virtuoso feats of Man Ray and Jerry Uelsmann—seamless combination of images is possible in Photoshop with an ease that would not have been imaginable in the past. I believe that the opportunity presented by the relative simplicity of photo compositing in the Photoshop darkroom opens the door to a new field of creative endeavor.

THE CONCEPT: I've often thought that shadows contain entirely separate worlds from the objects creating the shadow. When a shadow has a life of its own that is distinct from the object, then the effect is magical. This is most interesting to me when there's a difference in scale between the shadow and the world within it—for example, an entire landscape or seascape in a small shadow.

MAKING THE CONCEPT A "REALITY": Cast a shadow through a small translucent marble and photograph it and its shadow. Then, use the Photoshop darkroom to put an image of pounding surf into the marble's small shadow.

TOOLS AND TECHNIQUES: Photographing the marble and its shadow for this use requires some finesse—you have to generate the right kind of shadow and photograph it using a macro lens. Combining the marble's shadow with the seascape in the Photoshop darkroom means—once again—using layers, layer masks, and painting.

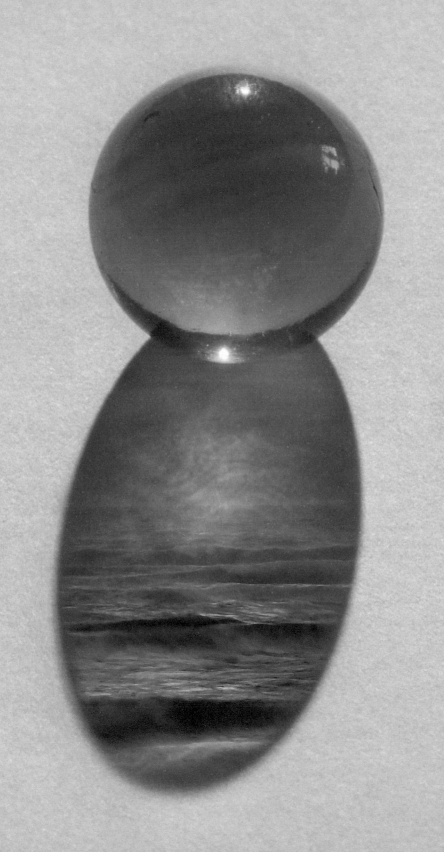

>> Photographing to create the shadow

Setting up the photo

Photographing small objects and their shadows doesn't have to be difficult. You need a strong, non-diffuse light source that you can easily direct. I used a Lowell tungsten light equipped with barn doors, but you don't need professional lighting equipment to get this right.

I placed the marble on textured paper with the light source directly opposite the camera position as shown in the diagram below.

The camera position is crucial to getting this shot right. You need to angle the light down on the marble to create the shadow and also angle the camera down so both the shadow and the marble are in the frame.

It's easiest to get the camera position right with a telephoto macro lens so you don't have to position it too close to the marble. If the camera is too close to the marble it will pick up unattractive flaring from the light source.

You could use this lighting setup to photograph shadows made by other objects. The seed photo on page 147 uses this same setup.

Here's the setup for the marble macro shot

Strong direct light, not diffused

barn doors

Macro telephoto lens

shadow

table

marble on textured paper

camera on tripod

I shot a lot of different marbles using this lighting setup, bracketing exposures for each one. I made sure that I took a dark, medium, and light exposure of each marble setup so I would have the full dynamic range to work with once I got to my computer

These two marbles were shot with a 200mm telephoto macro lens with a 36mm extension tube for 1 and 2 seconds at f/36 and ISO 100. I processed them both in ACR and opened them as copies in Photoshop (see page 112)

The light meter in my camera said that this 1/2 second shot was the "correct" exposure. The capture was too dark for my purposes

I looked through all the marble/shadow photos and decided to work on the blue marble first. The shadow looked really interesting to me—as if there was already some kind of world waiting to be realized

» Creating a translucent marble and its shadow

Combining layers to extend exposure range

Hand-HDR strikes again! The overall exposure of the lighter marble capture is pretty good. The only things that need a little work are the color saturation of the marble and the color depth of the shadow. With the second, darker exposure, adjusting this is easy using a layer mask, and the Brush Tool.

Info about setting up the Brush Tool and using it to paint on a layer mask is on pages 23–24

1 Select the Move Tool from the Toolbox, hold down the Shift key and drag the "Medium" layer onto the window containing the "Light" layer.

2 Add a black Hide All layer mask to the "Medium" layer. Select the Brush Tool and set it to 0% Hardness and 20% Opacity. Gently paint in the marble and the area of the shadow farthest away from the marble.

The steps for adding a Hide All layer mask are on page 22

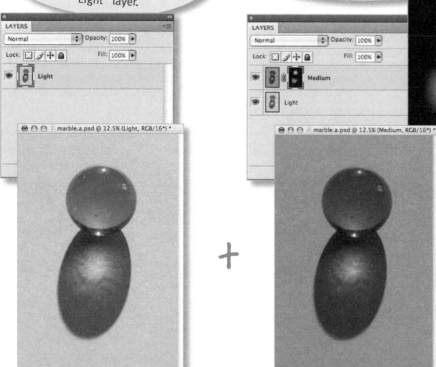

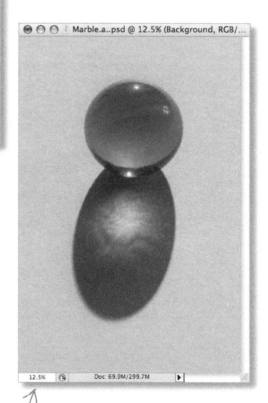

+ =

To find out how to drag an image from one window to another, take a look at Step 4 on page 47

The marble and shadow are now ready for compositing

›› Finding pieces of a new world

Thinking about content, color, shape, and scale

What kind of world should be in the marble shadow? For me, the blue color of the marble and its shadow spoke of the night sky and the sea. So looking through my image library, I tried to find captures that were bluish in tone and contained clouds and the sea. The two images below seemed to fit the bill.

When working with a composite like this, it is important to consider the color of the area where you want to insert something as well as the shape and scale. The fact that the marble photo is vertical and the two images that I chose for the composite are horizontal really didn't matter since only portions of the images were going to be used.

Remember that you have a powerful set of tools in Photoshop: you can rotate, resize, skew, and change perspective using the commands found in the Edit ▶ Transform menu. If you choose an image for compositing that doesn't have the right scale, it is easy to change it.

In this example, since the area of the marble shadow is small, the scaling that I did downsized the images that were composited into the shadow. Sometimes you need to upscale an image that is going to be composited— meaning make the image larger. If there is substantial upscaling involved, I use a couple of Photoshop plug-ins: SI Pro from Fred Miranda Software or Genuine Fractals from OnOne Software.

This is a view from Mount Tamalpais, California, after sunset

This is South Beach at Point Reyes National Seashore, California, on a winter day shortly after sunset

The clouds in this photo are going to be painted in with a layer and layer mask to create the sky in the marble shadow. You'll only use a very small portion of this image in the final composite

There are many photos of waves in my library. I decided to use this one because there's a good color match and the scale of the waves makes visual sense. The rolling blue surf in this capture will work really well when layered on top of the marble and painted in using a layer mask

›› Putting it all together

Inserting a new world

As far as tools go, layers, layer masks, and the Brush Tool are all you need to create this world within a shadow. But more important than tools is your idea. You need to have a sense of how the pieces of your new world are going to fit together before you start layering, masking, and painting.

I found that it takes a certain amount of attitude adjustment to get the planning process right. I've had to remind myself a number of times that I don't need to use an entire image, I can just use a little piece of it as needed. For that matter, I'm not interested in where a photo that is going into a composite was taken. My concern is whether a portion of the photo will fit well in the planned composite that I have in mind.

For this reason, you'll sometimes find strange things in my composites. Parts of horizontal images are used to create a final image that is vertical.

Architectural details that are thousands of miles apart end up in one composition, and so on. the key thing is to create a harmonious ersatz world in which all the pieces fit together seamlessly.

So, you've got a plan in mind and you've got the pieces. The mechanics are straightforward: size the pieces, add them as layers to the composite, position them correctly, add layer masks, and then use the Brush or Gradient Tools to blend them in.

1 *Checkpoint*
Save and archive the work you've done on the marble before compositing. Save a copy of the image with all the layers. Then, flatten the layers by choosing Image ▸ Flatten and save the file with a new name.

2
Use the Move Tool to drag the "Clouds" photo from its image window onto the image window containing the marble.

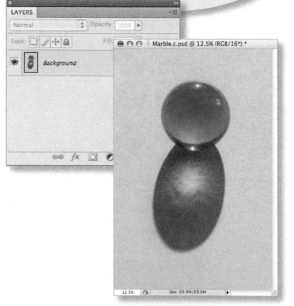

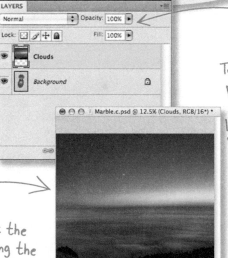

Don't worry about the "Clouds" layer covering the marble. You'll apply a Hide All layer mask in Step 3, and then paint in a tiny portion of the "Clouds" layer

To get the "Clouds" layer positioned correctly, use the Layer palette to lower the Opacity of the "Clouds" layer to 50% so you can see the marble underneath. Once you are finished positioning the "Clouds," return the Opacity back to 100%

3 Add a black Hide All layer mask, and then use the Brush Tool to paint on the layer mask in the shadow area closest to the marble, blending in the clouds.

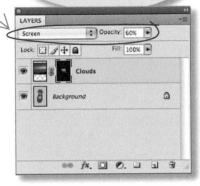

4 Use the Layers palette to change the blending mode to Screen and reduce the Opacity to 60%.

This is where the clouds are painted in

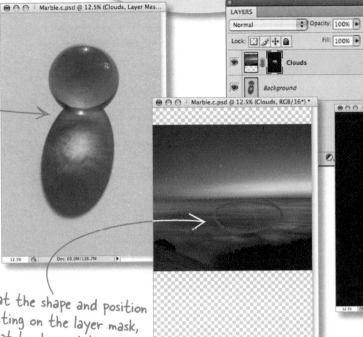

If you look at the shape and position of the painting on the layer mask, you'll see that I only used this small portion of the "Clouds" layer

6 Add a black Hide All layer mask to the "Surf" layer.

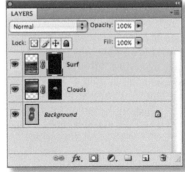

5 Use the Move Tool to drag the "Surf" photo from its image window into the image window containing the composite.

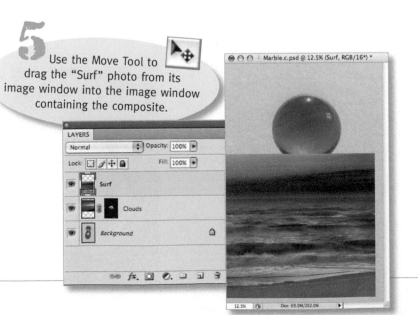

Keep going →

7 Choose the Elliptical Marquee Tool from the Toolbox. Make sure Anti-alias is checked on the Options Bar, and then use the tool to select the oval shadow area.

If the oval selection you make is a little too big or too small, don't worry! You can always use the Brush Tool and the layer mask in Step 9 to paint in areas that you want to include or paint out areas you don't want

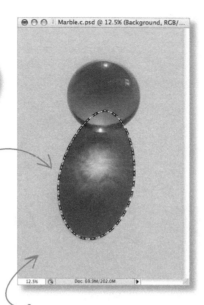

Where's the Elliptical Marquee Tool?

If you look at the Toolbar, the second button down gives you access to marquee selection tools. Click the tiny black arrow on the tool button to open the tool fly-out and select the Elliptical Marquee Tool.

	Rectangular Marquee Tool	M
	Elliptical Marquee Tool	M
	Single Row Marquee Tool	
	Single Column Marquee Tool	

Once you select an area in an image, the rest of the image that isn't selected can't be altered. In essence, a selection is a mask

While using the Elliptical Marquee Tool to make a selection, you can reposition the selection by pressing the Space Bar (don't let go of the mouse button!)

8 In the Layers palette, click the layer mask on the "Surf" layer to make it active. Then, choose the Gradient Tool from the Toolbox and drag a white to black gradient from the bottom of your oval selection to about the middle of the selection. The gradient will appear only on the layer mask in the area contained by the selection.

As you drag the Gradient Tool, the blue waves in the "Surf" layer become visible in the shadow area

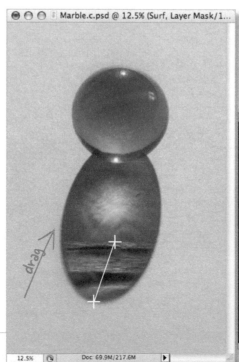

drag

For a detailed discussion of the Gradient Tool, take a look at PD1, pages 37–39

With the layer mask on the "Surf" layer still selected, use the Brush Tool to blur the edges of the oval so the final composite doesn't have hard edges. Paint with white or gray to reveal areas that are still hidden or paint with black to hide areas of the waves that you don't want to see.

As you paint to complete the mask, work around the flare in the marble's shadow so it looks integrated into the composite

Finished Composite Image

I can't see what I'm doing!!

If you're having trouble seeing where you need to paint, it might help to make the layer mask visible. To do this, go to the Channels palette and click the eyeball icon next to "Surf Mask." (Leave all the other channels visible, too.) The mask will appear as a transparent red overlay in the image window. The red area corresponds to the black area of the mask that hides that part of the layer. The clear area (that isn't red) corresponds to the white area on the layer mask that reveals the surf.

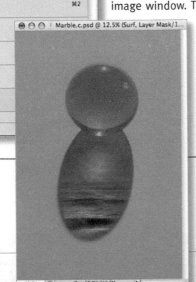

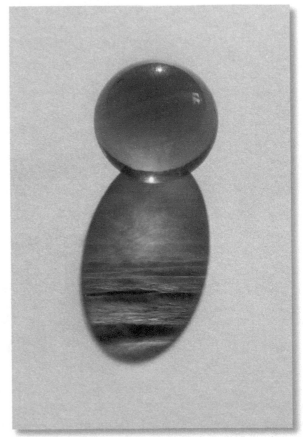

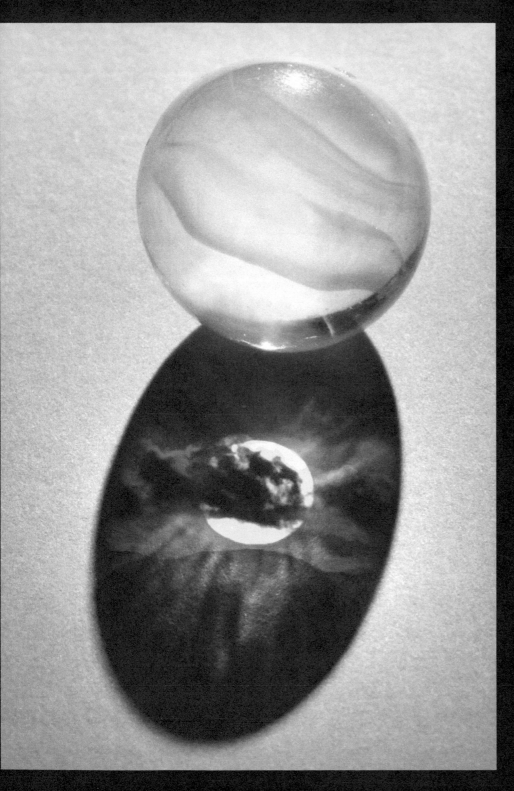

Marble of Power

When I photographed the blue marble used as the base image in the case study shown on pages 136–145, I also photographed some other marbles and their shadows, including the marble shown below, following Hand-HDR post-processing.

Sometimes imperfections are a starting place for me in my photo compositing work. Looking at the marble and the shadow, it was striking to me how the flaws in the marble created an interesting effect in the shadow.

Since the aim of a photo composite is to create plausible alternative realities, it is a better strategy to build on what is already suggested in an image than to create something entirely artificial.

I saw right away that the shadow created by the marble's flaw could easily be converted into a dramatic sunset and that the shadow as a whole could be used to convey emotions of "the dark side"—as might be the case if you had a marble of power rather than a ring of power.

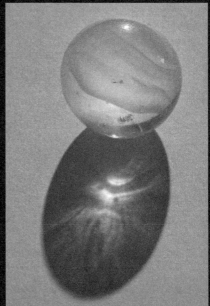

Shadow Play

I tremendously enjoy photographing objects and their shadows even when I don't have photo compositing in mind. For example, the Godetia seeds and their shadows (right) created a striking and zen-like pattern when photographed on a sheet of white paper.

To complete the image, I added a split-filter effect going from blue at the bottom to yellow at the top at about 20% opacity using the Bi-Color User Defined filter in the Nik Color Efex Pro 3.0 Photoshop plug-in.

Fancy color filters are nice but sometimes simplicity is nice, too. The patterns that the seeds and their shadows made intrigued me so much that I decided to create a monochromatic version of the image (below) in addition to the color version.

In the black and white version, the contrast between the rough and spread-out "shadow seeds" and the more clearly delineated "real seeds" lent drama to the image that wasn't as apparent in the colored version.

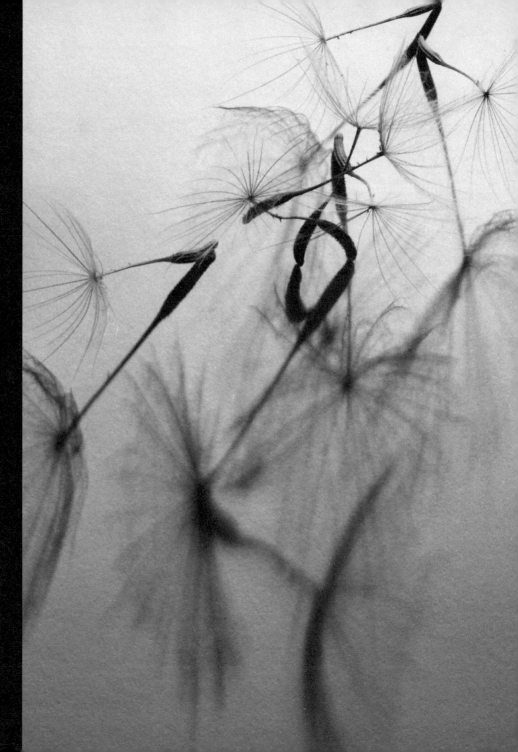

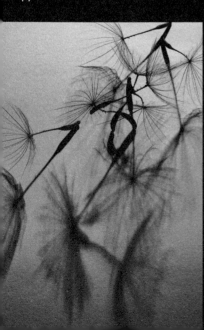

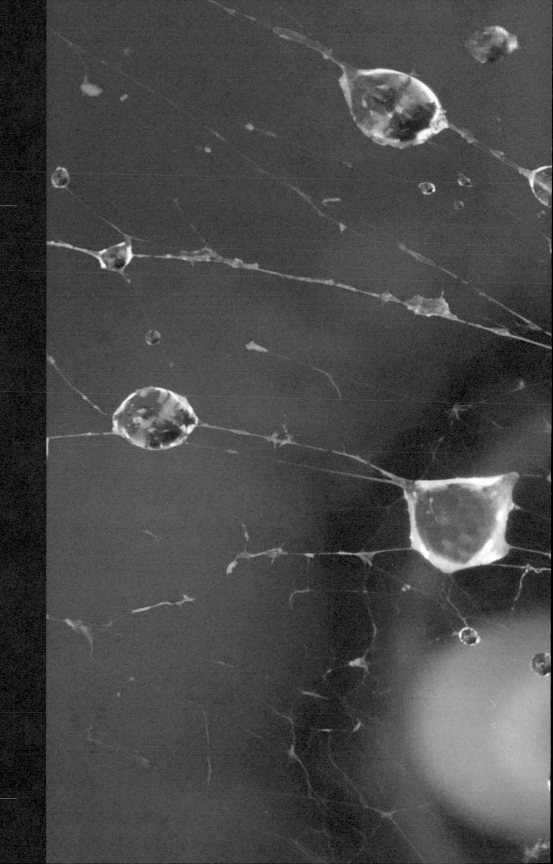

Photographing the Infinitesimal

This photo was taken in one of my "spiderweb studios" shown on pages 40–41. The flowers in the water drops are reflections of the "giant" Passion flower in the background.

To make this image, I used a stationary camera on a tripod and took six exposures, bracketing shutter speeds. In other words, this photograph of the infinitesimal uses the same Hand-HDR techniques in both photography and the Photoshop darkroom as the transparent poppy case study on pages 106–121.

In field conditions, to get as close to the water drops as this image shows, I find it is best to use a telephoto macro lens. If you use a macro lens of a normal focal length, then the lens is likely to be reflected in the water drops. Even if reflections are not an issue, it is almost certain that normal macro lens positioned extremely close to a very small subject will cast a shadow and interfere with the lighting.

I used a 200mm macro lens equipped with a 36mm extension tube and a +4 close-up lens. This really cranked up the magnification to microscopic levels. Because of the equipment I used, I was able to position the camera about a foot away from the spider web.

Each of the six exposures was taken at f/40 and ISO 200. Shutter speeds ranged from 8 seconds to 1/2 a second.

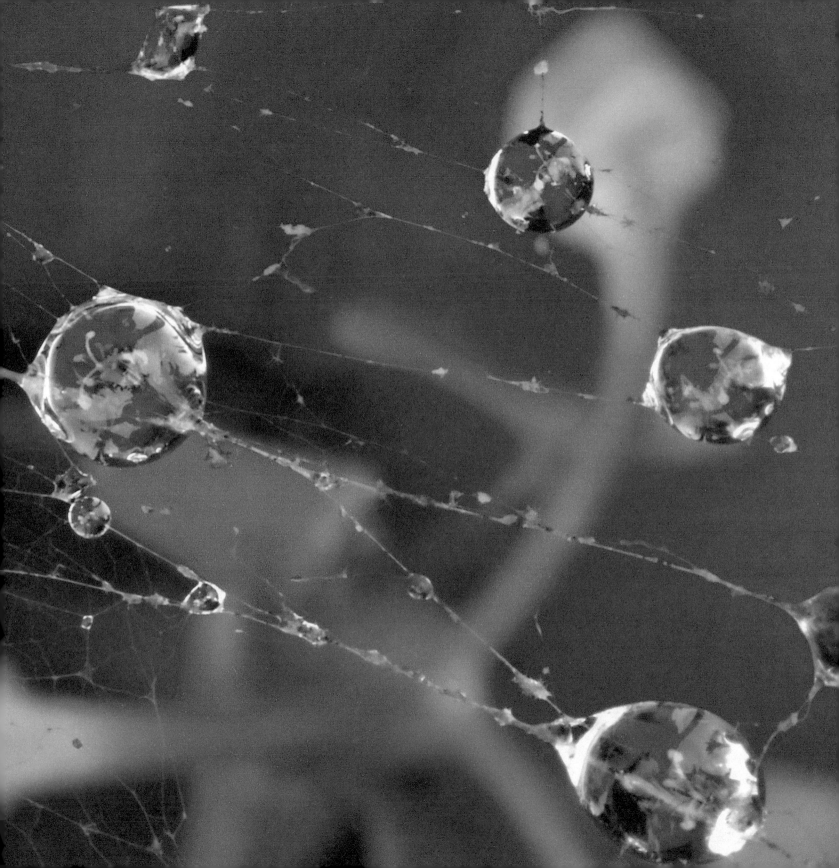

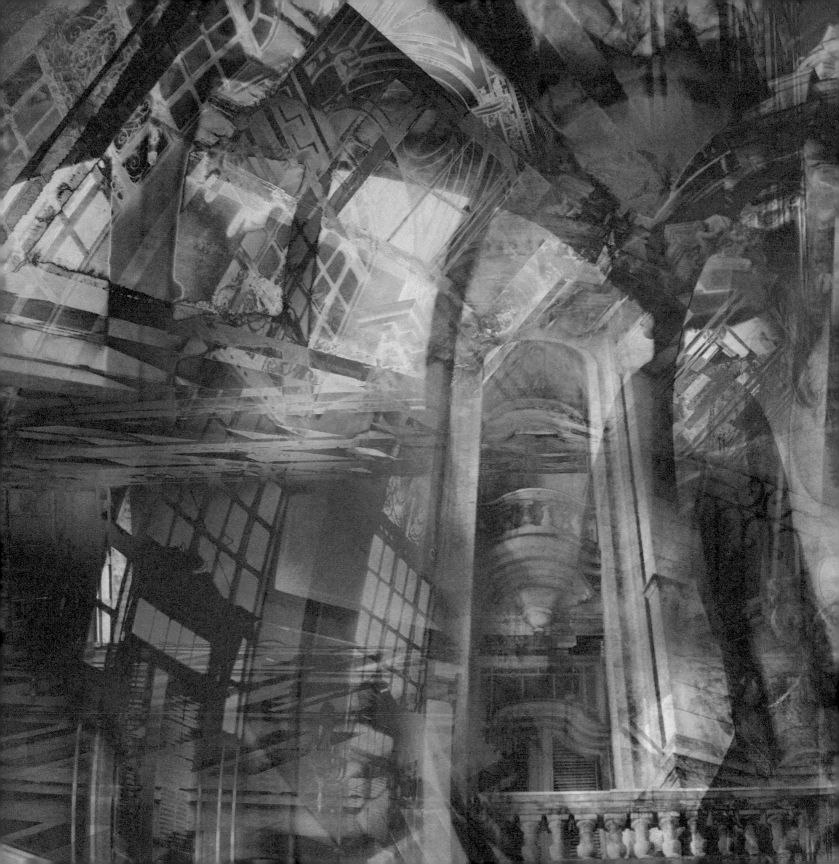

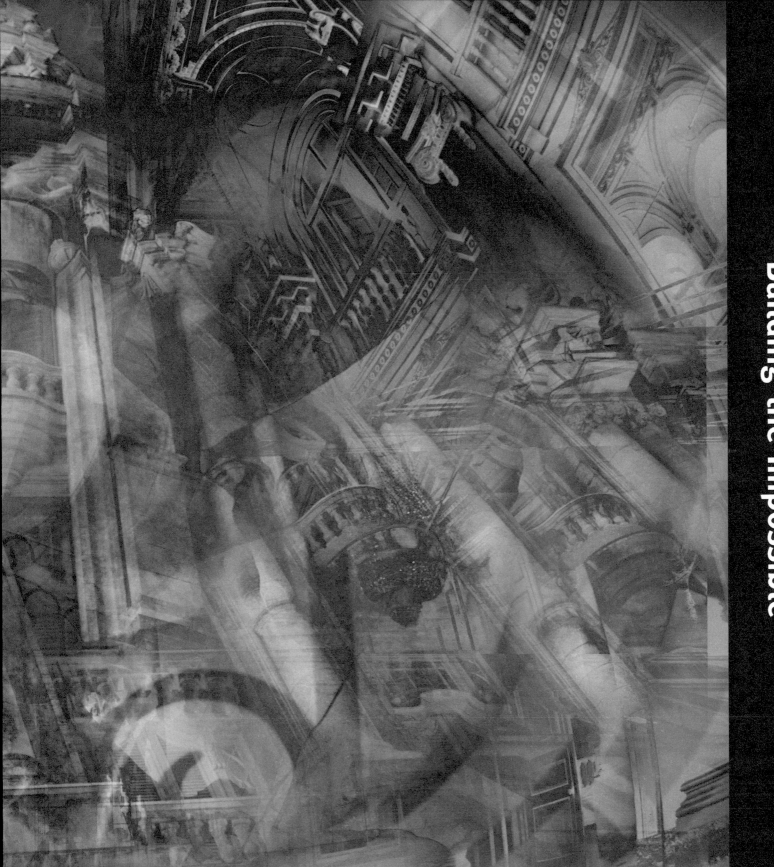

Building the Impossible

›› Harold's Manifesto: Losing the Chains of Reality

Since the birth of photography in the early nineteenth-century, there has been a long standing debate about the relationship between reality and its depiction in photographic imagery.

Essentially, there have been two schools of thought. Journalistic photography should show the world as it is and when a photo of this sort is too obviously manipulated, it is considered fraudulent. On the other hand, it's always been realized that a photo that is art can do anything. With art it's not how you get there that matters, it's the final image. Another way of putting this: photos of reality go to heaven but unreal photos go everywhere. In the world of film photography, manipulations have always been slightly "naughty."

Digital photography is untied to any conception of reality.

The advent of digital photography has changed everything. It's no longer a question of whether photos have been manipulated, because all digital photos are inherently manipulated before they can be displayed or printed. A digital photo is one part photography and one part software. This has some drawbacks in terms of loss of immediacy to the photographer but it has great advantages in terms of the increased power of the new medium.

Digital photography is a new art form not tied to any conception of reality.

This new medium is in your hands and you can take it where you want it to go. The only limit is your vision and imagination! No digital photo is truly an objective representation of reality. Digital photos can be used to create almost any kind of scene whether or not the scene occurred naturally. Digital photography can also be used as a tool to create abstract imagery that has nothing whatsoever to do with the world at large. After all, it is all pixels.

With freedom comes responsibility. In the past it was possible to excuse a flaw in a photo by saying, "but it was really like that." Reality can no longer function as a viable excuse.

Digital photos are the primitives. What you take with your camera—or digital scanner—is the input to a new creative process. There's a universe of opportunity for new artistic expression in the Photoshop darkroom.

Take advantage of this great opportunity! This is your chance to make images that show things that no one has seen before—whether it is the world portrayed differently or exotic combinations of colors and shapes. Play! Experiment! Have fun! You have nothing to lose but the chains of reality.

Good photographers need to have hungry eyes. This composite image to the right—created from four photos—shows my eye isolated on a flower stalk: all-seeing, all-knowing, or maybe just an alien life form.

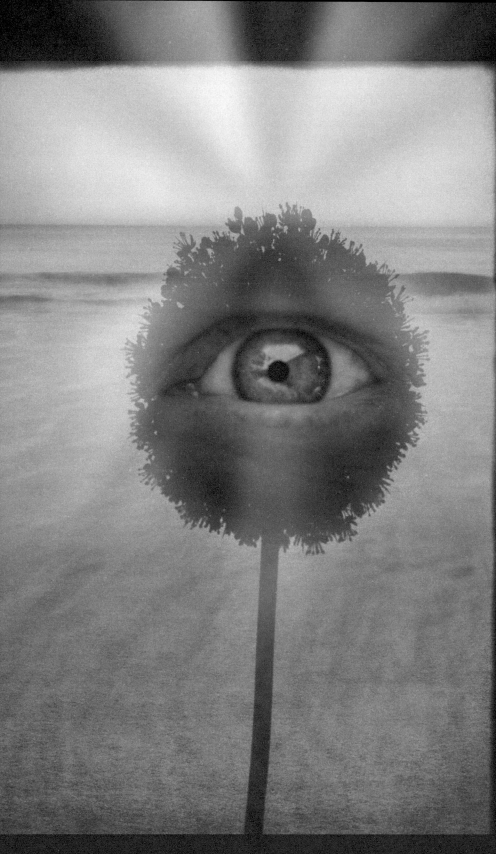

Creating an Abstraction

On a bright, overcast day, I shot a macro of kelp on Weston Beach in Point Lobos State Natural Reserve near Carmel, California. I guess all things photographic show up on the Edward Weston beach eventually!

The RAW file is shown below in Adobe Bridge. As you can see, the image as shot is pretty abstract—so it occurred to me to continue and make it even more abstract.

First, I rotate the image 90 degrees clockwise to create a vertical rather than horizontal abstraction because

I felt that vertical lines worked better with the composition. Next, I converted the image to LAB color and inverted and equalized both the image as a whole and each of the three LAB channels. This gave me eight different color palettes to choose from. The A channel equalization became the

predominantly green version shown at the top of page 156. The B channel equalization with its blue palette is shown on the bottom of page 156. The equalization of the entire image is shown to the right.

Taking the abstraction one more step, I combined the three versions into a new layer stack using a variety of layers, blending modes, and masks. A great deal of the amplified color in the version shown to the right was generated using the Difference blending mode. One of the layers in the new version was made by flipping the base layer horizontally, adding a layer mask, and then partially painting it in. This created some new patterns in the final image including some that I think resemble human faces crying out, almost like Edvard Munch's *The Scream* or the suffering figures in Rodin's sculpture based on Dante's *The Gates of Hell*.

Left: I shot several photos of kelp washed up on the beach. I liked the image circled in red because I could see abstract patterns in the seaweed.

Right: It's almost as if there are grotesque faces embedded in the lines of this ocean plant. When I processed the image, I altered the colors to emphasize the abstract patterns I saw.

Above: To create this version of the abstract kelp, I converted the image to LAB color. Next, I selected the A channel and chose Image ▸ Adjustment ▸ Equalize. This emphasized the green tones already present in the image.

Far right: While I like all the abstract versions created from the kelp I photographed on Weston Beach, I regard this colorful blended version as the final image.

To create it, I duplicated each of the prior LAB adjustments and layered them in over the original image using layer masks and painting. Some of the saturated color effects were created using the Difference blending mode. In addition, I duplicated the image one more time and flipped it vertically. The flipped version was then copied back over the original and selectively blended in with a layer mask and gradient.

Below: I converted the original kelp image to LAB color again. The predominantly blue tones were created by applying an equalization adjustment to the B channel in LAB color.

THESE ABSTRACT COMPOSITIONS
were created from a photo of a
pile of Mulberry tree bark. The
Mulberry tree is also sometimes
called a "Paper Tree" because its
bark is used to create paper in
some cultures.

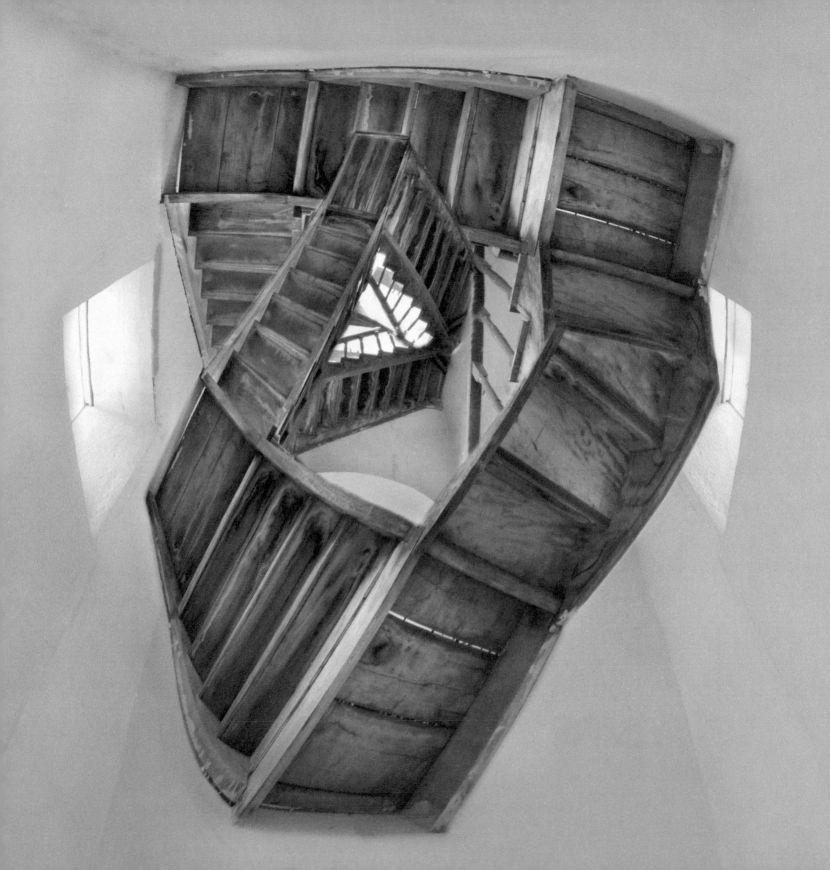

›› Stairs à la Escher

Steps toward the impossible

On a sultry day wandering the cobble-stone streets of Trinidad, a provincial Cuban capital, I came across the ornate belfry of a building that had formerly been a church.

Now a museum dedicated to the Cuban Revolution, the tower was closed to visitors. I bribed a guard with a few pesos and was allowed to go up the rickety wooden stairs.

What most interested me was a view from underneath the stairs looking up as you can see in the sequence shown below in Adobe Bridge.

Since there was a great dynamic range contrast between the bright sunlight coming into the bell tower and the dark shadowed areas of the stairs, I shot eight exposures at shutter speeds ranging from 1/3 of a second to 4/5 of a second, a 20x range (each exposure

was shot at f/22 and ISO 400).

I used a 10.5mm digital fisheye lens to capture as much of the staircase as possible. Using a fisheye lens resulted in considerable distortion and curvature which I liked.

Four of the eight exposures were used in a Hand-HDR blend (see pages 108–121 for details about this technique). The results of this blend can be seen on page 164.

I chose the four captures of the rickety wooden stairs circled in red because they gave me a nice exposure range to work with for Hand-HDR processing

To find out more about Hand-HDR, take a look at pages 108–113

The Hand-HDR stairway

Looking at the results of my HDR composite, it became clear to me that the interesting part was not the foreground stairs with a hand rail. Rather it was the stairs further back that seemed to twist their way up into the bell tower. My goal was to exaggerate and emphasize the twisted nature of these stairs. By the way, if you look closely at the image, you will see that you are looking at the underneath of the stairs rather then the steps that anyone would walk on.

To create the twisted and unreal stairs shown on pages 160–161, I started with the "more real" image shown to the right:

- As I've mentioned, I used Hand-HDR to create an extended dynamic range version of the original image.

- Next, I cloned out the bottom part of the stairs with the railing that I wasn't particularly interested in. This left me with a free-floating somewhat-twisted staircase in the air.

- Using the free-floating stair-case as the base, I duplicated the image, copied it on top of itself, scaled the versions, skewed them, and cloned in portions as necessary to create the images shown on pages 160–161.

I needed 37 saved files, or checkpoints, for these operations with a total of approximately 425 layers spread out through the files. While it is impossible to show you each of these layers, I will show you the most important steps along the way.

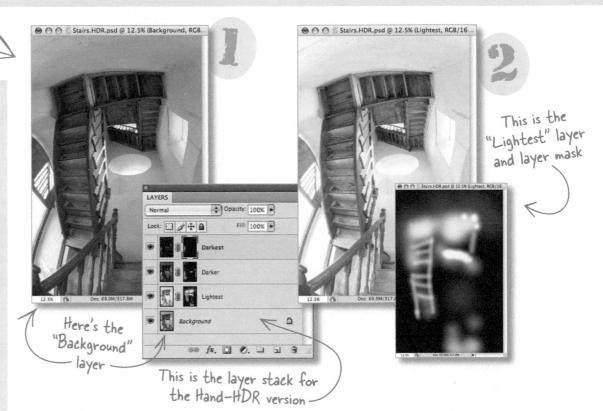

Here's the "Background" layer

This is the layer stack for the Hand-HDR version

This is the "Lightest" layer and layer mask

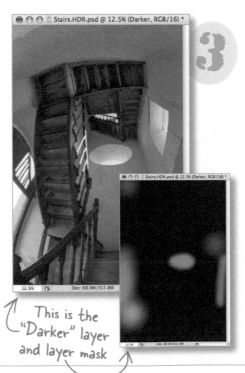

This is the "Darker" layer and layer mask

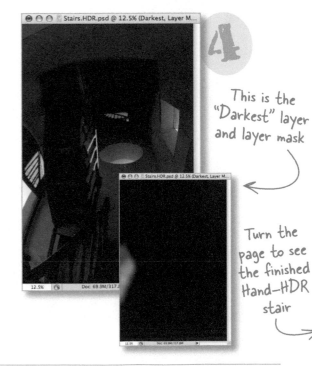

This is the "Darkest" layer and layer mask

Turn the page to see the finished Hand-HDR stair

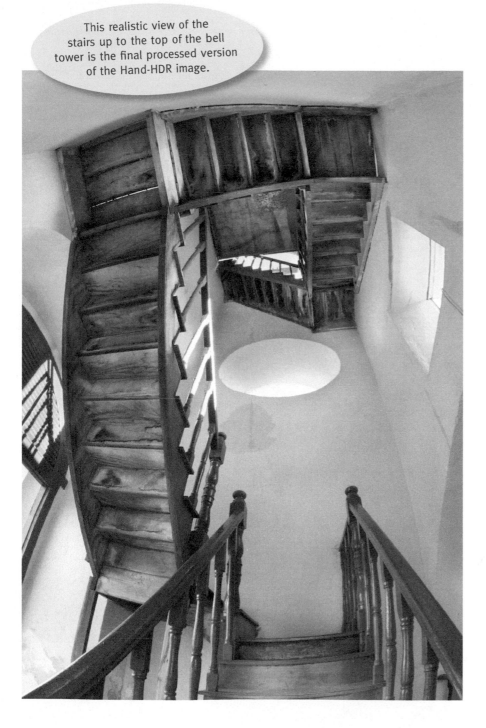

This realistic view of the stairs up to the top of the bell tower is the final processed version of the Hand-HDR image.

›› Creating the basic building block

A man, a plan, a stair

When I sat down to think about the problem of creating Escher-like stairs using the bell tower stairs, I realized that this was basically a construction problem. Sure the construction is virtual and digital, but it's still a construct. So putting my virtual hard hat on, I needed to create a basic building block. I knew that with the right building block, I could construct anything. The building block had to be flexible in that I could flip, twist, rotate, and skew it, merge it with itself, and use it at a variety of different sizes.

With this building block, I could construct any number of fantastic stairs, witness the images on pages 160–161 and 179. So the first item on my construction job was to create the building block which I think of as my *primitive*—it is a relatively simple image that I can use over and over to build images that are much more complex.

Removing the bottom of the stairs

Looking at the bell tower stairs, it was clear to me that my primitive element had to be the stairway above the first landing. This portion of the stair is very generic and has some scrumptious twists and turns in it as opposed to the relatively short set of steps up to the first landing that would be hard to join with anything else.

So I pulled out the Clone Tool and Brush Tool and got to work. Besides cloning out the bottom part of the stairs, I adjusted the color for greater neutrality.

This is the primitive that the *Twisted Stair* images will be created from. In other words, it is the fundamental building block that will be used to create my stairs à la Escher.

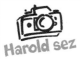

Harold sez I like to start with a construction plan, but I find that something like the *Twisted Stairs* are too complex to fully plan out with the equivalent of a virtual blue print. Things never go exactly according to plan.

Once I have my primitive I can experiment and see what I can come up. Experimenting doesn't mean that the image will work. My first attempt used more than 500 layers and several days, but it didn't work visually, so I had to trash it.

Fortunately, I had developed the primitive, and my experience from the first false start let me put together the subsequent images much more quickly and efficiently.

Now the real adventure begins! Turn the page…

This cloning is a bit sloppy, but I'm not worrying too much about it until I begin to put some of the pieces together because the messy bits probably won't be in the combined image anyhow

>> The Compositor's Cafeteria

✳ All of these tools are at your fingertips in Photoshop. Play with them and see what they can do to an image!

Take a bite out of reality

The menu in the Compositor's Cafeteria is varied and tasty. You've got your appetizers, you've got your dessert, and most important of all you've got your main course. As your mama always said (maybe), you need to eat a balanced meal with your protein and veggies.

The main course is on the Edit ► Transform menu. You like your composite simple? Then, Scale, Rotate, Flip Horizontal, or Flip Vertical. You want to get things a little more gourmet? Then, Skew and Distort. Rich butter sauce more your thing? Go for Perspective and Warp. This tasty buffet of options is arranged for your delectation right over here.

The Edit ► Transform menu is one of the keys to successful photo compositing.

Edit

Undo Make Layer	
Step Forward	
Step Backward	
Content-Aware Scale	⌥⇧⌘C
Free Transform	⌘T
Transform	►
Auto-Align Layers...	
Auto-Blend Layers...	
Define Brush Preset...	
Define Pattern...	
Define Custom Shape...	
Purge	►

Again	⇧⌘T
Scale	
Rotate	
Skew	
Distort	
Perspective	
Warp	
Rotate 180°	
Rotate 90° CW	
Rotate 90° CCW	
Flip Horizontal	
Flip Vertical	

If these commands are grayed out, check the Layers palette... are you trying to work on a "Background" layer?

You can't use these commands on a "Background" layer because it is locked. To change a "Background" layer to a regular layer, choose Layer> New>Layer from Background

How to use the Transform commands

1. In the Layers palette, select the layer you want to transform.

2. Choose Edit ► Transform and pick a command from the fly-out menu. *Handles* (which look like little squares) will appear around the edges of the layer in the image window.

3. Position the mouse over a handle and click and drag to adjust the layer. If you are scaling an image and want to resize it proportionately, hold down the Shift key while you drag.

Changing commands as you work

If you are working with a transformation command such as Rotate and you want to change to another command like Skew, right-click/Control+click to access a pop-up menu and select the new command.

Compositor's Condiments

Clone and Patch Tools
Pages 30-37

Brush Tool with layers and layer masks
Pages 22-24

Brush and Pencil Tools for painting in colors, patterns, lines, etc.
Pages 80-83

● ● ● © stair primitive.psd @ 12.5% (Fli...

12.5%

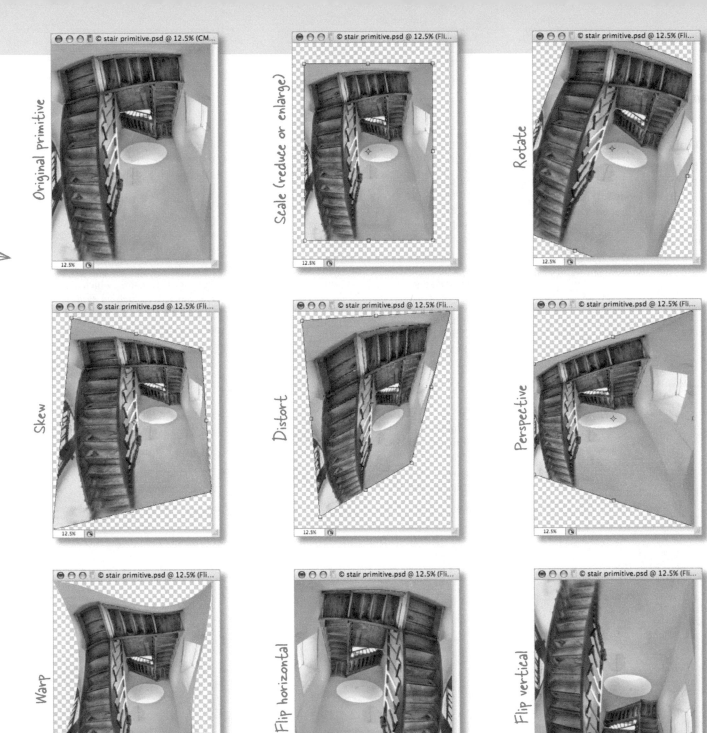

» Version 1: Creating the "Twisted Stairs"

Duplicating and flipping

The first photo composite that I created from my primitive stair was simple in concept. I made a duplicate of the primitive, flipped it vertically and then put the duplicate together with the original primitive to create two meshed staircases going up (or down depending on how you look at it).

The really tricky part of getting this composite right was managing the area where the stairs meet in the middle. Blending the stairs seamlessly to create the illusion was the challenge.

There are always "meeting points" or "mesh points" where the different pieces of a photo composite come together to join. These mesh points are always the most difficult areas in a photo composite because you have lines coming in from different perspectives.

What you have to figure out when joining the mesh points is how to create an illusion that seems satisfactory to the viewer from all the different perspectives. It's harder to make this joining seamless when working with architectural images because the mesh points are very precise with no wiggle room. For instance, a stair railing has to appear exactly spaced between its neighbors or something will look wrong to the viewer.

Other types of composites, which use natural elements, such as clouds or leaves, leave more room to make these mesh points look possible because they are not precise shapes.

Let's go!

1 Open the primitive in Photoshop.

2 Create a duplicate image of the primitive by selecting Image ▸ Duplicate. Convert the duplicate image from a "Background" layer into a regular layer by selecting Layer ▸ New ▸ Layer from Background. Name the layer "Flipped."

3 Flip the duplicate image vertically by choosing Edit ▸ Transform ▸ Flip Vertical.

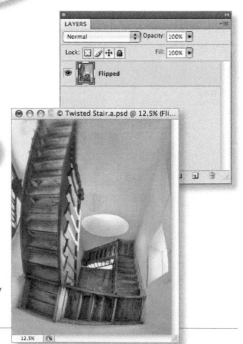

For more about the Transform commands, turn to pages 166–167

4

Drag the original primitive from its image window onto the duplicate image you just flipped. Name the layer "Primitive."

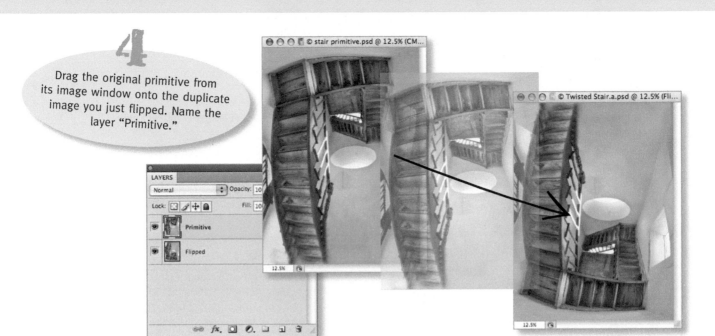

5

Select the "Primitive" layer in the Layers palette and lower the Opacity to 50%. Use the Transform commands to rotate and resize the primitive until the stairs line up here

Set the Opacity to 50% to make the layer semi-transparent so you can see what you are doing while rotating and sizing the "Primitive" layer

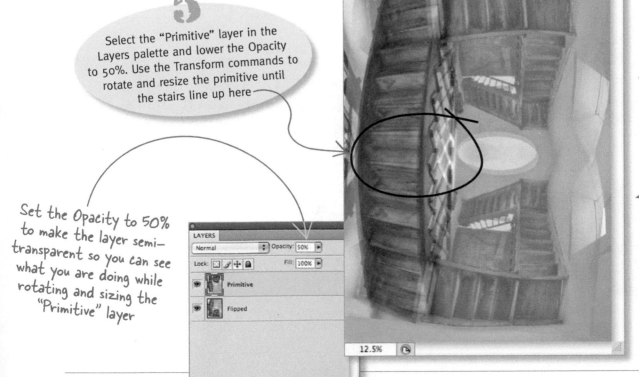

Take advantage of all possible natural synergies. It's much better to start with composited pieces that have a natural fit rather than trying to force things where there's no obvious fit

Keep going ——→

6

With the "Primitive" layer still selected, choose Layer ▸ Layer Mask ▸ Hide All to add a black Hide All layer mask. Raise the layer's Opacity back to 100%.

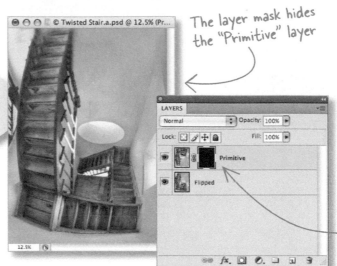

The layer mask hides the "Primitive" layer

For more about layer masks, turn to page 22

7

In the Layers palette, make sure the layer mask on the "Primitive" layer is selected. Use the Brush Tool to paint in the portion of the layer that you want visible.

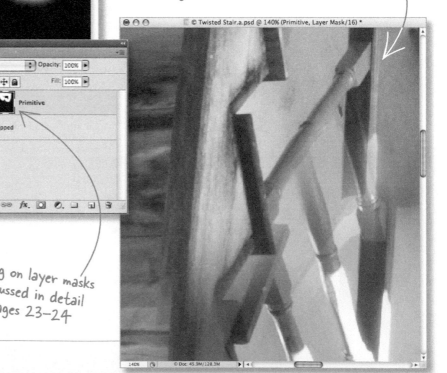

The bannister and the stairs don't quite fit together. This mesh point is going to need a bit of work

Painting on layer masks is discussed in detail on pages 23–24

» Fixing the mesh point

Creating the illusion

Now that the stair layers are lined up, you need to work on the mesh points to make the Escher-like world you are creating seem viable.

To create the illusion of plausible reality, you make the mesh points work, so that the image looks right from all perspectives.

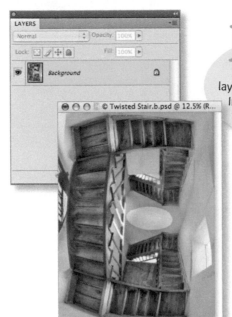

1 Checkpoint
Save and archive a version of the composite image with all the layers. Then, flatten the layers by selecting Image ▸ Flatten and save the file with a new name, ready for further editing.

What you have to do is figure out how to create an illusion that looks satisfactory from all perspectives

2 Start fixing the mesh point by putting in a stair railing. Open the primitive that you created back on page 165 in Photoshop.

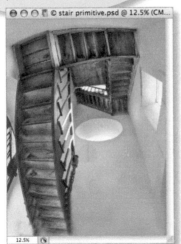

3 Drag the primitive from its image window into the window containing the composited stairs. Name the new layer "Stair Railing" and lower the layer's Opacity to 50%.

Lower the Opacity to 50%

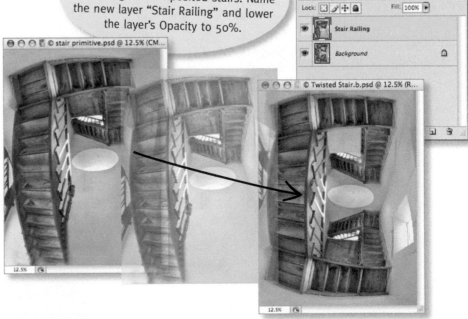

4 Use the Move Tool to position the "Stair Railing" layer like this so this railing is spaced evenly. You may have to rotate the layer to make it fit just right.

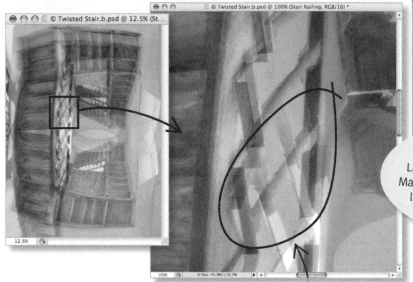

5 With the "Stair Railing" layer selected in the Layers palette, choose Layer ▸ Layer Mask ▸ Hide All to add a black Hide All layer mask to the layer. Raise the layer's Opacity back to 100%.

This is the railing you are adding

6 Using the Brush Tool with white set as the foreground color, paint on the "Stair Railing" layer mask to make the stair railing visible. This is a very small area, so zoom in so you can really see what you are doing.

7 Checkpoint Save and archive a version of the composite image with the two layers. Then, flatten the layers by selecting Image ▸ Flatten and save the file with a new name, ready to finish the *Twisted Stairs*.

Paint on the layer mask to make this railing visible

You can use the Navigator to zoom in and out while you work. Take a look at page 34 for more info

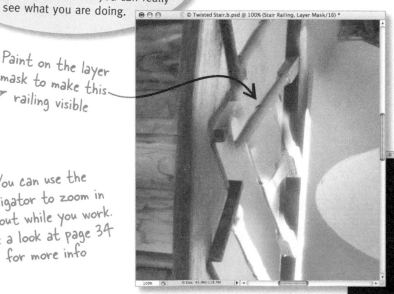

As you can see from the layer mask, only a tiny portion of the "Stair Railing" layer is used

8 Select Layer ▶ New ▶ Layer via Copy to create a copy of the "Background" layer. Name this new layer "Paint Railing."

9 Use the Clone Tool to clone out these railings using background wall color. Clone in the underside of the bannister.

To find out more about the Clone Tool, turn to pages 30–37

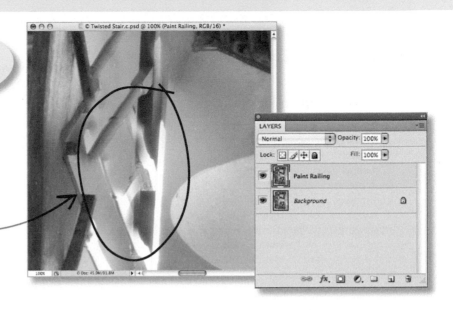

The finished "Twisted Stairs"

10 Use the Brush Tool to paint in the bottom part of the stair railing that's missing. Use the Eyedropper Tool to sample the colors you are going to "paint" with. Clean up any other areas using the Clone and Brush Tools.

For more about sampling with the Eyedropper Tool and painting in railings, turn to pages 36–37

Here are the fixed railings and bannister

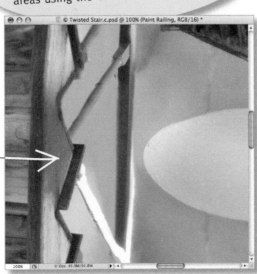

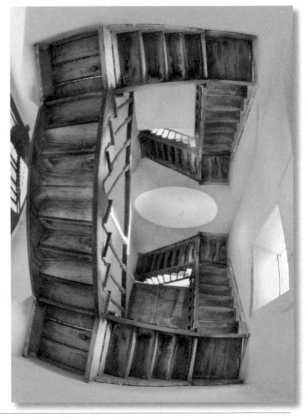

» Version 2: Creating the "Stair Knot"

Getting tied up in knots

I was pretty happy with the *Twisted Stair* image but something kept tickling in the back of my mind. Somehow I wanted the stair to be more like a Möbius strip, continuous and joining with itself. To try to put together the photo composite in my mind's eye, I went back to the "primitive"—the free-floating stair up the bell tower seen from underneath.

Open the primitive in Photoshop.

2 Save a copy of the primitive with a new name, ready for compositing. If you take a look at the Layers palette, you'll see that you have one "Background" layer.

3 Select Layer ▸ Duplicate Layer to make a copy of the "Background" layer. Name this new layer "Flipped." Next, choose Edit ▸ Transform ▸ Flip Vertical.

4 Make sure the "Flipped" layer is selected in the Layers palette, then choose Edit ▸ Transform ▸ Rotate. Position the mouse pointer over one of the corner handles, hold down the Shift key, and rotate the layer 45° counterclockwise. Press Return to accept the changes.

As you drag with the Shift key held down, the layer rotates in 15° increments

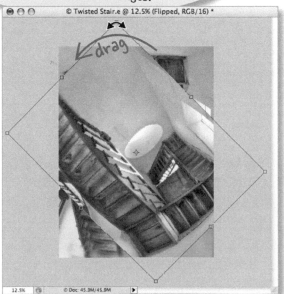

5 Lower the "Flipped" layer's Opacity to 50% so you can see the "Background" layer underneath.

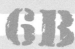

6A

Choose Edit ▸ Transform ▸ Warp. Use the handles and grid to shape the "Flipped" layer so the stair landing on the "Flipped" layer lines up with the stair landing on the "Background" layer here

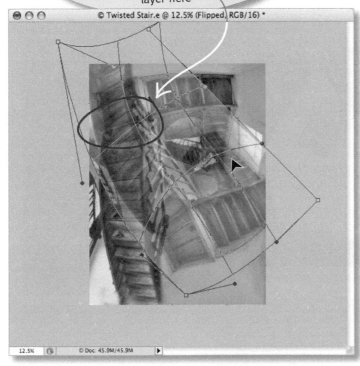

© Twisted Stair.e @ 12.5% (Flipped, RGB/16) *

12.5% | © Doc: 45.9M/45.9M

6B

Continue working with the Warp handles and grid to make the top of the "Flipped" layer stairs line up with the top of the stairs on the "Background" layer here

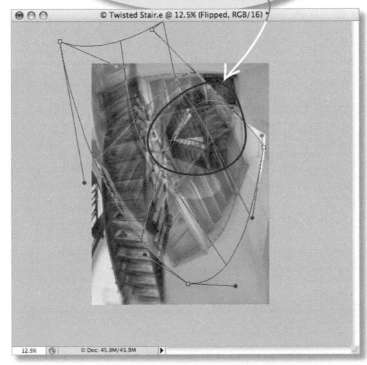

© Twisted Stair.e @ 12.5% (Flipped, RGB/16) *

12.5% | © Doc: 45.9M/45.9M

7

Press Return on the keyboard to accept the Warp editing. If you raise the "Flipped" layer's Opacity to 100%, here's what the layer looks like at this point.

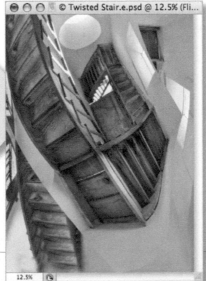

© Twisted Stair.e.psd @ 12.5% (Fli...

12.5%

LAYERS

Normal | Opacity: 100%
Lock: ☑ ⁄ ✦ ⛫ | Fill: 100%

👁 Flipped
👁 *Background*

8

With the "Flipped" layer selected in the Layers palette, choose Layer ▸ Layer Mask ▸ Reveal All to add a white Reveal All layer mask to the layer.

Now for the masking →

9 In the Toolbox, set the foreground color to black. Then use the Brush Tool to paint on the layer mask to hide the parts of the "Flipped" layer you don't want visible.

If you make the layer mask on the "Flipped" layer visible by clicking the eyeball in the Channels palette, here's what you'll see

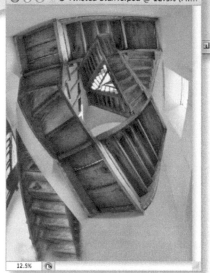

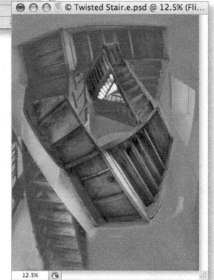

For more about viewing masks, turn to page 145

For more about viewing masks, turn to page 145

10 Next, you need to remove this bit of stairs here and add a window on the left that mirrors the window on the right. So start by opening the primitive image file again.

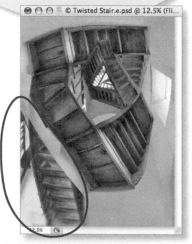

11 Drag the primitive from its image window into the window containing the composite you've been working on. Name the new layer "Wall and Window."

12 With the "Wall and Window" layer selected in the Layers palette, choose Edit ▸ Transform ▸ Flip Horizontal.

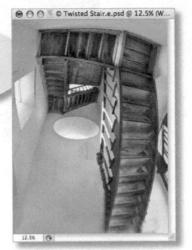

14 *Checkpoint* Save and archive a version of the composite image with the layers. Then, flatten the layers by selecting Image ▸ Flatten and save the file with a new name, ready to finish the *Stair Knot*.

15 Select Image ▸ Image Rotation ▸ Flip Horizontal to finish the image.

13 Select Layer ▸ Layer Mask ▸ Hide All to add a black Hide All layer mask to the "Wall and Window" layer. Set white as the foreground color in the Toolbox and use the Brush Tool to paint in the wall area and the window.

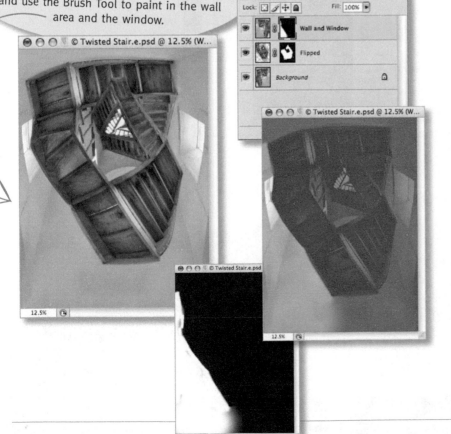

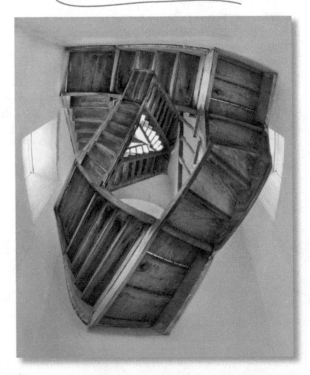

The finished "Stair Knot"

Complexity versus Simplicity

From a graphic design perspective, the *Twisted Stair* images shown on pages 160–179 are pretty simple. While the primitive component of an old wooden stair viewed from underneath with a wide angle lens has been replicated in a couple of different ways, the final images are simply of a staircase—albeit very strange and twisted stairs indeed.

It's possible to take the same primitive—the simple floating staircase—and use it to make an image of great compositional complexity. Stairs can run into stairs, and the stairs can be twisted around several different perspective planes. The various sets of stairs can be scaled differently from one another. In addition, landscapes and sunsets can be composited behind the stairs.

Of course, complexity is not always better than simplicity. In fact, compositions that get too complicated often degenerate into a kind of visual "mush." I have found myself going too far, arriving at an endpoint that was not satisfactory, and having to start over. Part of the trick is knowing when to stop. When a complex photo composite has some underlying clarity, it can be very satisfying indeed—and it's a matter of individual taste whether you prefer complex composites to simple ones with a clear underlying thrust.

LAB inversion with Difference blending mode applied in RGB

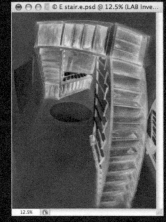

Flipped L-channel LAB inversion before blending

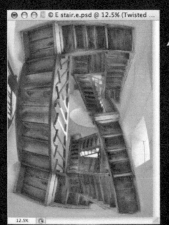

Composite created starting with the Twisted Stairs

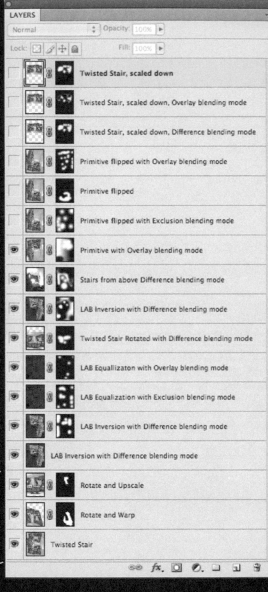

The image shown to the right that I call Stairway to Heaven *was created starting with the* Twisted Stair *image shown on page 160. I used many layers to create the image, often blending with the Difference and Overlay blending modes. Above are just a few of the hundreds of layers that went into this image, but this layer stack will give you a pretty good idea of how I constructed the final image.*

Note that I worked in RGB although many of the layers were created using LAB color. This is because there are some useful blending modes, such as Difference and Exclusion, that are available in RGB but not in LAB color.

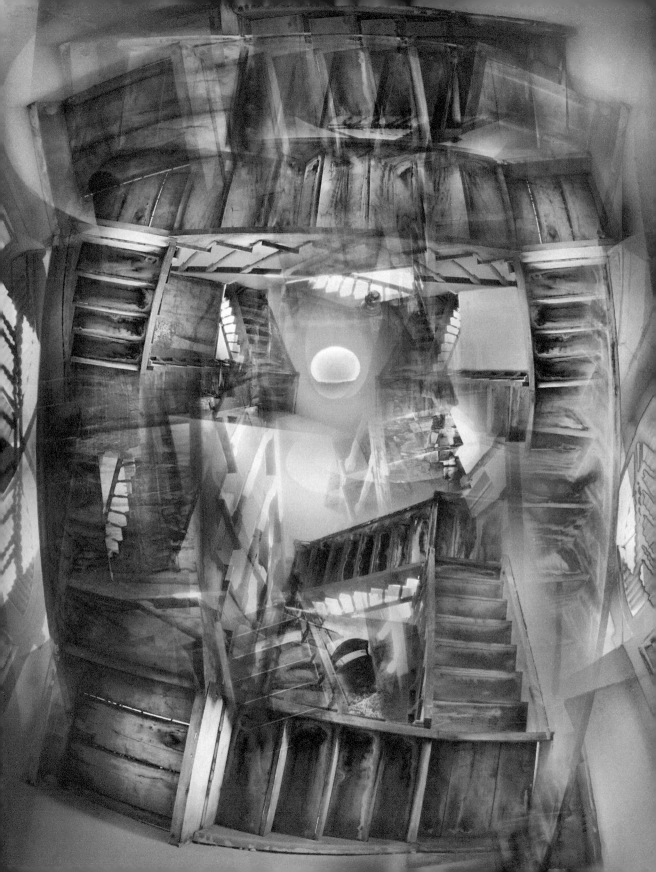

Do Plants Think?

I photographed this succulent with my camera on a tripod and my lens stopped down to f/22 for maximum depth-of-field. Reviewing the image on my computer, I was struck by how the iterative pattern of the petals surrounded a central focal point. It seemed to me that this focal point, the center of the succulent, could interestingly be represented as the "eye" of the plant.

To create an image from my visualization, I composited a human eye—mine, actually!—into the center of the plant. However, the image still didn't seem complete. This was a human eye in a plant, not a plant eye in a plant.

My next step was to composite a version of the plant image itself into the white of the human eye. This made it look much more plant-like, and the image was nearly complete.

If you look at the close-up below, you'll see that I took things a step further by adding succulent petals to the center of the pupil as well.

In my opinion, there's no good reason to believe that plant life is not sentient, although undoubtedly "green" thoughts move very slowly by human standards. This image illustrates my feelings about the possibility of sentient plant life.

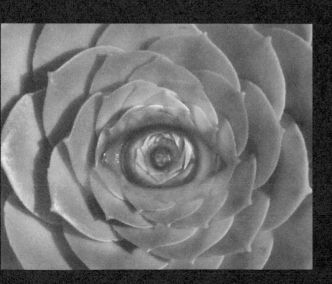

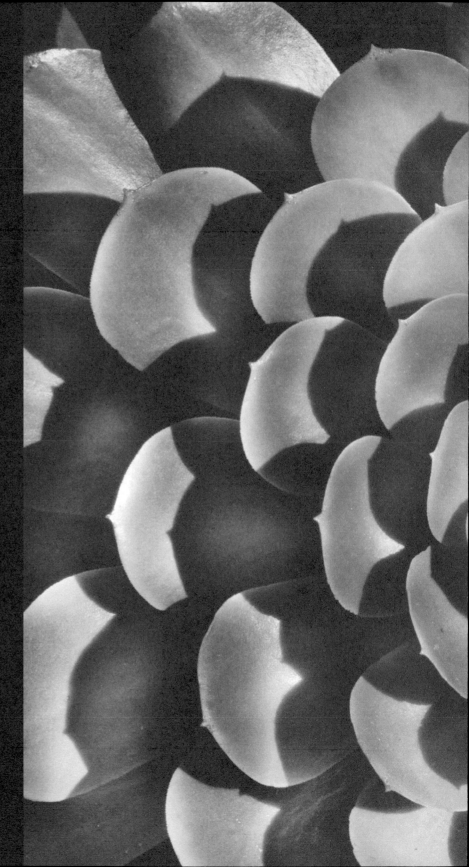

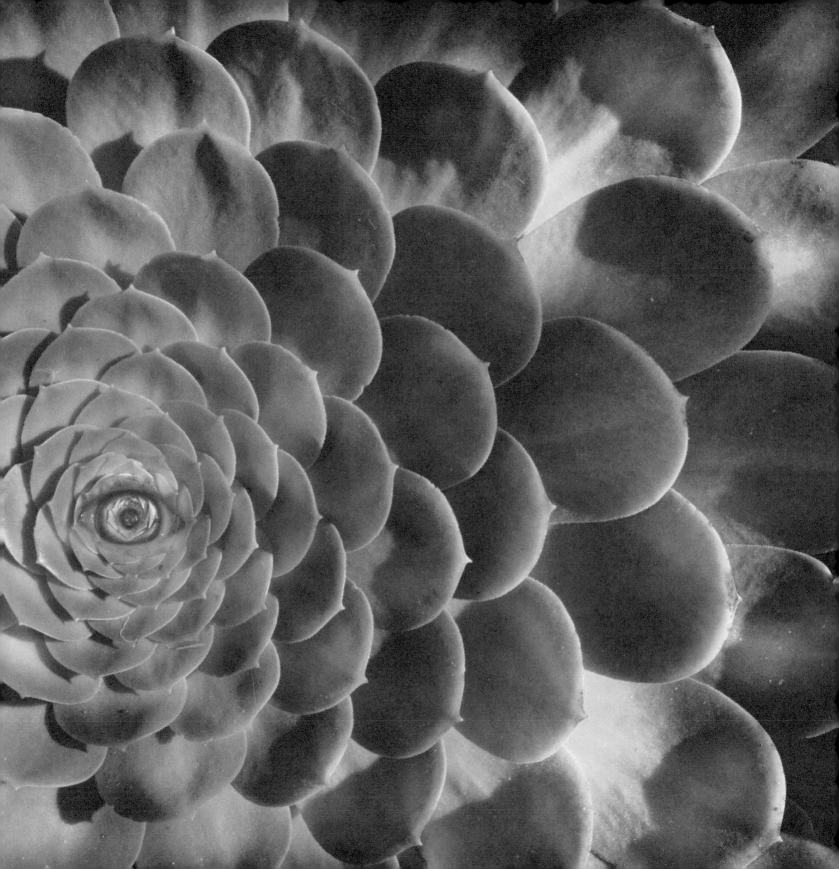

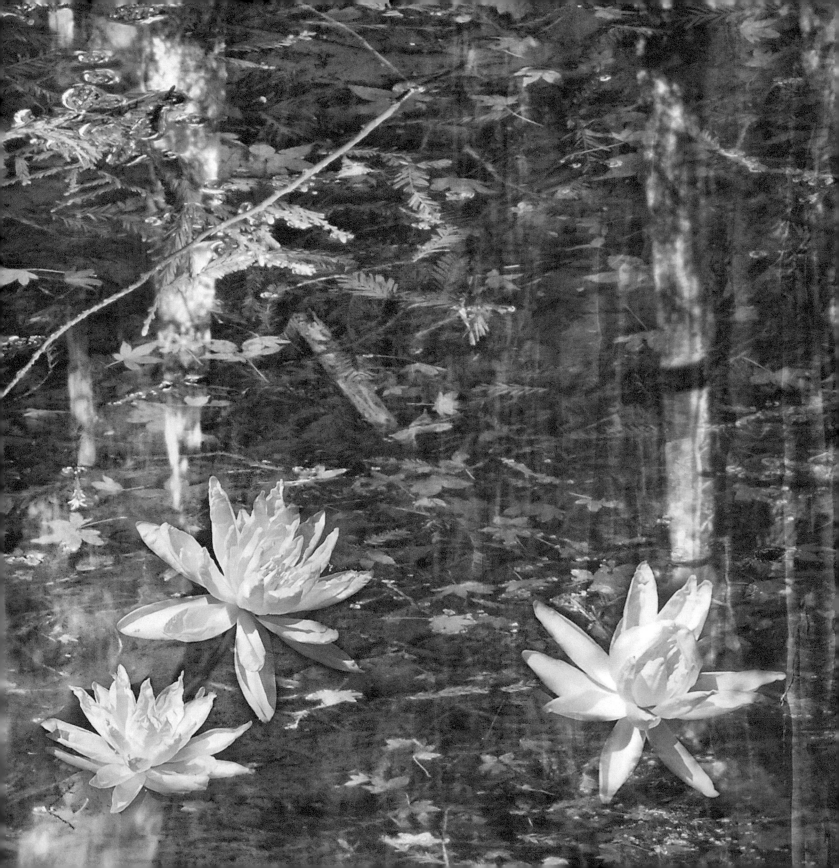

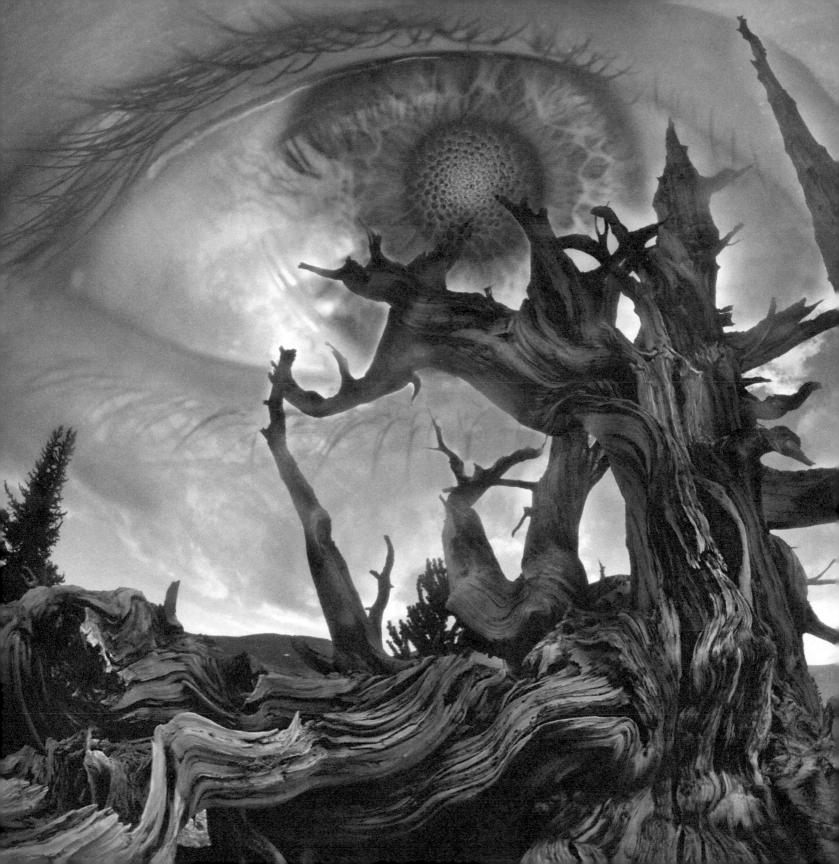

>> A Poke in the Eye

MANY THINGS ARE BETTER than a poke in the eye, particularly when the eye is in the sky. It wasn't my intention when I created this photo composite to illustrate the concept of poking the sky in the eye. My idea was to create an image that showed the ancient forces of nature in conflict with themselves.

The tree in the foreground is one of the oldest living things—a Bristlecone Pine from the White Mountains of California. I added the large eye to the sky and then saw that the image needed some additional work in the pupil. So I composited the core of a flower into the pupil.

Interestingly, the primary work on this composite was done in the LAB color space. Normally I use LAB for adjustments and for adding color effects, not for the gut Photoshop techniques of layering, painting, and masking. It takes a different perspective to see what you're doing when you are working on images that have had the black and white information inverted—as I did in this composite. Of course, to get things back to the way they look in the "real world" required another adjustment: inverting the inversion.

›› LAB: The neglected color space

Creating the layer mask for the Bristlecone Pine image

The key to this photo composite is combining the foreground image of an ancient Bristlecone Pine plausibly with the close-up photo of an eye so that it looks like the eye belongs in the sky and as part of the composition.

There's no shortcut for sitting in your chair at your computer and painting when you are dealing with a masking challenge as complex as the foreground image of the tree in this composite. This means spending hours with a brush of varying size, opacity, and hardness.

The trick here is to make sure to work at appropriate magnifications. To paint in the edges of the mask correctly, you're going to need to get very, very close. On the other hand, to see how the effect is working, you need to be

further back from the image. I almost always find that getting this kind of mask right is an issue of looking at each piece I am painting at three or four different magnifications.

Every time I get lazy and think I can just paint on the image without getting closer, before too long I realize that I've messed up. Bear in mind that I work on a 30" wide Apple Cinema monitor. If you are working on a smaller monitor, it becomes even more important to magnify the image for accurate work and also to keep checking on your progress at more normal magnifications.

Getting close when you need to

Two things I find really handy for managing magnification issues are the Navigator (see page 34 for info) and a couple of keyboard shortcuts. Person-

ally, I'm not that big on shortcut keys, but these are really useful because you don't have to change to another tool to use them. On the Mac: ⌘ and the + key zooms in; and ⌘ and the − key zooms out. On Windows, press Control and the + key to zoom in; and Control and the − key to zoom out.

Compositing in LAB

It's pretty common to do routine Photoshop work such as compositing in RGB or CMYK, but pretty unheard of to do it in LAB color. Since LAB has a greater gamut than other color spaces and in some respects more flexibility, this makes no sense. If you can get used to working in LAB, you'll find it can give your Photoshop work some extra oomph.

LAB color is explained in detail in PD1 starting on page 150.

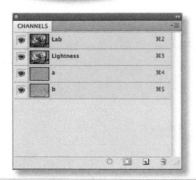

Start by opening the Bristlecone Pine image in Photoshop and convert it to LAB color by selecting Image ▸ Mode ▸ Lab Color.

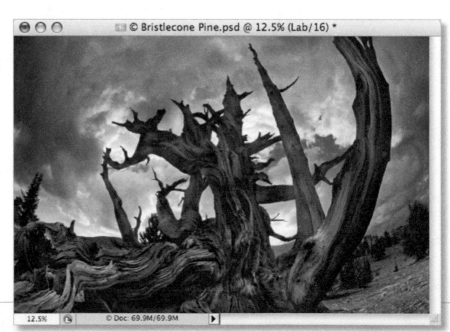

2

Select Image ► Adjustments ► Invert. This inverts all three channels in the image: the Lightness, A, and B channels.

When you invert all the LAB channels, whites become black, and blacks become white, and the colors in the other channels are also swapped for their opposites. Usually, this adjustment creates electric blues like those seen here

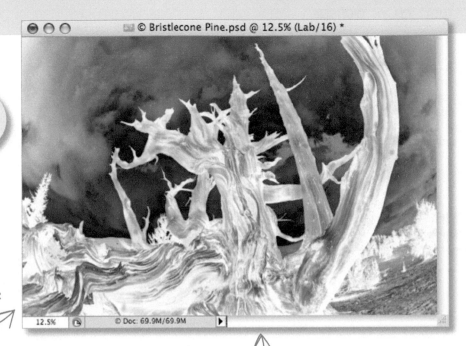

Inversion adjustments create interesting effects in LAB color because of the color opponent architecture of the space. In other words, each channel contains information at opposite ends of a color scale

3

Open the eye image in Photoshop and convert it to LAB color by selecting Image ► Mode ► Lab Color.

4

Select Image ► Adjustments ► Invert. This inverts all three channels in the image.

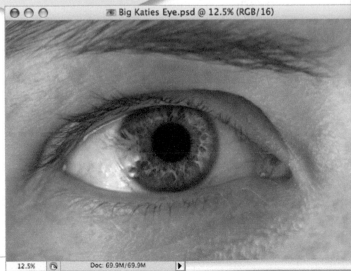

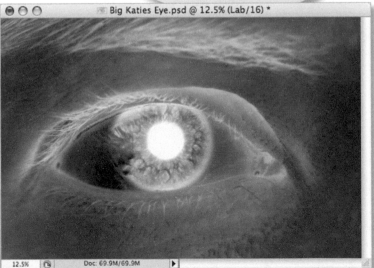

5 Drag the eye image from its image window onto the Bristlecone Pine window. The eye image becomes a new layer. Name it "Eye."

You're finished using the eye image you opened in Step 3, so close it to get it out of the way

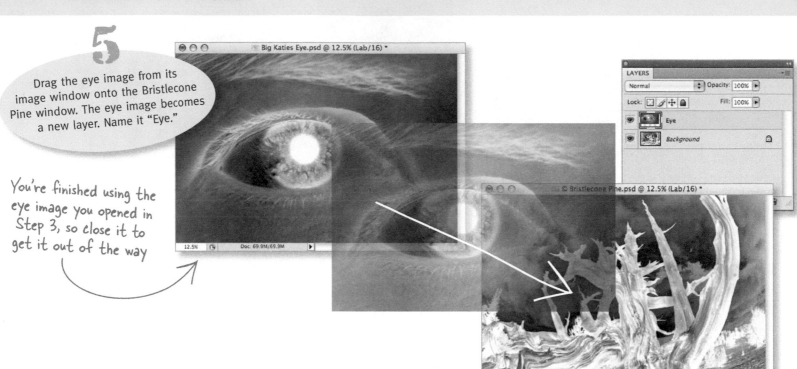

6 Lower the Opacity of the "Eye" layer to 50% so you can see the "Background" pine tree layer underneath. Position the eye behind the upper limbs of the pine tree.

7 With the "Eye" layer selected, choose Layer ► Layer Mask ► Reveal All to add a white Reveal All layer mask to the layer.

Lower the Opacity to 50% so you can see what you are doing

Zoom in so you can see to position the eye right where you want it

8 In the Toolbox, set the foreground color to black and use the Brush Tool to remove the areas of the "Eye" layer that you do not want visible. When you are finished working on the mask, set the "Eye" layer's Opacity up to 79% (that's where I liked it).

Take your time as you paint this mask! It took me several hours to get it right

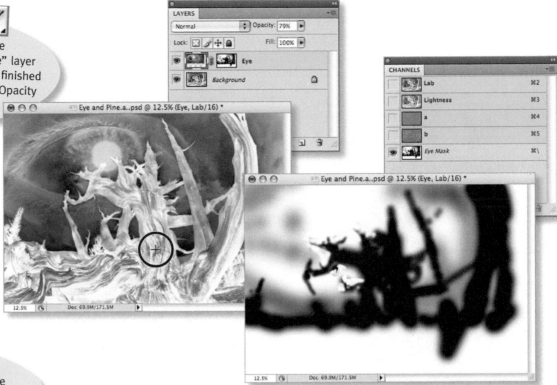

9 *Checkpoint*

Save and archive a version of the composite image with the layers. Then, flatten the layers by selecting Image ▸ Flatten and save the file with a new name.

At this point I had a really neat photo composite that I titled "When Worlds Collide." I started to wonder what would happen if I inverted or equalized the different channels...

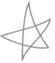 For <u>a lot</u> more about LAB color inversions and equalizations, take a look at PD1, pages 150–181

While I ended up using the "inversion of the inversion"—actually a "normal" looking view—working in LAB gave me the opportunity to consider a number of extraordinary and colorful possibilities

Lightness channel inversion

A channel inversion

B channel inversion

LAB channel equalization

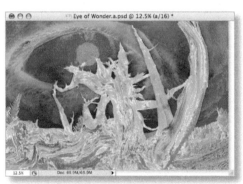

A channel equalization

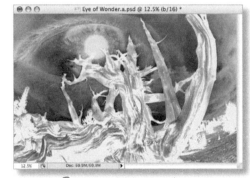

B channel equalization

Then I "inverted the inversion" by selecting all three channels—the Lightness, A, and B channels—and then inverting them. I realized I had another interesting image on my hands...now what to make of it?

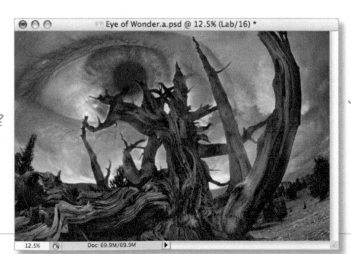

...I really liked this image but I thought the pupil of the eye needed something. So I went looking through my library of flower images and found just the right thing, an Echinacea...

Even though this looks "normal," the image is still in the LAB color space

10

Open the Echinacea image and choose Image ▸ Mode ▸ Lab Color to convert it to the Lab Color space.

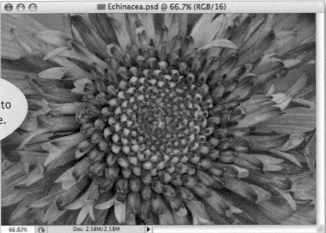

11

In the Channels palette, select the Lightness channel, and then click the eyeball icon to the left of the LAB channel so you can see how the inversion effects the image. Next, choose Image ▸ Adjustments ▸ Invert.

Click the L channel in the Channels palette and then click the LAB eyeball (don't select the combined LAB channels). Only this channel should be highlighted

All the channels should be highlighted in blue

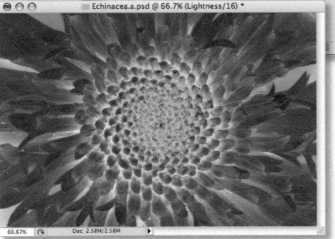

I wanted a really green center of the flower to mask into the pupil, so I inverted the Lightness channel. This swapped the black and white information in the image, making the green center almost neon

12

With the Echinacea window still active, go to the Channels palette and select the LAB channel. Next, click the *Eye of Wonder* image window to make it active and select the LAB channel.

13 Click the Echinacea window to make it active again, and then drag the inverted Echinacea image from its window onto the *Eye of Wonder* image. Name this new layer "Flower."

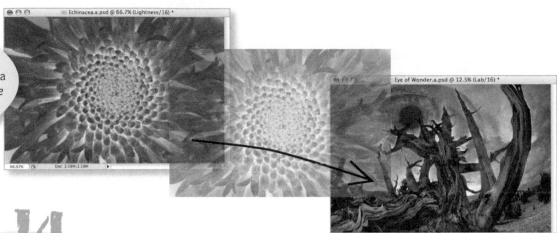

14 Compared to the pupil in the composite, the center of the Echinacea is very large, so you'll need to scale it down to fit. Lower the Opacity of the "Flower" layer to 55%. Choose Edit ► Transform ► Scale to reduce the size of the Echinacea. Be sure to hold down the Shift key as you drag a corner handle; that way, the flower will scale down proportionately.

Lower the Opacity to 55% so you can see the eye underneath the flower

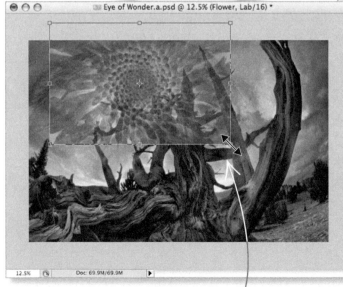

Hold down the Shift key and drag toward the center of the flower

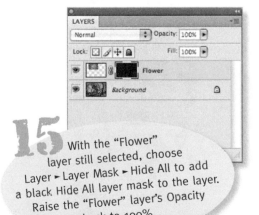

15 With the "Flower" layer still selected, choose Layer ► Layer Mask ► Hide All to add a black Hide All layer mask to the layer. Raise the "Flower" layer's Opacity back to 100%.

16

In the Toolbox, set the foreground color to white and paint with the Brush Tool on the "Flower" layer mask to make the center of the flower layer visible in the eye's pupil.

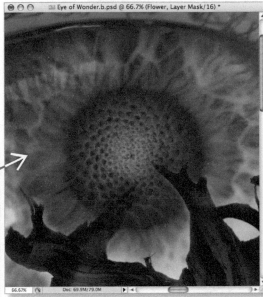

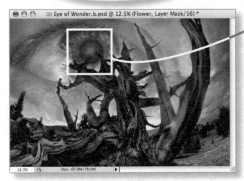

Make sure you zoom in so you can really see what you are doing

For more about the Brush Tool and painting on a layer mask, turn to pages 22–24

The finished "Eye of Wonder"

17 Checkpoint

Save and archive a version of the *Eye of Wonder* with the layers in the LAB color space. Then save the file with a new name.

18

Select Image ▸ Mode ▸ RGB to convert the image back to the RGB color space. Then, choose Layers ▸ Flatten to finish the image.

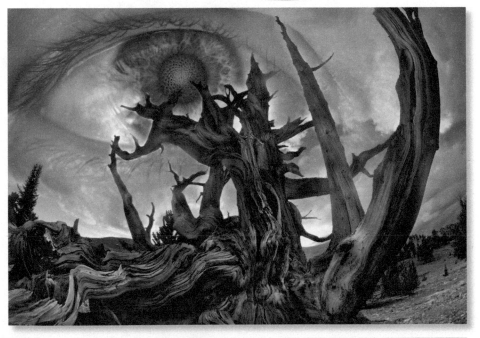

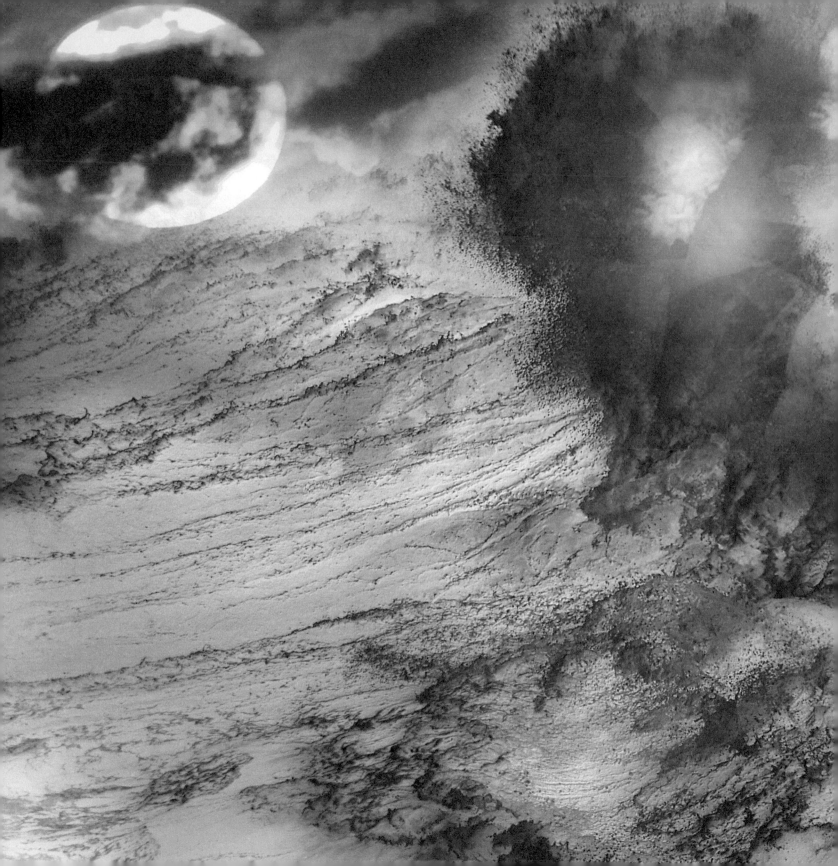

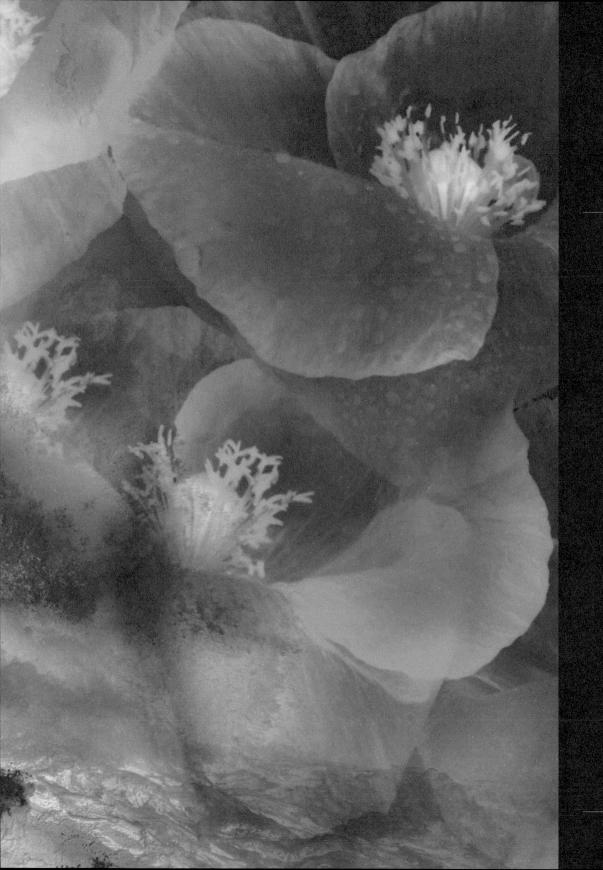

Using Different Color Spaces to Add Color Effects

This photo composite shows a surging sea at sunset crashing into a coastline made up of strange blue flowers.

As you can probably tell, I put the image together from three different photos: an image of crashing waves, a sunset, and flowers.

I used the LAB color space to create this image—but in a different way from *Eye of Wonder* shown on pages 184–193. In this case, the weird colors that can be generated using LAB are integral to the ethereal and otherworldly nature of this image. In particular, the crashing wave was created using an L channel inversion of the original photograph of surf crashing against a cliff. The flowers are an LAB inversion of an image of poppies from my garden. On the other hand, the sunset is, well, a pretty natural sunset processed in the "normal" RGB color space.

Combining these three images with their different color characteristics allowed me to create a composite with a look that would have been impossible had I just used a single color space.

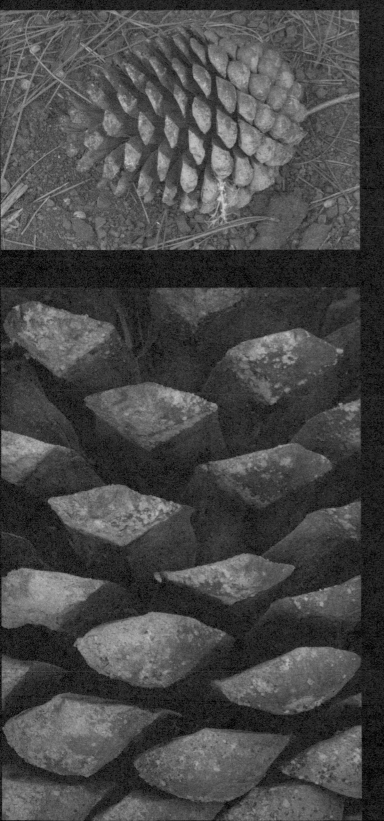

Creating a World in a Pine Cone

Walking down a trail in a pine forest under misty skies, I saw an attractive pine cone (top left), made visually interesting because of the variegated green lichen on the pine cone scales.

I photographed the pine cone using a macro lens with my camera on the tripod (bottom left). I used three bracketed exposures to capture the full dynamic range from light to dark.

I combined the three exposures using the Hand-HDR techniques explained on pages 108–121 to create an almost abstract close-up pattern between lights and darks. Looking at the combined image, you wouldn't understand at first glance that you are seeing a pine cone close-up.

As I studied this abstraction, I realized that it looked like an aerial view of a landscape with mesas and canyons. All this pine cone needed to become its own little world was a few waterfalls, some cloud cover, a river flowing in the "canyons," and a rainbow.

The waterfalls came from photos of Yosemite, California; the water in the "canyons" came (logically enough) from images of the Grand Canyon; the rainbow came from the White Mountains in California with an assist from the Mystical Lighting Photoshop plug-in from AutoFX Software; the clouds came from many places.

In each case, I needed to scale the composited images way down, rotate them and skew them so that they made visual sense within the reality of the pine cone landscape. My idea was that the pine cone landscape essentially is a bird's-eye view with the foreground in clear focus and a kind of swooping view of the more distant parts of the pine cone. That way, you can look right down into the "canyons" in the foreground, but you are looking through the rainbow at the distant view of the waterfalls.

My "world in a pine cone" is convincing enough that I have had people ask me where it is because they want to go there, too.

An illusion of this sort works better and is more believable when you don't see how it was made. If you just look at the final composite, without seeing the photo of the pine cone, you are more likely to take it as a fantastic, but plausible, landscape.

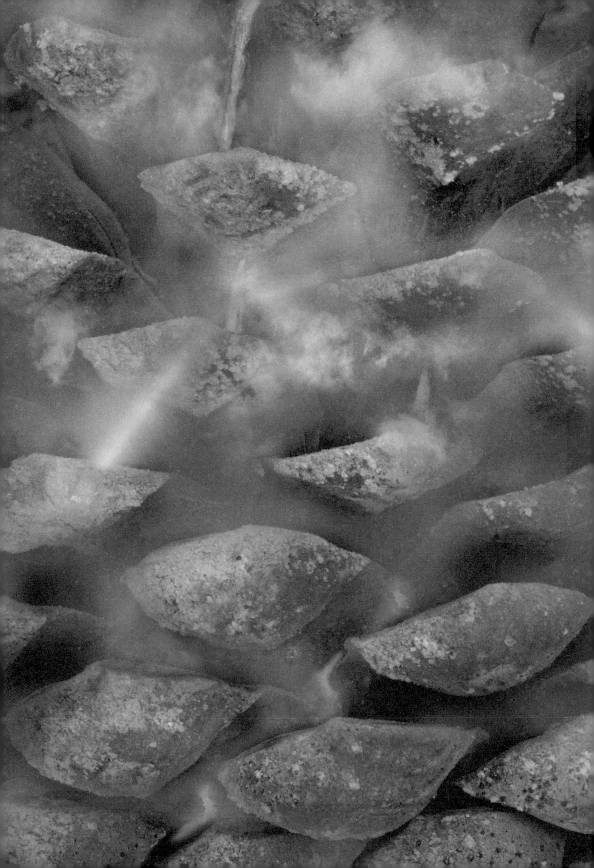

Creating a Magical Portal

According to Bruno Ernst, M.C. Escher contemplated creating a "fascinating" fairy tale landscape in which a magic ornamental gate in our normal world opens to reveal a magical and different world.

Escher took this conceit a little further in his plans, intending the magical world within the portal to be back in time. In one description of the work that he was never to actually make, prehistoric birds in the ancient world fly out through the gate to become airplanes in the external, workaday world.

Photo compositing can bring in subject matter from diverse times and places. The arched bridge was photographed in spring in San Francisco while the lake was shot in the mountains in winter. These two images are on roughly the same scale—both show views that are partly distant and recede to infinity.

A challenge in compositing is to include images on a different scale like the fish. This decorative koi filled almost the entire frame of a photo. To make it work in the composite, I reduced it to a small fraction of its original size.

I put these three photos together to create the composite image using layers, layer masks, and painting.

Like Escher's idea, this image is a version of the fairy tale common in many countries of a magical portal that opens on a different world. The ornamental bridge and koi are from the Hagiwara Tea Garden, Golden Gate Park, San Francisco, California. The landscape seen through the bridge is Don Pedro Reservoir in the Western Sierra foothills of California.

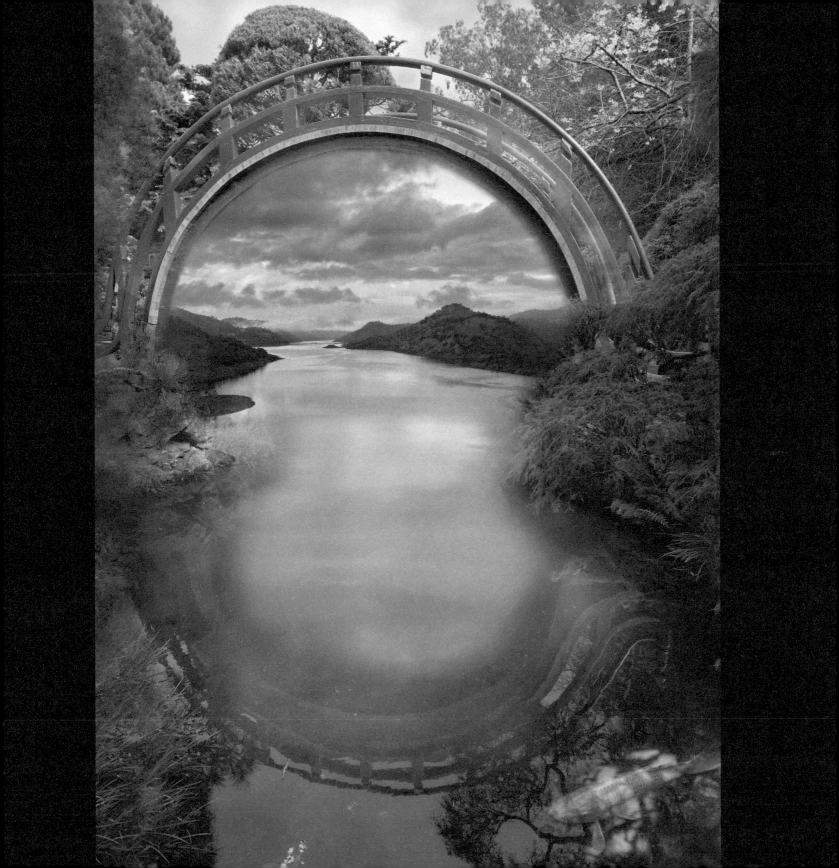

ONWARD & UPWARD

This Challenge is for You!

You've read *The Photoshop Darkroom: Creative Digital Post-Processing* and *The Photoshop Darkroom 2: Creative Digital Transformations*. This means that you understand how I created my images using the magic of the Photoshop darkroom and you know a bit about how I think about post-film digital imaging.

I believe that the possibilities are infinite. As digital photographers and artists, we stand at the threshold of a new world that is not bounded by mundane reality. Anything that can be visualized can be created.

It's time to throw the challenge to you! My books have given you many ideas, tools, and techniques. What will you do with them?

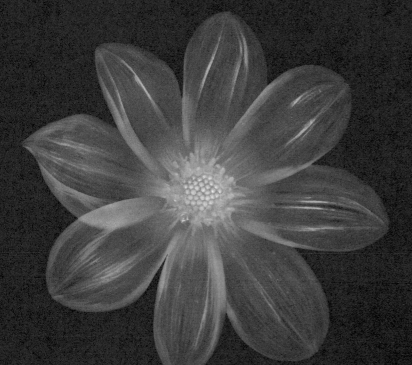

I suggest starting somewhere. It really doesn't matter where. Start with a photo or a scan or a concept and transform it into something new. Make it better! Make it more fun! Make it more interesting!

Okay, so I admit that not all my experiments in the Photoshop darkroom have worked out the way I wanted them to. I can live with this. It's a fact of life. If you wait for perfection, then you will never do anything. So don't hesitate and get started. Make mistakes, get messy!

The tools the Photoshop darkroom provides are powerful beyond belief. Sure, there are less time consuming ways to process digital photos if all you want to do is process photos to make them look like "normal" photos. I recommend Adobe Lightroom for this purpose.

In the hands of creative masters, the chemical darkroom was about more than just processing film. Creative mistakes led to new creative processes and as Ansel Adams—photographer and pianist—famously put it, if the negative was the score, the print was the performance.

The chance to be a great performer is even more manifest with digital than it was with film. My digital images use my photos as the grist for my imaginative mill. You may want to take the same approach—or you may find new ways to proceed. That's the beauty of living at the birth of a new art form. All the paths have not yet been trod and the world is filled with attractive trails that have not yet become super-highways.

So choose a digital path, make it your own, and use the techniques shown in this book to create stunning digital imagery that is uniquely your own.

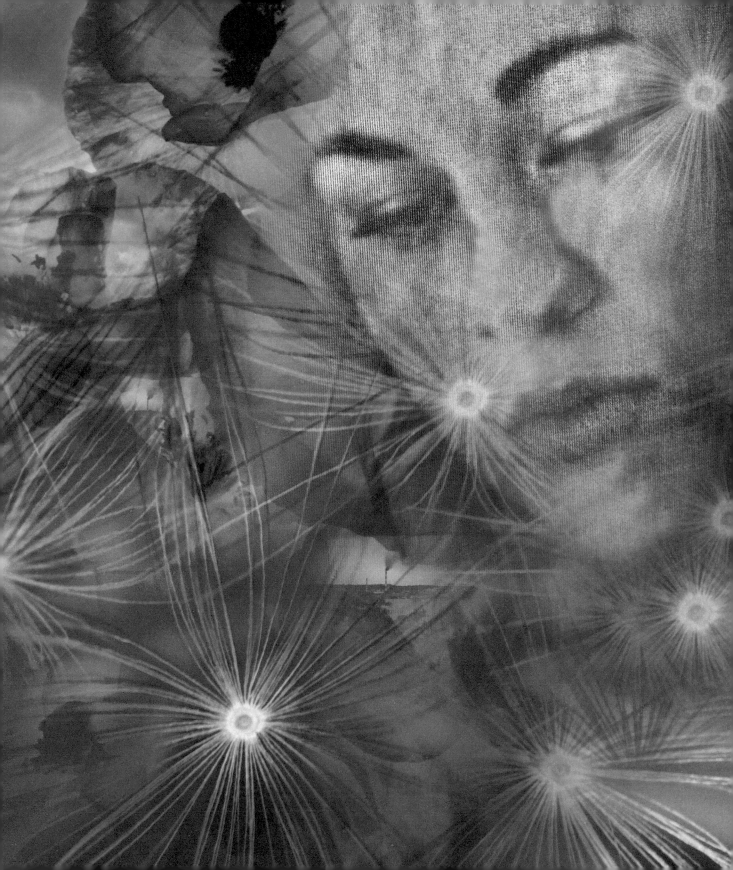

>> Glossary

Adjustment layer: A special kind of layer that holds information about the changes made to the associated layer rather than the entire layer's information.

Adobe Camera Raw (ACR): Used to convert RAW files Into files that Photoshop can open.

Ambient light: The general background light in a given situation.

Aperture: The size of the opening in a camera lens.

Blending mode: Determines how two layers in Photoshop will combine.

Bracketing: Shooting many exposures at a range of settings. It is more common to bracket shutter speed than aperture.

Burn: To selectively darken an area in an image.

Channel: In Photoshop, a channel is a grayscale representation of color (or black) information. In RGB color there are three channels, red, green, and blue.

Checkpoint: A step in post-processing in which good workflow requires archiving a copy prior to continuing work.

Color temperature: The apparent warmth or coolness of a light source, as indicated in degrees Kelvin.

Compositing: See *Photo compositing*.

Curve: An adjustment used to make precise color corrections.

Depth-of-field: The distance in front and behind a subject that is in focus.

Dodge: To selectively lighten an area in an image.

DSLR: Digital single lens reflex camera.

Equalization: A Photoshop adjustment that maximizes the color in a channel or channels.

EXIF data: Information added to a photo or image file, such as shooting data and copyright.

Gradient: A gradual blend, often used when working with layer masks in Photoshop.

Hand-HDR: The process of creating HDR images using Photoshop layers and masking without using automation to combine the images.

High key: Brightly lit photos that are predominantly white, often with an intentionally "overexposed" look.

Histogram: A graph that represents a distribution of values; an exposure histogram is used to display the distribution of lights and darks in an image.

HDR: High Dynamic Range images combine multiple captures at bracketed exposures to have greater tonal range than conventional photos.

Inversion: A Photoshop adjustment that inverts the color in a channel or channels.

ISO: Scale used to set a camera's sensitivity to light.

JPEG: A compressed file format for images that have been processed from the original RAW file.

LAB color: A color model consisting of three channels. The L channel contains the luminance (black and white) information, the A channel contains

magenta and green, and the B channel holds blue and yellow.

Layer: Photoshop documents are comprised of layers stacked on top of each other.

Layer mask: Masks are used to selectively reveal or hide layers in Photoshop.

Low key: Dimly lit photos that are predominantly dark, often with an intentionally "underexposed" look.

Mesh points: The area in a photo composite where component images meet.

Multi-RAW Processing: Combining two or more different versions of the same RAW file.

Noise: Static in a digital photo that appears as unexpected, and usually unwanted, pixels.

Overexpose: An overexposed photo appears too bright; the exposure histogram is bunched towards the right side.

Photo compositing: Combining one or more photos to create an image that is often impossible or unreal.

Primitive: The smallest underlying image that is altered and replicated to create an entire composite image.

Programmable interval timer: Used for a wide variety of tasks especially astronomical photography. With the camera on a Bulb setting, the interval timer allows you to specify an interval before an exposure starts, the length of an exposure, the length of time between exposures, and the number of exposures.

"Proper" exposure: A proper exposure is an exposure that is theoretically correct for a given subject based on overall or average light readings. With a proper exposure, the histogram is usually a bell-shaped curve in the middle of the graph. Often compared with a "creative" exposure, which is used for creative purposes but may appear too dark or bright in some or all portions of an image.

RAW: A digital RAW file is a complete record of the data captured by the sensor. The details of RAW file formats vary between camera manufacturers.

Shutter Speed: The interval of time for which the camera shutter is open.

Similars: Closely related captures from the same photo shoot.

Stacking: A process derived from astronomical imaging that displays the brightest pixels in a stack of images.

Tonal range: The range of color and light and dark values in an image.

Underexpose: An underexposed photo appears too dark; the exposure histogram is bunched towards the left side.

White Balance: The color temperature of the light source of a photo.

Workflow: The process that starts with a RAW digital capture and concludes with a finished and archived image file.

Dedication

The future is now. This book is for all those digital photographers and artists who see the possibilities.

Acknowledgments

Special thanks to Ed Berlien, Bill Bachmann, Mark Brokering, Matt Buchanan, Gary Cornell, Martin Davis, Virginia Davis, Valerie Geary, Katie Gordon, Barbara Hopper, Denise Judson, Jade Vernau, Matt Wagner, and Stacey Walker.

And, as always, Julian, Nicky, Mathew, and Katie Rose—we are 'ohana.

Case study images

Personally, I would prefer you to try the techniques I explain in *The Photoshop Darkroom 2* on your own photos. However, I know that some folks will like to follow the steps using the exact images in an example.

If you're one of these people, you'll be happy to know that I have made low resolution versions of the photos used in every case study in *The Photoshop Darkroom 2* available for download.

Go to *www.focalpress.com/9780240815312*

» Index

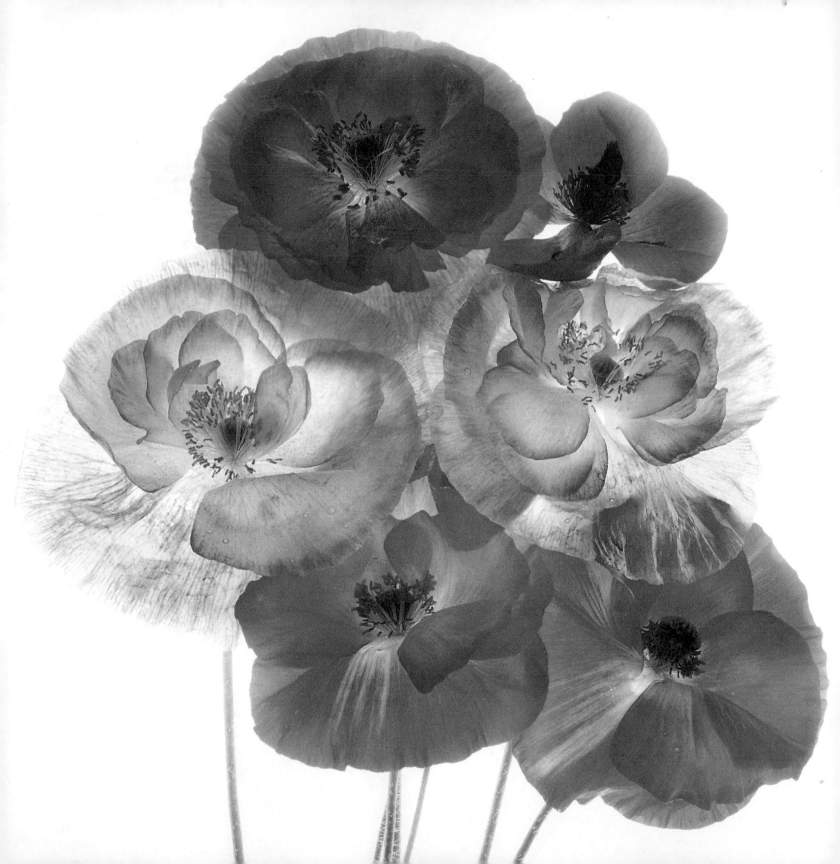